A Complex Delight

The publisher gratefully acknowledges the generous contribution to this book provided by the Graduate Theological Union's Center for the Arts, Religion, and Education.

A Complex Delight

The Secularization of the Breast
1350–1750

MARGARET R. MILES

UNIVERSITY OF CALIFORNIA PRESS

BERKELEY LOS ANGELES LONDON

University of California Press, one of the most
distinguished university presses in the United States,
enriches lives around the world by advancing scholarship
in the humanities, social sciences, and natural sciences. Its
activities are supported by the UC Press Foundation and
by philanthropic contributions from individuals and
institutions. For more information, visit
www.ucpress.edu.

University of California Press
Berkeley and Los Angeles, California

University of California Press, Ltd.
London, England

Chapter 2 is a revised version of "The Virgin's One Bare
Breast: Female Nudity and Religious Meaning in Tuscan
Early Renaissance Culture" by Margaret R. Miles,
adapted and reprinted by permission of the publisher
from *The Female Body in Western Culture: Contemporary
Perspectives,* edited by Susan Rubin Suleiman, pp. 193,
196–208, Cambridge, Mass.: Harvard University Press,
Copyright © 1985, 1986 by the President and Fellows
of Harvard College.

Library of Congress Cataloging-in-Publication Data

Miles, Margaret R. (Margaret Ruth)
 A complex delight : the secularization of the breast,
 1350–1750 / Margaret R. Miles.
 p. cm.
 Includes bibliographical references and index.
 ISBN 978-0-520-25348-3 (cloth : alk. paper)
 1. Breast—Religious aspects—Christianity.
 2. Body, Human—Religious aspects—Christianity.
 3. Breast—Social aspects. I. Title.
BT741.3.M55 2008
233'.5—dc22

 2007029484

Manufactured in the United States of America

17 16 15 14 13 12 11 10 09 08
10 9 8 7 6 5 4 3 2 1

For Leslie

pulchritudo pulchrorum omnium

AUGUSTINE
Confessions 3.6

CONTENTS

PREFACE

The Word is no other than See.

JAN VAN RUYSBROECK

To make a long story—the story of this book—short: In 1350, the breast was a religious symbol; by 1750, the breast was eroticized and medicalized, no longer usable, or used, as a religious symbol. Perhaps I should begin by explaining what I mean when I say that the breast was a symbol.

According to theologian Paul Tillich, a symbol points beyond itself to "something else" in whose power it participates.[1] It "opens up levels of reality that are otherwise closed," and "unlocks elements of our soul which correspond to the dimensions and elements of reality." A symbol cannot be produced intentionally; "like living beings [symbols] grow and die. They grow when the situation is ripe for them and they die when ... they can no longer produce response in the group where they originally found expression."[2] A sign is not a symbol. Signs do not "participate in the reality to which [they] point"; they are powered by conventions (for example, red traffic lights are signs that, in Western societies, signal drivers to stop). Did secularization change the breast from a symbol to a sign? For the moment, I leave this question open, returning to it later in the book.

Clearly, the Virgin's breast met Tillich's criteria for a symbol: in early modern Western societies in which Christianity was the dominant religion, her bared breast, appearing in paintings and sculptures, signified nourishment and loving care—God's provision for the Christian, ever in need of God's grace. Moreover, referencing every human being's earliest pleasure, the breast pointed to and "opened up" the greater reality of the universe's provision of life and the sustenance of life. The infant's acceptance, pleasure, and

gratitude were the appropriate responses, reminding viewers of the foundational moment of their existence and thus unlocking "elements of our soul which correspond to the dimensions and elements of reality." In short, the breast acted effectively as a religious symbol.

Theologians who write about symbols are characteristically far more interested in the "something else" to which the symbol points than to the concrete embodiment that creates the symbol. They are more comfortable with acknowledging human dependence—for the next breath—on the universal provision Christians call God than with our initial utter dependence on an actual woman for birth, care, and nourishment—for life itself. They are willing to acknowledge that the helplessness of the infant *is* the lifelong human condition, but they prefer to ignore the reality of our birth and infancy. So they rush to the symbolic interpretation.

The religious breast prohibits abstraction, however. The revelation of a naked breast startles viewers into attentiveness to the concrete—even mundane—reality of the feeding breast. Come to think of it, that *is* the way the sacred operates in the real world. The "something else" and the actual experience must be held together if the symbol is to retain its energy. By departing too hastily from the mother's body, we eviscerate the symbol we intend to augment. Separated from human care and nourishment, God's provision becomes abstract, not experienced, and therefore unknowable.

Augustine (356–430), unblinking observer of human nature and behavior, seems to have endeavored to hold together the concrete and the symbolic when he described the experience of the infant at the mother's breast: "Neither my mother nor my nurses filled their own breasts with milk; it was you [God] who, through them, gave me the food of my infancy."[3] But the language he used collapsed the mother's provision into God's provision. Like many later theologians, he was evidently eager to transcend the actual experience in order to draw attention to the "something else" to which the actual experience points. By moving too quickly to the symbolic, he minimized the reality of the bodily experience that gave the symbol its power.

The problem of language is that it is often clear at the direct expense of nuance and delicacy. Images have no such problem. Leon Battista Alberti, author of the first treatise on painting (1435), claimed that what one who gazes attentively at a body in a painting *sees* is the state of the figure's soul; a language of gesture, posture, skin, bones, and muscles makes it possible for the patient and committed viewer to grasp who the painted figure most essentially *is*. "What can be shown cannot be said," the twentieth-century

German philosopher Ludwig Wittgenstein wrote.[4] Paintings *show,* inviting viewers to see—indeed, insisting that they see—by imaginatively entering the physical and emotional feeling of a body that looks like this. Thus, a late medieval viewer, gazing at a painting of the nursing Virgin, *experienced* God's love by imaginatively experiencing the loving care of a woman, yet without jettisoning the actual in favor of the symbolic. For this reason, images are essential to religion.

This book began with the images, with my startled recognition that dozens, perhaps hundreds, of medieval and early modern images document a shift in the public significance of representations of breasts. These images served as primary texts in my research to understand how and why representations of the breast changed so dramatically in early modern Western Europe. Written texts alone would not have revealed this development, since the significance of breasts was never, to my knowledge, explicitly contested. However, once the evidence of painted and sculpted images of breasts is noticed, texts can be readily identified that discuss the shifting values that explain this phenomenon. In this book, I seek to demonstrate that images, carefully interpreted in their historical setting, constitute historical evidence.

ACKNOWLEDGMENTS

I am grateful to friends who listened as I talked through ideas, entertaining my thoughts with the kind of enthusiasm an author needs in order to feel that an idea is worth seemingly endless research and writing: Deirdre Anderson, Lynda Burris, Susan Burris, Leslie Ewing, Michael Morris, Ann Pellegrini, and Mary Tolbert. Martha Stortz, Owen Thomas, and Deborah Haynes gave the manuscript careful and thoughtful expert readings and made invaluable suggestions. Reed Malcolm, acquisitions editor at the University of California Press, saw the possibility of a book in one of my collected essays. My grateful thanks to Vanessa Lyon for her expert research assistance. Alicia Fessenden and Ann Mark of Art Resource, New York also gave valuable research assistance. I am indebted to Professor Doug Adams and the Center for the Arts, Religion and Education at the Graduate Theological Union, Berkeley for contributing to the subvention that made color plates possible. Breasts need flesh tones!

This book could not have been written if other books had not been written first. Responsible cross-disciplinary research into a complex cultural imagination can no longer be done—if it ever could—by a single author. Especially important to this book were *The Invention of Pornography: Obscenity and the Origins of Modernity, 1500–1800,* edited by Lynn Hunt; Hans Belting's *Likeness and Presence: A History of the Image before the Era of Art;* Walter Stephens's *Demon Lovers: Witchcraft, Sex, and the Crisis of Belief;* and Thomas Laqueur's *Making Sex: Body and Gender from the Greeks to Freud.* Arnold Davidson's *The Emergence of Sexuality: Historical Epistemology and the Formation of Concepts* supplied a model for the contextual exploration of ideas. These are, of course, by no means all of the books to which I am indebted, but they furnished key pieces of the puzzle. The title of the book comes from a sentence in Anne Hollander's *Seeing Through Clothes:* "Images of breasts are always sure conveyers of a complex delight."[1]

The Secularization
of the Breast

The object was to learn to what extent the effort to
think one's own history can free thought from what it
silently thinks, and so enable it to think differently.

MICHEL FOUCAULT
The Use of Pleasure

AUGUSTINE'S FAMOUS AUTOBIOGRAPHY, the *Confessions,* begins with his reconstruction of his own infant experience from attentive observation of another infant's first experiences at the breast. "I was welcomed then with the comfort of woman's milk. . . . Then all I knew was how to suck, to be content with bodily pleasure, and to be discontented with bodily pain; that was all."[1] Satisfaction, pleasure: the infant's first experience of the feeding breast evoked these feelings. But, according to Augustine, these were not the infant's only feelings at the breast. Frustration and envy also made their first appearance in the infant's life in his experience at the breast: "I myself have seen and known a baby who was envious; it could not yet speak, but it turned pale and looked bitterly at another baby sharing its milk. . . . Can one really describe as 'innocence' the conduct of one who, when there is a fountain of milk flowing richly and abundantly, will not allow another child to have his share of it?"[2]

Augustine's reflections on infant experience at a woman's breast taught him two of his most fundamental theological lessons, namely, God's love and human perversity. Even if the infant has no overt frustration, the breast is not always provided as immediately as he demands it, or the milk it

supplies is limited: "I cried for more as I hung upon the breast."[3] As Augustine recognized, and Freud was to make explicit centuries later, early childhood learning—for better or for worse—remains with a person across a lifetime. The breast, powerful symbol of provision and source of the earliest frustration, is part of the body of a woman, a mother or a surrogate mother.

Twentieth-century psychoanalyst Melanie Klein developed a theory of individual development from observations similar to Augustine's. "Object relations start almost at birth," Klein writes, "and arise with the first feeding experience."[4] The infant, gendered male in both texts and images in the dominantly Christian West, "encounters a world which is both satisfying and frustrating," a world in which the anxiety caused by the close interaction of love and hate directs psychic development.[5] In order to tolerate this anxiety, the neonate splits the breast into a gratifying breast and a hostile breast, an "extremely perfect" and an "extremely bad" object. He internalizes a "devoured and thus devouring breast," projecting his own destructive impulses onto the "extremely bad," or withholding, breast and experiencing it as persecuting. He idealizes the "extremely perfect" breast as a defense against this persecutory anxiety.[6] The critical importance of the infant's relation to the breast arises because "the breast, toward which all his desires are directed, is instinctively felt to be not only the source of nourishment but of life itself."[7] The infant's experience at the mother's breast forms the core of his ego and "vitally contributes to its growth and integration."[8] Moreover, Klein observes that in the child's growth and development, "all emotions attach themselves to their first object."[9]

Klein did not extend her analysis beyond individual psychic development. Nor did Augustine, but Augustine did extrapolate from his observations of the infant at the breast to a theory of religious subjectivity. He made the infant's experience of delight the prototype for his experience of God: "What am I at my best but suckling the milk you give and feeding on you, the food that is incorruptible?"[10] He characterized his own "infancy" in the Catholic Church after his conversion as that of a feeding infant:

> As then the mother, when she sees her child unfit for taking meat, gives him meat, but meat that has passed through her flesh, for the bread upon which the infant feeds is the same bread as that which the mother feeds on; but the infant is not ready for the table, he is only ready for the breast, and therefore bread is passed from the table through the mother's breast, that the same food may thus reach the little infant; thus our Lord Jesus Christ . . .

the bread, made himself milk for us, being incarnate and appearing in mortal shape. . . . On this let us grow, by this milk let us be nourished. Let us not depart from our faith in the milk before we are strong enough to receive the Word.[11]

By contrast with the ambiguous breast of his mother/nurse, Augustine discovered a reliable breast, an "inexhaustible and always bountiful breast, an ideal breast" that offered unlimited gratification.[12]

Writing his *Confessions,* Augustine split his preconversion past from his converted present, characterizing his past as replete with the frustration he described so vividly. Undernourished, Augustine "panted for honors, for money, for marriage. . . . I found bitterness and difficulty in following these desires. . . . I was eaten up by anxieties."[13] He summarized his preconversion life as the frenetic gratification of a repetition compulsion, "scratching the itching scab of concupiscence."[14] Denying his preconversion experience any positive pleasure or value, Augustine used it as a rhetorical foil against which to highlight God's trustworthy and satisfying nourishment.

According to Klein, the infant's first response to his experience of the breast as both gratifying *and* frustrating is an effort to control the breast's provisions, to enjoy its satisfactions and to eliminate anxiety about its negative effects. The mechanisms of splitting, projection, and introjection serve, however ineffectually, the project of control. Neither Augustine nor Klein extended their insights about individual development to a theory of culture.[15] However, in the later twentieth century feminist and gender theorists and historians of women's history identified and analyzed the persistence of the masculinist desire to control women across the societies and geographical locations of the dominantly Christian West. After several decades of detailed analysis of gender arrangements in many societies, it was possible to suggest that the infant's experience at the breast informs men's concerted efforts to control—to design and administer—gendered social arrangements that maximize male pleasure and minimize frustration. In the chapters that follow, I examine this theory of culture and its limitations in relation to early modern Western European societies.

Women, in the period we explore, did not own the breast. The Virgin Mary was perhaps the only woman who invoked the authority of her feeding breast to demand that Christ grant salvation to sinners who sought refuge in her cloak. We will see that in the case of actual women, fathers and husbands owned and dispensed the breast and its provisions. It is therefore not my intention to glorify the religious breast and describe a

progressive "fall" into secularity. In public texts and images, the breast was, at all times, "mastered." However, women seem to have enjoyed more respect in societies in which the breast was regarded as a powerful symbol of nourishment and loving care than in those societies in which it was viewed as an erotic and/or medical object.

As bearers—not owners—of the breast, women experienced the most evident damage from men's mechanisms for coping with the anxiety of the ambiguous breast. The masculinist perspective on which the creation of Western societies and institutions was based saw women as either "extremely bad" or "extremely perfect," either dangerous seducers and persecuting witches, or idealized and infinitely benevolent madonnas. Yet although women were prevented from exploring the full range of their humanity, their skills, and their possibilities in early modern societies, men suffered too from their society's expectations. Unjust social arrangements and attitudes damage whole communities, constraining relationships and forcing both women and men to occupy a narrow range of feelings and activities.

Is another development of the male psyche in relation to the female breast possible? And what about the female infant's development in relation to the mother's breast? After exploring the social and religious history in which "ownership" of the breast coincided with power and authority in late medieval and early modern Western Europe, I return to these questions in the afterword to this book. Guided by recent psychoanalytic theory that takes into account the development of the female infant, I discuss Jessica Benjamin's suggestion that mutual recognition is an alternative to the mechanisms of splitting and control, projection and introjection.

Clearly, the breast was a powerful symbol in Western societies. The particular content of the symbol, the interpretation of the breast, changed as social authority migrated in the early modern period. The breast lost its hegemony as a religious symbol as Christian churches lost authority in the sixteenth century, largely due to the emergence of Protestant alternatives to "the one true Church." Moreover, new secular authorities competed to interpret the breast. This book examines the complex social, institutional, and religious changes in which the secularization of the breast occurred. The medical and erotic interpretations of the breast that then arose became amazingly stable—persisting even to our own time.[16]

What does "secularization" mean in the context of an early modern world in which struggles over religious ideas had never been fiercer, a world of Luther and polyglot Bibles, a world of Catholic reformation zeal, a world

willing to fight, kill, and die for religious commitments? The theory that Western Europe was secularized in the sixteenth to eighteenth centuries seems to imply that religiosity declined, but this is demonstrably not the case, and it is not what I mean by "secularization."[17] Secularization was not the enemy of religion; rather, one must picture an intensification of *both,* largely stimulated by the printing press and its capacity for generating and disseminating information, education, and propaganda. By secularization, I mean that some of religion's traditional functions—such as the organization of societies, the surveillance of public morality, and the circulation of basic information—were appropriated by secular authorities. For example, Elizabeth Eisenstein has pointed out that before the advent of the printing press, medieval sermons had functioned to circulate news about "local and foreign affairs, real estate transactions, and other mundane matters," a role that was assumed by broadsheets and monthly, weekly, and daily newspapers. Circulating information more efficiently, these products of the printing press thus allowed sermons to focus more directly on religion.[18]

Hans Belting, Francis Ames-Lewis, Mitchell Merback, and others have discussed a fundamental change that occurred in the ways images were painted and viewed during the early Renaissance. Artists established that they were no longer to be considered craftsmen whose work had to meet the specifications of their ecclesiastical patrons, but independent and creative professionals whose work should be considered equal to that of other intellectuals. This sea change (discussed in chapter 3) not only altered religious paintings themselves, but also how viewers related to them. Belting argues convincingly that after the professionalization of painting, the viewer was invited to "look and think," rather than to "look and feel," as the medieval viewer had. Images became "art," as we understand the word today. He writes: "The image became an object of reflection as soon as it invited the beholder not to take its subject matter literally but to look for the artistic idea behind the work."[19]

Early modern secularization can be seen as a distribution of interest and agency by which society and the world came to be understood as the arena Christians must engage.[20] Rather than lamenting a deplorable slide into secularity, one must seek to understand the gains and losses accompanying secularization. That this book describes what I consider one of the losses embedded in secularizing processes should not be taken to imply that I regard all the effects of secularization as regrettable. My interest lies is seeing how the daunting complexity of early modern Western Europe *worked.*

I focus primarily on four centuries in Italy, but since Italy was the acknowledged center of artistic activity and innovation for most of the

early modern period, it was common for artists from other regions of Western Europe to study in Italy and/or to admire and emulate Italian painters. Thus, my more general frame of reference is Western Europe. The advantage of focusing in particular on Italian images is that I remain within the context of an image-using Catholic culture. In Protestant worship, sensory engagement in liturgical and devotional practice was reoriented from vision to hearing.[21] In the Roman Catholic reformation, on the contrary, new challenges were created for images.

THE BREAST IN TRANSITION

From the fourteenth to the eighteenth century, the Virgin/Mother Mary was frequently depicted in paintings and sculptures with one exposed breast. Although images of the Virgin with a single bare breast had appeared earlier, their number increased dramatically during the fourteenth century. This insistent focus on the breast that nourished the infant Christ—and by identification with him, all Christians—is startling. Why one breast instead of two? An image in which one breast is bared communicates differently than an image of full exposure: one breast is carefully, purposefully, and meaningfully *revealed* (Latin *ostendere:* to show, display, expose to view), inviting the viewer to discern the revelation implicit in its unveiling.

Two frequently painted scenes show Mary with one bare breast. Giovanni Pisano's sculpture *Nursing Madonna* (before 1314, figure 1) depicts the Virgin and the infant Christ gazing at each other as Christ feeds at her breast. The interlocking gaze between mother and infant is the basis of mutual recognition, making the infant aware that the mother is another being, someone who gazes back at him. It is also the origin of the infant's subjectivity, his "sense of having an interior experience, knowing that [another] has it too, and the possibility of sharing it." Mutual recognition includes "emotional attunement, mutual influence, affective mutuality, sharing states of mind."[22] If recognition goes only one way—that is, if the mother recognizes the infant's subjectivity without communicating her own subjectivity—the infant does not achieve the "balance *within* the self [that] depends on mutual recognition *between* self and other."[23] In Ambrogio Lorenzetti's *Madonna del latte,* the Virgin gazes at her suckling infant while he turns to gaze at the viewer. Through eye contact, the infant establishes a relationship with the viewer, inviting her into the scene and offering her access to the nourishing breast (plate 1).[24]

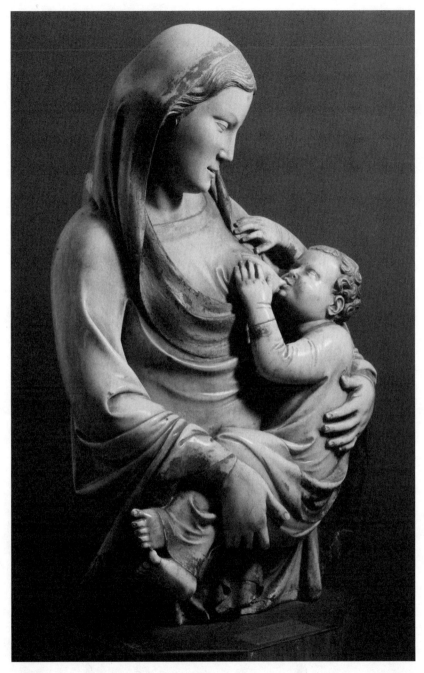

Figure 1. Giovanni Pisano (1248–c. 1314), *Nursing Madonna,* before 1314. Museo Nazionale di San Matteo, Pisa (photo: Scala/Art Resource, NY).

A fresco by a Florentine painter shows another scene in which the Virgin displays her breast (plate 2). She cups her breast in her left hand, showing it to the adult Christ, while pointing with her right hand to a group of sinners huddled at her feet, for whose salvation she pleads. The inscription reads: "Dearest son, because of the milk I gave you, have mercy on them." In a gesture parallel to Mary's presentation of her breast, Christ points to the wound in his side with his right hand, gesturing with his left hand toward Mary and the sinners she shelters. The Virgin's "extremely perfect" breast claims Christ's advocacy and initiates the cycle of salvation. With such powerful pleading—both the Virgin and Christ—how could God fail to provide salvation? Indeed, at the top of the painting, God opens his right hand toward Christ, releasing the dove of the Holy Spirit. Painterly strategies, such as the unrealistic size and placement of the breast, direct the viewer away from a naturalist interpretation and toward religious meaning. I discuss the Virgin's breast further in chapter 2.

To examine a historical image in its cultural context, the visual associations of its original viewers must be considered. While a modern viewer may associate an image of a woman with an exposed breast with the soft pornography that covers our newsstands, a medieval viewer was likely to associate the sight of an uncovered breast with an everyday scene in the home or marketplace in which a child was being nursed. In other words, a medieval viewer was likely to notice the similarity of the Virgin to familiar women. The breast was anything but an abstract symbol: in societies that lacked refrigeration and in which animal milk was thought to foster stupidity in infants, almost every human being experienced her first nourishment and pleasure at a woman's breast. In texts and images, the breast represented the Christian's dependence on God's care and sustenance. Religious meaning bonded with physical experience to form a singularly powerful symbol.

From Plato forward, a popular theory of vision (adopted by Augustine and through his writings transmitted to the medieval and early modern world) held that sight occurs when the viewer's visual ray *touches* an object.[25] The visual ray was believed to originate in the fire that warms and animates the body, thought to be most intense behind the eyes. According to this theory, when an object is seen/touched, an imprint of that object moves back up the visual ray to imprint itself on the memory. For this

reason, many late medieval worshippers left Mass after the priest had elevated the host, thinking that they had communicated even before they ate the sacred bread, when their visual ray had touched it and had appropriated its spiritual nourishment. I suggest that people of the late medieval and early modern period believed that something similar occurred when they gazed at a painting in which the Virgin's nursing breast was shown: in addition to receiving spiritual nourishment by identification with the infant Christ, they touched the breast and assimilated its nourishment by the act of looking.

PAINTED BREASTS

Beautiful painted breasts seem to have fascinated historical people endlessly. Representations of the female breast provide a vantage point from which to track the secularization of the breast between 1350 and 1750 (plate 3). These images define a watershed between the worlds of late medieval and early modern Christianity.[26] The question I will endeavor to answer in the following chapters is this: What were the cultural and religious circumstances within which a religious symbol came to be thoroughly "mastered" by erotic and medical meanings?

Early modern iconoclasm—rejection of certain images—and iconophobia—rejection of, and hostility toward, all images—are outside the scope of my project, as is the rejection, in several Protestant reforms, of the most frequent subjects of Catholic painting and sculpture—the Virgin Mary and the saints. In Protestant territories, removing religious attention from these traditional foci of religious attention made room for the representation of other kinds of nakedness. Lucas Cranach's and Rembrandt's paintings of the naked and vulnerable Adam and Eve show them in a moment of innocence *just before* the Fall. But nakedness also represented evil. Naked witches were a major interest of artists associated with Protestant reform, such as Albrecht Dürer and Hans Baldung.[27] The "extremely bad" and "extremely perfect" breast did not disappear from Protestant images.

However, representations of the breast did not direct viewers to the same interpretation throughout the centuries of our study. As Jessica Benjamin has commented, "The breast is a powerful metaphor because it evokes multiple meanings."[28] In paintings of the fifteenth and sixteenth centuries, three changes began to appear. First, the breast became increasingly

realistic. No longer a cone-shaped appendage that emerged, often at shoulder height, from a slit in the Virgin's garment, it now began to look like an engorged nursing breast.[29] But increments of realistic representation created increased emotional and erotic attachment, simultaneously activating arousal and fear.[30] In Catholic regions the male clergy that commissioned and controlled religious images were aware that the heightened realism of representations of breasts stimulated arousal that could not be directed unambiguously to religious meaning. They responded, at the Council of Trent (December 1563), by rejecting "inappropriate" representations in religious painting. This decree was immediately interpreted as a rejection of nakedness.[31] Although enforcement depended on local bishops and clergy and existing images displaying partial nakedness were not always removed from churches, new religious paintings usually conformed to the Tridentine decree.

Second, by the end of the fifteenth century painted and sculpted breasts were no longer seen in purely maternal contexts. Increasingly, classical subjects, such as Lucretia and Cleopatra, as well as allegorical topics and portraits depicted female figures with one bare breast (figure 2). Hebrew Bible narratives, such as Susanna and the Elders, Joseph and Potiphar's Wife, and Judith and Holofernes, provided an opportunity to paint naked breasts (figure 3). By the sixteenth century, the nourishing breast of the Virgin and the vulnerable, penitent breast of the Magdalen were only two of many pictorial contexts in which breasts were featured. By the seventeenth century, naked breasts presented frankly erotic images, though often still with scriptural warrant (plate 4).[32] In the eighteenth century, unapologetically secular breasts, larger and rounder than a century before, were frequently painted.[33]

The third change in early modern representations of breasts was that the deliberate exposure of a single breast was replaced by depictions of both breasts. The breast replete with religious meaning became two breasts that depended for interpretation on the immediate location and context of the representation. Mary Magdalen was an important transitional figure in this development.

RELIGIOUS AND SECULAR BREASTS

The symbolic religious repertoire of late medieval and early modern people split representations of female bodies into the good body (the Virgin Mary and women saints) and the dangerous sexual body (Eve and witches).

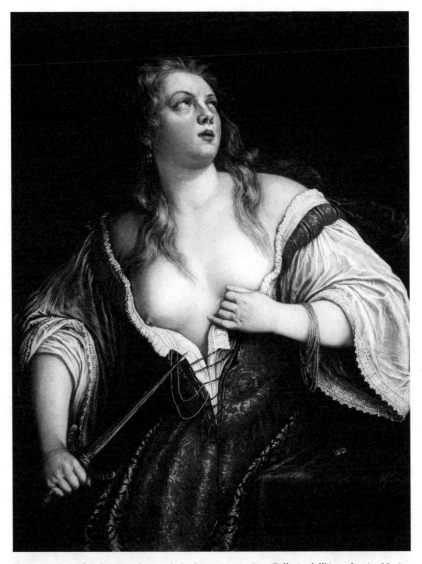

Figure 2. Leandro Bassano (1557–1622), *Lucretia,* c. 1622. Gallerie dell'Accademia, Venice (photo: Cameraphoto Arte, Venice/Art Resource, NY).

Within this scenario, the figure of Mary Magdalen conflated the virtuous and the sexual female body. By tradition, and without scriptural warrant, she was a former prostitute who became Christ's disciple. According to medieval sermons, drama, and devotional manuals, her breast signified abjection and penitence. But depictions of Mary Magdalen migrate between the repentant sinner and the erotic sex worker. In her figure, the

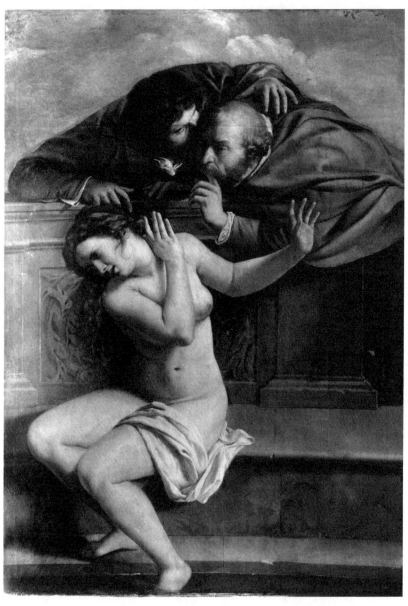

Figure 3. Artemisia Gentileschi (1593–c. 1651), *Susanna and the Elders,* 1610. Schloss Weissenstein, Pommersfelden, Germany (photo: Foto Marburg/Art Resource, NY).

religious meanings of breasts took a subtle turn toward the erotic. For example, in Donatello's 1454 wood sculpture of Mary Magdalen, her hair completely covers her breasts (figure 4); a century later, in Titian's *Mary Magdalen,* her hair parts, revealing her nipples (plate 5). Perhaps it was

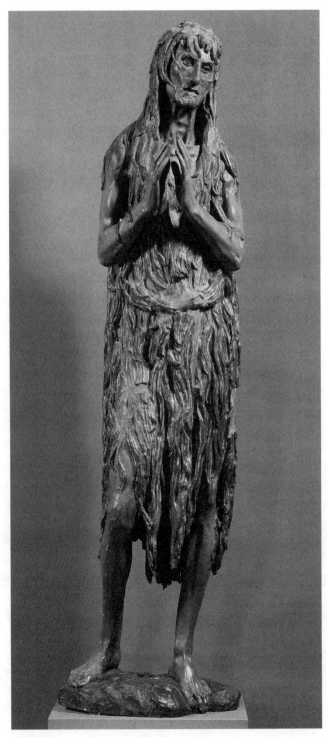

Figure 4. Donatello (1386–1466), *The Magdalen,* 1454. Museo dell'Opera del Duomo, Florence (photo: Scala/Art Resource, NY).

paintings like Titian's that prompted clergy at the Council of Trent to forbid "inappropriate" figures in religious paintings. In chapter 3, I will suggest that the Magdalen represented a wider range of meaning than penitence: her figure also represented a longing for the convergence of the erotic and the spiritual.

The secular breasts that began to be painted in the fifteenth century carried two different meanings—medical and erotic. First, when the dissection of corpses began to be publicly practiced in medical theaters, the anatomical breast made its appearance in medical illustrations, such as Andreas Vesalius's *De humani corporis fabrica* (1543). In anatomies (discussed in chapter 4), bodies—both male and female—were understood not as sites and symbols of religious subjectivity, but as objects to be dissected, studied, and drawn.[34] Second, the invention of the printing press at the end of the fifteenth century created a popular market for erotic and pornographic images, which had formerly been available only to elite men with access to engravings in limited editions. The "invention of pornography" was intimately linked to the origins of modernity in ways explored in chapter 5.[35] The emergence of pornographic and anatomical breasts was intimately connected to the changing economic, social, and religious institutions through which early modern societies were restructured. By the eighteenth century, secular associations with the female breast prevailed over religious meanings in the cultural imagination of Western societies.

It is not possible, however, to identify a date before which the breast symbolized physical and religious nourishment and after which its only meanings were medical and erotic. In geographical locations throughout Western Europe, both kinds of images continued to be produced during the same time period until the middle of the eighteenth century. The development I explore is more subtle: gradually, over a period of several centuries, depictions of bare breasts lost their religious significance and acquired secular meanings. By the mid-eighteenth century, the absence of paintings of the Virgin with an exposed breast suggests that it was no longer possible to signify religious subjectivity by depicting a naked breast.[36]

The story is even more complicated. Paintings of the Virgin and other saints and scriptural female figures with exposed breasts require that we reevaluate the common modern assumption that "erotic" and "religious" images are opposite and opposing.[37] The effectiveness of religious or erotic images, whether verbal or visual, depends on arousal. Sex and violence are perennial and ubiquitous stimulators by which a viewer's attachment can be intensified and his affective engagement heightened.

Indeed, just as the literature of mystical experience of the time used overtly sexual language to describe powerful and ineffable religious experience, late medieval and early modern religious paintings deliberately and skillfully engaged erotic interest in order to provoke religious affect. As David Freedberg observes, "from bad seductiveness to good effectiveness is no great distance."[38]

Ultimately, then, "religious" and "secular" images of breasts cannot be absolutely distinguished. As evidence permits, however, I will seek to understand what features of an image designated it as erotic and/or religious for its first viewers.[39] Perhaps we can be sure that the intended function of an image was to arouse religious feeling only if we know that it was specifically created for, and placed within, a church or a devotional manual.[40] Even when the original location of an image is known, we seldom have clues about how viewers responded to the image.[41]

The Council of Trent's proscription of nakedness in religious painting called into question a traditional method for augmenting devotional engagement. But Catholic reformers affirmed the use of religious images and were interested in identifying images that intensified devotion. Trent carefully defined how images were to be understood:

> not that any divinity or virtue is believed to be in them by reason of which they are to be venerated or that something is to be asked of them, or that trust is to be placed in images, as was done of old by the Gentiles who placed their trust in idols; but because the honor which is showed them is referred to their prototypes which they represent, so that by means of the images which we kiss and before which we uncover the head and prostrate ourselves, we adore Christ and venerate the saints whose likeness they bear.[42]

How could emotional engagement be stimulated without exposing naked body parts? Gian Lorenzo Bernini's sculptures demonstrated that it was possible to depict a saint experiencing religious ecstasy and stimulate a complex erotic/religious response without employing the device of nakedness. Bernini's *Ecstasy of St. Teresa* (1645) and *The Blessed Ludovica Albertoni* (1674)[43] depict fully clothed female saints with an unmistakable eroticism (figures 5 and 6). Bernini's sculptures *suggest* the breast without displaying it: in *Ecstasy of St. Teresa,* a serenely smiling cherub prepares to lift the saint's loose robe with his left hand as his right hand, holding the divine arrow, approaches her breast; Ludovica Albertoni, lips parted in ecstasy, indents her draped breast with the strong pressure of her right hand. Bernini's sculptures reference the religious breast, without revealing it in the flesh.

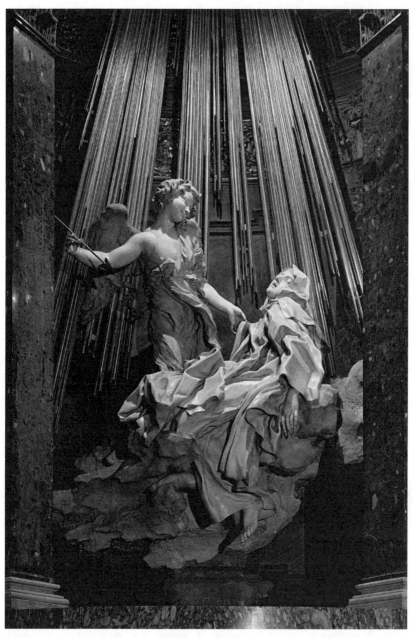

Figure 5. Gian Lorenzo Bernini (1598–1680), *The Ecstasy of St. Teresa,* 1645. Cornaro Chapel, Santa Maria della Vittoria, Rome (photo: Nimatallah/Art Resource, NY).

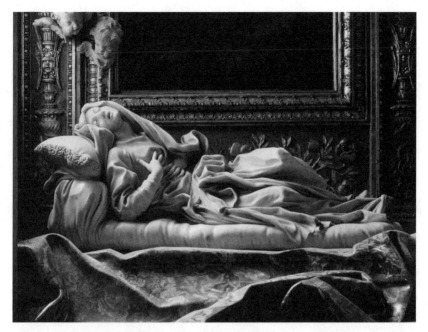

Figure 6. Gian Lorenzo Bernini (1598–1680), *The Blessed Ludovica Albertoni,* 1674. Paluzzi-Albertoni Chapel, San Francesco a Ripa, Rome (photo: Scala/Art Resource, NY).

ASSUMPTIONS AND METHODS

This study can be classified as a history of ideas as long as it is recognized that ideas are not expressed only in language. Conceptualizations of the world, the community, and the person are *primarily* formulated and circulated in material culture, in social arrangements, in institutions, in liturgies, in the ways a society imagines and socializes gender expectations and roles, in what constitutes dissent, and in the social, religious, and legal punishments of dissent. All of these—and other—features of early modern Western European societies will be considered in the following chapters. Finally, however, my description of the breast's secularization depends on painted and sculpted images accessible to broad audiences in public buildings in Western Europe from the mid-fourteenth century to the middle of the eighteenth century.

It is likely that a visual image, repeatedly depicted, attracted a broad audience in its culture of origin and was able to evoke and address strong common anxieties, interests, and longings. However, even though a society supplies a common interpretive repertoire, an image may be seen very

differently by different people. "All images are polysemous," Roland Barthes writes; "they imply, underlying their signifiers, a floating chain of signifieds."[44] Viewers *see* some meanings and not others based on interests directed by their life situations and their need for meaning. Communications *intended* by the painter or commissioner of a painting are not necessarily the same as those perceived by viewers. Thus, searching for a text that "explains" a painting's features is not helpful if we seek to reconstruct the painting's multiple communications. Moreover, if we do not wish to remain within the associative repertoire of a culturally and educationally privileged viewer, we must seek a popularly accessible interpretive reservoir. For example, I have not sought clues to the interpretation of public images in sermons originating in, and confined to, monastic settings.[45] Texts that provide suggestions about how an image may have been seen by a broad range of a society's population are those that were accessible to a largely illiterate public in spoken, sung, or dramatic form.

A diverse cultural ground must be sought if we seek to understand messages received, if we are not content simply to identify the intended message of an artwork. Such intimate variables as life expectancy, availability of food, marriage customs, child-rearing practices, gender expectations and arrangements, laws, and punishments might reveal possible reasons for the popularity of an image in a particular time and place. A sensitive and educated historical imagination is needed to identify features of the social and cultural experience that enable a historian to see what cultural "work" was done by a particular image in a particular society at a particular historical moment. I can, of course, do so only suggestively. Interpretations of anything as complex as cultural events and artifacts cannot be conclusively demonstrated.

Changes in the imagery of breasts and in the attitudes focused by this imagery are intricately imbricated in social and cultural history. Yet metaphors that indicate that a changing phenomenon can be foregrounded against a stable background or context are misleading. No firm boundaries between visual "text" and social "context" exist. There is nothing but highly energetic interactivity. Thus, everything needs to be said at once—plague epidemics, wars, witch persecutions, the invention of the printing press, anatomies, ecclesiastical and civic legislation, laws, texts, and images—and, of course, everything cannot be said at once. I have placed information that helps us to track this highly volatile interactivity where I think it is most relevant. Ultimately, however, I must trust the reader to gather and combine features of early modern society that I have

distinguished and labeled for purposes of clarity—that is, for practical, not for intellectual, reasons.

Finally, a certain humility is necessary in relation to the historical pattern I propose. Did the people who lived in early modern societies of Western Europe see what I see? The past is always more complex than any "history" can describe. It is possible that people who *lived* this history, engulfed in the events, assumptions, and perspectives of their time and social location, did not see the pattern I see. I believe that historical people saw at least a moment of the development I reconstruct, but the luxury of detecting patterns across several centuries is reserved for the historian—a questionable luxury in that it carries the possibility of error. Robert Darnton writes: "As soon as a historian desires a certain result, he or she is likely to find it."[46] In sum, the evidence supports my conviction that what I see was really "there," but, then, so were many other things that, if taken into account, might alter beyond recognition the pattern I see.

Historians are often tempted to pretend an assurance in regard to their interpretation that goes beyond the possibility of documentation. The more self-assured and air-tight a historian's account, the more readers should be prompted to ask, What is *not* there, and how might a different palette of evidence change the proposed pattern? I claim only to highlight one pattern among an infinite number of possible arrangements of the historical evidence. Nevertheless, this acknowledgment should not undermine the picture I present; it merely recognizes and states the condition of all historical description.

A PERIOD EYE

Historians of images are fortunate to have an unusually rich early modern account of painters and their public, Leon Battista Alberti's *On Painting* (1435). Alberti suggested that attentive looking at bodies, whether painted or actual, can reveal the person's inner disposition to the beholder. The painter's role, he wrote, is to facilitate recognition of the soul's condition: "Movements of the soul are recognized in movements of the body. . . . There are movements of the soul, called affections—grief, joy, fear, desire, and others. There are movements of the body: growing, shrinking, ailing, bettering, moving from place to place. We painters, wanting to show movements of the mind with movements of the body's parts, use only the movements from place to place."[47]

The skill of recognizing the soul's emotions by careful scrutiny of the body can be learned and practiced with paintings. The beholder of religious paintings was expected to reproduce the emotions of the sacred figures by imitating their postures and gestures. Once trained and experienced in "being there"—that is, in the subjective reproduction of painted sacred scenes—the viewer was expected to construct her own interior visualizations. Michael Baxandall has described the repertoire of information and visual associations fifteenth-century Italians brought to "reading" a religious picture.[48] He reconstructs a period religious eye from a wealth of associations, examining aspects of fifteenth-century painting from its production and circulation, familiar stylistic conventions, and contemporary sermons and texts that comment on religious paintings. For example, Baxandall shows that gestures described by preaching manuals also appeared in paintings, where they would evoke in contemporary viewers the particular emotions ascribed to them in preachers' sermons.

The visual skills Alberti described were central to religious practice. A 1454 devotional manual, *The Garden of Prayer,* written for young girls, admonishes readers to create private representations of scenes from Christ's Passion. The author instructs his readers to inhabit the sacred scene by imagining it taking place in a familiar location and among familiar faces. Jerusalem is to be pictured as "a city that is well known to you"; likewise, the people in the scene—Jesus, the Virgin, Mary Magdalen, Peter, Caiaphas, Judas, and others—must be visualized as "people well-known to you." Baxandall suggests that often painters purposely painted unparticularized, generic people so that viewers could more easily personalize them according to their private visualizations.[49]

The complexity and detail with which Baxandall reconstructs a sixteenth-century Italian "period eye" is both instructive and daunting. Is it possible to reconstruct an early modern "erotic eye"? In *Seeing Through Clothes,* Anne Hollander suggests a method for reconstructing a period erotic eye. Fashions, Hollander writes, exist to create erotic attraction. In the fetishistically clothed societies of the Christian West, the "body-and-clothes unit" defines people's perceptions of bodies. Even when someone looks at a naked body, the "implied absent clothing" stimulates erotic attraction. For example, early modern painted naked female bodies show the small, high breasts, short waist, and rounded belly characteristic of clothed figures of the time. Fashionable clothing for women, though variable in different times and geographical locations, often required "long, heavy skirts spreading out from below a tiny rib cage, encased in a meagerly cut bodice with high, confining

armholes." The belly must "thrust its sexy swell through the fabric" of the skirt; indeed, "in the erotic imagination of Europe, until the late seventeenth century, it was apparently impossible for a woman to have too big a belly." Heavy breasts, however, were "characteristic of ugly women and witches."[50] I speculate that during the centuries in which the European population was rebuilding after its decimation by malnutrition, war, natural disaster, and plague, pregnancy may have defined the ideal of female beauty.

BODIES AND HISTORY

While human bodies may seem to be a universal element common to all societies through time, physical experience and attitudes toward particular bodies are among the most variable and difficult features of historical study. I do not use the term "the body" because it suggests either a generic, universal, sexless body, or the male body of traditional usage. No one has ever seen or touched "the body"; it is important to be reminded that bodies are always marked by sex, race, social location, age, and other variables that create vastly different physical, emotional, and intellectual experiences.

Laws, customs, institutions, social arrangements, distribution of wealth, availability of food, religious ideas and practices: all of these and many more factors might be relevant to a reconstruction of how bodies were imagined and experienced in a particular culture and society. The symbolic repertoire of a culture is a uniquely resonant index of the cultural attitudes that shaped actual experience. For example, noticing the changing depictions of breasts in the centuries of our study undermines the impression that bodies are "natural" and therefore always experienced similarly. The impression that bodies are perennially the same supports the illusion that the historian's own experience can provide a bridge to the past.[51] Rather, responsible historical interpretation must be based on painstaking reconstruction of the complex interactivity of social and cultural change and representations of (in the present study) female breasts.

During the centuries in which the secular breast gained currency over the Virgin's nourishing breast, intense and violent debate about women's "nature" culminated in virulent witch persecution. Theological literature consistently targeted women as the source of temptations and evils.[52] Indeed, Melanie Klein's "extremely bad" breast was as present in the hysterical misogyny of Heinrich Kramer and James Sprenger's witch-hunting

manual, the *Malleus Maleficarum* (1484), as in the learned and cultured Erasmus of Rotterdam's best-selling devotional manual, the *Enchiridion Militis Christiani* (1519). In these writings, "woman" represented danger, sin, and death. However, literary and theological works rarely function as sole perpetrators of widespread attitudes; more frequently they reflect attitudes whose causes are intimate and painful. Fear and hatred of women was also stimulated by the outbreak of the first epidemic of syphilis to sweep Western Europe, a disaster for which men blamed prostitutes in particular and women in general.[53] Connections between the secularization of the female breast and the toxic misogyny that swept Western Europe will be examined further in chapters 4 and 5.

In short, erotic and medical bodies—so obvious and "natural" to twenty-first-century Westerners—did not always define representations of naked breasts in dominantly Christian Western Europe. Associations other than erotic or medical ones were, to generations of historical people, intuitively evident. In fact, the detachment of religious significance from human bodies, as this development can be tracked in the secularization of the breast, was cultural, not "natural."[54] The eclipse of the breast as site and symbol of physical and spiritual nourishment occurred in particular historical circumstances, as complex exchanges of social power shifted the communications embedded in visual images of women's bare breasts. Those changes are the topic of this book.

BODIES AND PLEASURES

Among the most difficult to interpret of historical images are those in which naked human bodies or parts of bodies play a central role. As Julia Kristeva has remarked, "Significance is inherent in the human body."[55] Yet no pictorial subject is more determined by a complex web of cultural interests than human bodies. Moreover, with no other subject is it less safe to assume continuity or even similarity of meaning between its original viewers and a modern interpreter. A further question has already arisen: Is it even possible to think in terms of the significance of a group of paintings for a whole historical society, or must one identify different significance for men and women, different significance for people of different social locations, different ages, or different points of access to cultural and economic production? Did women and men consider the same representations erotic? If projection of twenty-first-century experience is neither

legitimate nor helpful, does historical evidence support an answer to these questions?

Two considerations contribute to a provisional answer. First, unless people within a society criticize and actively resist the symbolic repertoire of their culture, they tend to accept their society's values, playing the roles assigned to them by those values, even if they are disadvantaged or oppressed by them.[56] Lacking institutional and public space in which to debate, construct, and support alternative values, most women and men work with the religious and social values of their society. Even an unusually accomplished woman like Teresa of Avila cloaked her theology and her vigorous and courageous reforming activities with the disclaimer that she was nothing but a stupid woman.[57]

In societies in which men enjoy virtually exclusive access to creating and controlling the public sphere—from its institutions to its symbolic resources—masculinist perspectives are unmodified by women's perspectives and values. Moreover, in societies in which dissidence is vigorously persecuted, individuals can do little to alter the values that dominate the public sphere. Thus, we may assume that most women accepted the roles assigned them, albeit often creatively finding ways to maximize their agency in societies not designed to further their interests. In addition to noticing broadly circulated values and the institutions by which they were promoted and supported, it is important to be alert to any evidence that suggests women's particular interest in images of female figures. However, it is quite possible, even probable, because women and men shared common cultural and visual experience, that they both saw images of the breast as simultaneously erotic and religious. As Baxandall demonstrates, paintings were not seen in a vacuum of cultural meanings; women and men were instructed in *how to look*. Private and particular meanings built on common meanings, rather than rejecting them.

Second, the common twenty-first-century assumption that sexual orientation inevitably and predictably directs people to find different objects erotic may not be accurate for historical societies.[58] Today, a century after Freud described "sexuality" as an intimate, nonnegotiable, and resonant key to the core of the self, sexual orientation is commonly assumed to be a permanent and central feature of the "self." For political purposes with the goal of creating just social and sexual arrangements, the concept of sexual orientation is useful, even necessary. As Michel Foucault has shown, however, our notion of fixed "sexual orientations" is questionable.[59] Polarized constructions of "heterosexuality" and "homosexuality" may not designate

stable and permanent states of desire.[60] Erotic attraction may be as insta-
ble, variable, and whimsical as spiritual attraction.

Moreover, it is possible that we do not yet have an adequate language for
what Foucault was content simply to call "bodies and pleasures." Examining
historical evidence with a "queer eye" suggests that "heteroerotic" and
"homoerotic" are not mutually exclusive categories.[61] These terms may
simply indicate a more or less stable object of attraction. Plato's description of
an *"eros* for the beautiful" can help us to imagine a larger category that simul-
taneously includes and subsumes sexual desire, that is, an energizing and
motivating passion for the beautiful.[62] In relation to depictions of breasts, the
concept of "eros for the beautiful" suggests the inadequacy of polarizing
objects of erotic pleasure according to sexual orientation. Whatever meaning
is ascribed to them, painted breasts are beautiful, a complex delight. And
visual pleasure is an end in itself; there is no question of possessing the
object—or perhaps we should say, as Augustine did, that to see *is* to possess.[63]

On the basis of these considerations, the question of whether one can
legitimately examine the public symbolic repertoire of a society without
assuming vastly different, even contradictory, interpretations by people
occupying different genders and social locations, can now receive a work-
ing answer. We can, I believe, assume that broadly accessible public signif-
icance circulated throughout Western European societies. We can then
notice any evidence indicating resistance to, or rejection of, public mean-
ings, as well as efforts to construct alternative meanings.

WHO BENEFITS?

Who controlled and benefited from representations of breasts? I will seek
to demonstrate that, in the centuries of our study, the symbol of the breast
marked the location of power in Western European societies. Until the end
of the fifteenth century, the church, through its clerical commissioners of
religious images, controlled representations of the breast. During the
sixteenth century, an emerging medical profession and a new pornography
industry contested the church's monopoly, and by the end of the seven-
teenth century, the breast had changed hands, as it were, from churchmen
to physicians and pornographers.

Moreover, the lives of actual women changed as the breast became
secular. A striking convergence of religious and social changes created a
new situation for women in early modern Western Europe. At the same

time that medicine was established as a profession and the care of women's bodies was no longer conducted primarily by midwives and women healers, the breast was appropriated by anatomy books, male physicians, and barber-surgeons. In the same centuries in which the public sphere was increasingly appropriated by market capitalist economic production, the locus of production and distribution moved away from the household. Male control of the means of production put women "in their place"—that is, in the home—and breasts became pornography.

The following chapters examine these developments in detail, sketching the changes in religion and society that converged to create the secular breast. In brief, naturalistic images of exposed breasts tipped the always extremely fragile and unstable balance, in images of the breast, between the erotic and the spiritual, in the direction of the erotic, provoking church leaders to pro-hibit nakedness in religious paintings and allowing the interpretation of naked bodies to be acquired by secular authorities. Although pervasive cul-tural change can never be pinpointed to a single event, the twenty-fifth ses-sion of the Council of Trent (December 1563) may be identified as a turning point in attitudes toward nakedness in religious art, for it was during this ses-sion that bodies and their representations officially lost their ability to convey religious meaning. In fact, by the time of this official decision, naked bodies had already lost credibility as site and symbol of religious commitment. No one seems to have protested the council's decree on *theological* grounds, even though a few centuries earlier no less a theologian than Thomas Aquinas had claimed the perfect analogy for God's grace to be "beauty of body."[64]

Within Christianity, representations of the breast as a religious symbol were tied to an understanding of bodies as being integral to religious com-mitment. Doctrines—of creation, the incarnation of Jesus Christ, and the resurrection of bodies—as well as the sacraments, each composed of a mate-rial and a spiritual element, affirmed that bodies are central to Christian faith and practice. The earliest descriptions of new members' initiation into Christian communities outline a program in which, in addition to religious instruction, bodies were converted to Christ's possession by ascetic practices and by daily exorcisms designed to release them from Satan's ownership. A long period of catechetical preparation culminated in the Easter Eve bap-tism, before the full congregation, of naked adults. It was apparently possi-ble until sometime late in the Middle Ages (when visual and textual evidence of the practice disappears) to *see* bodies as religious.[65]

How, then, did bodies, so insistently featured in the early practice of the religion of the "Word made flesh," largely disappear from Christian

understanding of religious commitment? Why do many twenty-first-century Christians think of religious commitment as based solely on certain beliefs, having little to do with bodies, practices, and lifestyle? By the conclusion of this book, I will present evidence to demonstrate that modern Christianity's attitude toward bodies began with the secularization of the breast. Before this claim can make sense, however, the historical ground must be surveyed.

The Religious Breast

There is something profoundly alien to modern
sensibilities about the role of the body in medieval
piety. . . . [For medieval Christians,] bodiliness
provide[d] access to the sacred.

CAROLINE WALKER BYNUM
*"The Female Body and Religious Practice
in the Later Middle Ages"*

LATE MEDIEVAL AND EARLY MODERN PAINTINGS and sculptures of the Virgin Mary with one breast exposed existed alongside questions concerning the appropriateness of nakedness in religious painting. In the mid-fourteenth century, frequent depictions of the lactating Virgin suggest that this image was compellingly attractive to viewers. But in the sixteenth century, the debate over nakedness in religious painting intensified in Italy. Controversy was not focused on images of the Virgin, however, but on depictions of human figures in paintings of the Last Judgment and the Resurrection of the Flesh (plate 6 and figure 7).

Toward the end of the fifteenth century, the Dominican preacher Savonarola (d. 1498), a harsh critic of Florentine morals and doctrine, fulminated against nakedness in artistic representations of all kinds.[1] His sermons, with their vivid and violent imagery of destruction and devastation, evoked terror. Indeed, his threats that God would punish the sins of Florentine society were substantially supported by the plague epidemics, famines, and war suffered by the city. Savonarola's sermons typically ended with bonfires of "vanities," including such items as cosmetics, playing cards, dice, games, wigs, jewelry, perfumes, mirrors, and dolls. So-called lewd books—volumes of Petrarch and Boccaccio—and paintings of nudes also made their way to the fires.[2] The sixteenth-century art historian Giorgio Vasari reported that these were some of the most beautiful paintings of Renaissance Florence. Savonarola's preaching was so persuasive that several painters, such as Fra Bartolommeo and Lorenzo di Credi, brought their own paintings to the bonfires.

Savonarola preached distrust and fear of the sexual seductiveness of naked bodies. Luca Signorelli (1441–1523) argued—in paint—against this position two years after Savonarola's execution for challenging the ruling

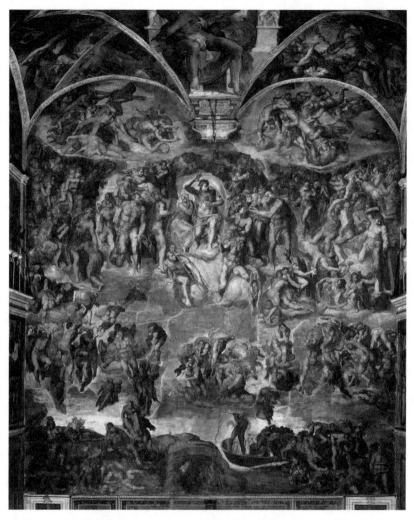

Figure 7. Michelangelo Buonarroti (1475–1564), *Last Judgment*, 1540. Sistine Chapel, Apostolic Palace, Vatican City (photo: Scala/Art Resource, NY).

families of Florence. His *Resurrection of the Flesh* (c. 1500) in the San Brizio Chapel of the Orvieto Cathedral endeavored to show that nakedness need not convey the reductively sexual meaning applied to it by Savonarola, but that naked human bodies, the culmination of creation, were the perfect form for the communication of religious meaning (Plate 6).

Signorelli's painted bodies in *Resurrection of the Flesh* exhibit the characteristics of resurrected bodies described by Augustine in Book XXII of

City of God. The painting depicts the moment just after the trumpeting angels have called the blessed to resurrection. Bodies in various stages of enfleshment appear, climbing out of their graves, drawn by their eyes, which, according to Augustine, are now capable of a corporeal vision of God. The women and men have fully fleshed and muscled bodies—*real* bodies, as Augustine had insisted—even though they are also spiritual bodies and thus, like the angels, weightless. Several of the figures explore their new weightlessness, stretching out their arms to test the lightness of the air, or gently hugging each other. Here are bodies "risen and glorious," in Augustine's phrase.

The female nudes in this scene do not represent the erotic Renaissance female body. They have neither the small, high breasts nor the exaggerated belly that counted as erotic at that time. Moreover, the men and women touch each other with infinite tenderness but without urgency or passion. They "enjoy one another's beauty for its own sake," as Augustine had described. These bodies are sexed male and female, but Signorelli eliminated the visual signs of gender socialization that mark real bodies: he created "bones, muscles, sense organs, nerves, brain, lungs, and circulation" that are distinctively masculine or feminine,[3] but removed differences of posture, gesture, stance, and musculature so that female and male bodies appear equally strong, flexible, and expressive. Signorelli's strategies for depicting religious bodies were apparently convincing to his contemporaries, for there is no evidence of controversy and his naked bodies were not subsequently overpainted.

Approximately forty years later, Michelangelo Buonarroti (1475–1564) filled the apse wall of the Sistine Chapel with hundreds of naked bodies in his *Last Judgment.* Knowledgeable contemporaries such as Giorgio Vasari and Ascanio Condivi recognized Michelangelo as a consummate master in the representation of human bodies and considered his *Last Judgment* the apex of his talent as an artist. But critics like Pietro Aretino (discussed in chapter 5) and the papal master of ceremonies Biagio da Cesena claimed that the *Last Judgment* turned the holiest chapel in Rome into a *"stufa d'ignudi"* (public bath). Michelangelo responded: "No other kind of figuration is possible in a representation of resurrected creatures." Beauty of body signaled the higher condition of humanity, he asserted: "No other proof, no other fruits of heaven on earth do we have."[4] But the climate of opinion had shifted since Signorelli's time, and religious nakedness was no longer credible. Within five years of its completion, Michelangelo's *Last Judgment* was overpainted to clothe the naked figures, and more clothing was added repeatedly in the following two hundred years.

In locations other than the highly scrutinized Vatican, painters continued to paint religious nakedness throughout the seventeenth century. The breast continued to focus the religious values of nourishment and penitence. But other associations, increasingly accessible in public images and printed texts, were gaining strength. In part 2, I discuss social and cultural changes that contributed to altered perceptions of naked bodies. But that is ahead of our story. In chapters 2 and 3, I focus on the religious breast.

The Virgin's
One Bare Breast

A sign is a thing which causes us to think of
something beyond the impression the thing itself
makes upon the senses.

AUGUSTINE
De doctrina Christiana

IN PAINTINGS AND SCULPTURES from the fourteenth to eighteenth centuries, the Virgin/Mother Mary is repeatedly shown with one exposed breast. Fourteenth-century people apparently found these images attractive and persuasive in the immediate circumstances of their lives. The harsh challenges of malnutrition and epidemic disease led them to value an image that most Western Europeans had not previously seen. The *Virgo lactans* image (figure 8) probably originated in Byzantium and came to Western Europe through Sicily and Venice in the thirteenth century.[1] The icon changed dramatically over time, becoming increasingly naturalistic. It is not difficult to see why symbolic reassurances of provision and nourishment became attractive to people who lived in the midst of the personal and communal instability and suffering caused by food scarcity and plague.

EARLY MODERN ITALY

From the fifteenth through eighteenth centuries, Italy was divided into warring states that were repeatedly invaded by France and Germany. At the same time, the Renaissance gave Italy intellectual and artistic leadership in

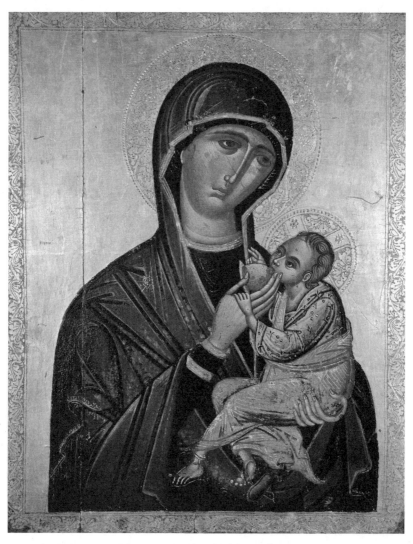

Figure 8. Anonymous, *The Divine Mother (Galaktotrophousa)*, c. 1600. Collection of Dr. Amberg-Herzog, Kölliken, Switzerland (photo: Erich Lessing/Art Resource, NY).

Western Europe.[2] In this time of dramatic contradictions, Italy, along with the rest of Western Europe, was also the site of diseases—pandemic plague and an epidemic of syphilis—for which the only known treatments were palliative. Contemporary authors claimed that plague prompted sexual promiscuity, a higher crime rate, and an increase of lesser vices.[3] Yet the same authors also claimed that God sent plague as punishment for the wickedness people were already committing.

Even before the onset of pandemic plague in the mid-fourteenth century, severe crises of food supply were frequent. From the tenth century to the last decades of the thirteenth century, a food surplus had increased the European population by thirty percent, but as fertility rates continued to increase, the area of arable land did not. By 1309, crop failures caused food shortages and brought about a continent-wide famine, the first in 250 years.[4] Although Italian cities were usually able to acquire provisions by seizing the harvest from surrounding villages, even the wealthy and competently administered city of Florence could not avoid the terror and social chaos caused by hunger. In 1347, bread was issued daily to 94,000 people in Florence, but contemporary sources say that 4,000 Florentines died that year "either of malnutrition or from diseases which, if malnutrition had not first existed, would never have proved fatal."[5] The Florentine chronicler Giovanni Villani wrote: "The famine was felt not only in Florence but throughout Tuscany and Italy. And so terrible was it that the Perugians, the Sienese, and the Pistolese and many other townsmen drove from their territory all their beggars because they could not support them. . . . The agitation of the people at the market of San Michele was so great that it was necessary to protect officials by means of guards fitted out with an axe and block to punish rioters on the spot with the loss of their hands and their feet."[6]

By mid-century, recurring waves of plague swept across Western Europe, devastating populations. Outbreaks of plague occurred approximately once in every generation from 1347 to 1721. With mortality rates approximating ninety percent, one-third to one-half of the European population died during this period—between two and three million people.[7] In Florence between 1340 and 1427, eight plague epidemics shrank the Florentine population by three-fourths; the average life span decreased almost by half, from over thirty to under twenty years.[8] Contemporaries suggested several reasons for the outbreaks; God's judgment on sinners was the favored explanation of clergy, but Jews and women were also blamed.[9] Attempting to control abuses, in October 1349 Pope Clement VI condemned flagellant processions, saying that "many [flagellants] . . . cruelly extending their hands to works of impiety under the color of piety, seem not in the least afraid to shed the blood of Jews, whom Christian piety accepts and sustains."[10] In England, 158 Jewish pogroms occurred between 1348 and 1351. In Western Europe during outbreaks of plague, hundreds of Jewish communities were burned to the ground "from Catalonia to Germany, often with their residents trapped inside."[11]

In short, early modern Italy and Western Europe were besieged by myriad catastrophic troubles: "There were many years in the sixteenth and early seventeenth century when large parts of Italy were afflicted by diseases, serious food shortages and war damage; often all three went together. Armies destroyed or seized food stocks, or prevented sowing; they spread plague, syphilis, and other diseases; panics over plague, flight from the area, the death of farmers meant less farming the following season. . . . Italy was a major war theatre from the 1490s until 1559, with the inflow of French, German, Spanish and Swiss troops."[12]

Clerics and women—those who were expected to care for sufferers—were often accused of neglecting their responsibilities. Plague created a crisis in church personnel caused both by the death of many clergymen and by the fact that, as numerous contemporary sources complain, many clergy made themselves scarce during plague crises. The English bishop Ralph Shrewsbury, in a 1349 letter to the clergy of his diocese, wrote: "The contagious pestilence, which is now spreading everywhere, has left many parish churches and other benefices in our diocese without an incumbent, so that their inhabitants are bereft of a priest. And because priests cannot be found for love or money to take on the responsibility for those places and visit the sick and administer the sacraments of the Church to them—perhaps because they fear that they will catch the disease themselves—we understand that many people are dying without the sacrament of penance."[13]

Women, the perennial caregivers, were also accused of "unnaturally" neglecting familial duties. Chronicler Gabriele de Muisis imagined the last words of a dying child: "Mother, where have you gone? Why are you now so cruel to me when only yesterday you were so kind? You fed me at your breast and carried me within your womb for nine months."[14] Contemporary sources reflect anger and desolation when spiritual and maternal care was not provided. The fact that priests and women were as susceptible to plague as anyone else did not alleviate the hostility directed toward them.

NURSING OR WET NURSING?

A third feature of Italian social life bears a special relevance to the paintings under consideration, namely, breast-feeding practices. James Ross describes the first experiences of a middle-class child in Renaissance Tuscany:

"Birth in the parental bed, bath in the same room, and baptism in the parish church were followed almost at once by delivery into the hands of a *balia* or wet nurse, generally a peasant woman, living at a distance, with whom the infant would presumably remain for about two years or until weaning was completed."[15]

Research in family history provides an important piece in our understanding of the social setting of images of the nursing Virgin. As Mary Martin McLaughlin states: "The infant's survival depended on one thing above all else: its access to breast milk of good quality."[16] In societies without refrigeration, the consistent availability of milk was a life-or-death matter for infants. In addition to the practical problems of preservation and transportation, animal milk was considered harmful, since infants were thought to acquire the physical appearance, intelligence, and personality of their milk source. A fourteenth-century Tuscan child-care manual states: "Be sure that the wet nurse has plenty of milk because if she lacks it she may give the baby the milk of a goat or sheep or ass or some other animal because the child, boy or girl, nourished on animal milk doesn't have perfect wits like one fed on women's milk, but always looks stupid and vacant and not right in the head."[17] The most popular Italian preacher of the first half of the fifteenth century, Bernardino of Siena, added his admonitions in favor of maternal feeding: "Even if you are prudent and of good customs and habits, and discreet . . . you often give your child to a dirty drab, and from her, perforce, the child acquires certain of the customs of the one who suckles him. If the one who cares for him has evil customs or is of base condition, he will receive the impress of these customs because of having suckled her polluted blood."[18]

Infant nourishment was also the focus of social conflicts. Although wet nursing had existed since antiquity, it was practiced with more frequency in fourteenth-century Italy than it had been previously. A literature of advice, admonitions, and warnings reveals contradictory, or at least ambivalent, attitudes toward mothers nursing their infants themselves. On the one hand, mothers were frequently instructed to nurse their own infants due to the danger of employing an unsuitable wet nurse. On the other hand, employing a wet nurse was a mark of upward mobility for middle-class families. Social meanings were apparently in direct conflict with advice from preachers and child-rearing manuals.

For many Italian families, an additional factor came into play: wet nurses were often slave women brought to Italy in increasing numbers by traders in the fourteenth century. Petrarch called this slave population

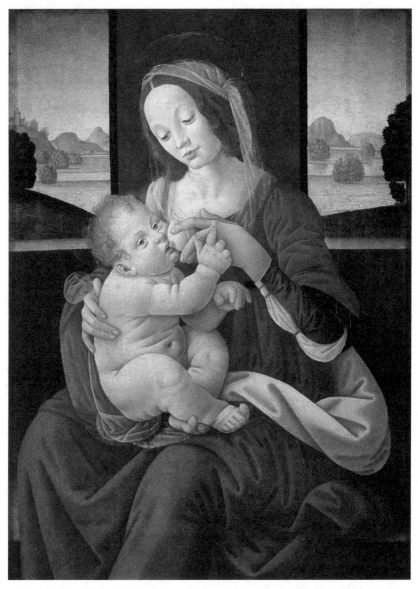

Figure 9. Lorenzo di Credi (1459–1537), *Madonna Nursing the Christ Child,* before 1537. Pinacoteca, Vatican Museums, Vatican City (photo: Scala/Art Resource, NY).

domestici hostes (domestic enemies). The employment of women regarded as hostile and untrustworthy contributed substantially to the anxiety surrounding a couple's decision about infant nourishment.[19] Further exacerbating this anxiety was the not-infreqent fate of infants in the care of a wet nurse: "smothering," a generic name for death from poor care as well as from inadvertent or deliberate suffocation.

Images of the nursing Virgin must have evoked in contemporary viewers the ambivalence surrounding wet nursing. For parents, this may have included guilt over exposing their infants to spiritual pollution and physical peril. Indeed, it is likely that the same clergymen who advocated maternal nursing in sermons also commissioned paintings to be placed in the public space of churches. Depictions of the nursing Virgin conveyed the same message carried in sermons, namely, that women should emulate the mother of Christ (figure 9).

THEOLOGICAL INTERPRETATIONS

From the third century forward, the Virgin's primary theological meaning was that she guaranteed Christ's humanity. Tertullian wrote: "Christ received his flesh from the Virgin . . . certain proof that his flesh was human."[20] At the Council of Ephesus (431 C.E.), Mary was called *theotokos* (God-bearer), affirming that Christ, born from her, was true God and true human. Mary's humanity provided her son's humanity.[21]

At no time was Marian popular devotion more prominent in Western European culture than in the fourteenth and fifteenth centuries. Dominicans and Franciscans debated heatedly the Virgin's attributes and powers; councils invoked Mary's presence and wisdom; academic theologians like Jean Gerson, chancellor of the University of Paris, attested her presence and participation at the Last Supper and Pentecost. Affirming her appointment to the priesthood, Gerson called her "the Mother of the Eucharist," the one who provided Christ's human flesh, which was offered to believers in the sacrament.[22] Excitement over the Virgin and her power was not, however, confined to the theological elite. Bernardino of Siena praised Mary in extravagant terms in his popular and passionate sermons, waxing eloquent over "the unthinkable power of the Virgin Mother." The charismatic evangelical preacher stated:

> Only the blessed Virgin Mary has done more for God, or just as much, as God has done for all humankind. . . . God fashioned us from the soil, but

Mary formed him from her pure blood; God impressed on us his image, but Mary impressed hers on God; . . . God taught us wisdom, but Mary taught Christ to flee from the hurtful and follow her; God nourished us with the fruits of paradise, but she nourished him with her most holy milk, so that I may say this for the blessed Virgin, whom, however, God made himself, God is in some way under a greater obligation to us through her, than we to God.[23]

Although some theologians protested such exuberant statements of Mary's significance, Bernardino's estimation of her power could have been a gloss on popular images. The Florentine fresco discussed in chapter 1 (plate 2) is, in effect, a visualization of Bernardino's sermon.

Theologians understood not only Mary's centrality to the redemption of humanity, but also her importance for the devotional needs of Christian communities. Posing the question "whether the matter of Christ's body should have been taken from a woman," Thomas Aquinas responded: "Because the male sex exceeds the female sex, Christ assumed a man's nature. So that people should not think little of the female sex, it was fitting that he should take flesh from a woman. Hence Augustine says, 'Despise not yourselves, men, the son of God became a man; despise not yourselves, women, the son of God was born of a woman.'"[24]

Despite the evident androcentrism of this statement, it raises a theme that was fundamental to incarnational doctrine from the earliest theological considerations of the Virgin's role, namely, women's and men's devotional need for gender parallelism in Christian symbols. In images, as in theological texts, the development of Marian theology took the form of an increasing parallelism between the character and life of Christ and those of the Virgin. Christ's conception was matched by Mary's immaculate conception, an unscriptural doctrine that was rejected by Thomas Aquinas and heavily contested from the fourth century until it became official dogma in 1854. Christ's birth and Mary's birth both received their full share of Apocryphal legends. Christ's circumcision found its parallel in Mary's purification. Christ's presentation in the temple is matched by the Apocryphal account, often depicted in paintings, of the Virgin's presentation in the temple at the age of three years.[25]

The ministry years of Christ's life did not always find a parallel in the Virgin's life, but in popular devotional works, like the mid-fourteenth-century *Meditations on the Life of Christ,* narratives from Christ's ministry were interspersed with accounts of the Virgin's presence, activities, and emotions. In fact, Christ's power and the Virgin's power might easily be seen as competitive rather than complementary, a possibility that Thomas

Aquinas tried to dismiss in his description of Mary's talents: "She possessed extraordinary gifts but could not use them publicly since it would detract from Christ's teaching."[26]

Marian theology also presented the Virgin as an indispensable spectator/participant in Christ's crucifixion. According to medieval tradition, her suffering paralleled Christ's: she suffered mentally what Christ suffered physically. She and her more flamboyant counterpart, Mary Magdalen, provided those listening to devotional stories or viewing religious paintings with models of the emotions they were instructed to experience. Because Christ's bodily ascension was clearly taught in scripture, the bodily assumption of Mary, although unscriptural and tortuously argued until its acceptance as doctrine in 1950, was a devotional requirement as a parallel to Christ's ascension.

Incidents from Christ's and the Virgin's lives were presented visually as well as verbally. Paintings in churches served as a focus for contemplation and provided access to worship for people for whom worship was primarily a visual activity. Images did not merely instruct and delight predominantly illiterate congregations; they directed religious affections in fundamental ways understood as essential for salvation. Accessible to all members of Christian communities on a daily basis, religious paintings were the equivalent of today's media images, strongly informing the self-images of medieval people and their ideas of relationships, God, and the world. The power of paintings to direct religious and social attitudes and behavior in late medieval and early modern Western Europe cannot be overestimated.

THE NURSING VIRGIN

How did images of the nursing Virgin differ from what people were accustomed to seeing in their local churches? How were these images related to other themes and subjects that began to emerge in religious painting in approximately the same time and place? Most early modern people saw no other images than those displayed in local churches, so we can expect that unfamiliar styles and subjects were noticed and puzzled over by their first viewers.

Images of Mary with one exposed breast were part of an artistic trend that arose at the beginning of the fourteenth century, in which the Virgin was depicted as a humble peasant woman, sometimes barefoot and seated on the ground. Painted in a naturalistic style, Madonnas of Humility

Figure 10. Anonymous, *Madonna and Child with Stories of Christ and Saints* (detail), 14th century. Museo Correr, Venice (photo: Cameraphoto Arte, Venice/Art Resource, NY).

(figure 10) were striking in contrast with earlier depictions of the Virgin. Throughout the thirteenth century, the Virgin had been pictured as a Byzantine empress, luxuriously robed, heavily jeweled, and seated on a throne surrounded by angels and worshippers. The new Madonnas suggested instead the Virgin's accessibility, sympathy, and emotional richness.[27] Depictions of the nursing Virgin and Child in which the infant

Christ twists around to engage the viewer's eye employed an established device for inviting the viewer to participate in the pictured scene (plate 1).[28] In the context of the artistic trend toward portraying scriptural figures as humble people with strong feelings, the Virgin with an uncovered breast represents comfortable simplicity and unpretentious accessibility.

VISUAL REPRESENTATIONS OF CHRIST'S HUMANITY

The Virgin was not the only sacred figure whose partially naked body was displayed in early modern religious paintings. In *The Sexuality of Christ in Renaissance Painting and in Modern Oblivion,* Leo Steinberg calls attention to a number of Renaissance paintings that feature Christ's exposed or scantily veiled genitals. Steinberg argues that these paintings presented, for the first time, the full humanity of Christ; he cites sermons preached in the papal court between 1450 and 1521 to document a contemporary theological emphasis on Christ's full humanity. Supported by dozens of illustrations, Steinberg shows that Renaissance depictions of Christ—in infancy, crucifixion, deposition, and resurrection—focus insistently on his penis.

Most strikingly, in some images of the resurrected Christ, Christ is shown with an artfully draped but unmistakable erection. "If the truth of the incarnation was proved in the mortification of the penis," Steinberg writes, "would not the truth of the Anastasis, the resuscitation, be proved by its erection?" Steinberg calls the erect phallus "the body's best show of power," an appropriate symbol of Christ's vivified flesh.[29] "The supreme power," he writes, "is the power that prevails over mortality," a power "reasonably equated with the phallus."[30]

Yet dozens of late medieval and early modern paintings of the Virgin Mary with one bare breast suggest that unless "the body" is assumed to be a male body, erection is demonstrably *not* "the body's best show of power." In fact, a human body's best show of power, and the evidence of Christ's fully human incarnation, was the Virgin's presentation of Christ *from her own body* (figure 11). It was she who provided both the flesh and the nourishment on which his humanity depended. *This,* the capability to give birth and to nourish and sustain life is "the body's best show of power."

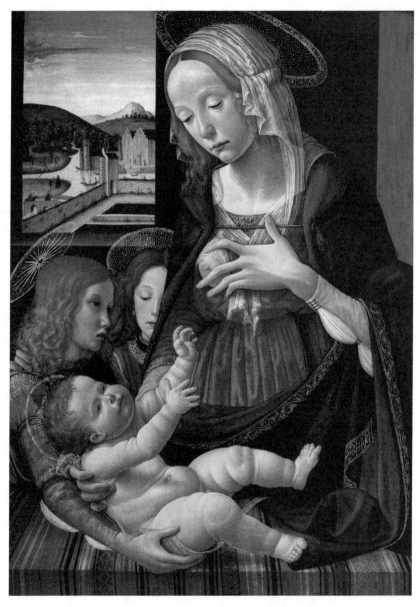

Figure 11. Sebastiano Mainardi (1460–1513), *Madonna with Child Nursing and Angels*, before 1513. Kunsthistorisches Museum, Vienna (photo: Erich Lessing/Art Resource, NY).

Nakedness or partial nakedness in religious paintings created two kinds of tension. First, there was a tension between cultural and natural meanings. For example, in societies in which almost all infants were nursed at a woman's breast, the bare-breasted Virgin evoked visual associations that inevitably emphasized her similarity with other women; yet devotional texts and images contradicted these associations by insisting on her difference. *Meditations on the Life of Christ* comments on an illustration of the nursing Virgin: "How readily she nursed him, feeling a great and unknown sweetness in nursing this child, such as could never be felt by other women."[31]

Second, nakedness in religious painting created a tension between erotic attraction and religious meaning. In *Seeing Through Clothes,* Anne Hollander argues that nakedness in art always carries a sexual message; images of a naked body are never so thoroughly devoid of sexual associations as to become unambiguous vehicles for theological messages. At the same time, however, nakedness intensifies a painting's narrative, doctrinal, or devotional message by enhancing the viewer's attraction. In paintings intended to stimulate religious feeling, nakedness must be depicted naturalistically enough to engage a viewer's erotic interest, but it must be carefully balanced with other visual content so that the erotic response does not dominate.

Were images of the Virgin with an exposed breast successful in maintaining a balance of erotic and religious meanings? Fourteenth- and fifteenth-century painters employed two strategies to ensure that the religious message—the viewer's participation in an intimate scene in which humanity and divinity are closely woven—was strengthened rather than subverted by its erotic content. First, they depicted a large breast, visually at odds with the small, high breasts considered erotic by contemporaries (plate 1 and figure 10). Second, Mary's dress does not show the provocative disarrangement that characterizes erotic exposure (figure 9). Moreover, the covered breast is perfectly flat, while the exposed breast is round and ample: the viewer's impression was not that of an illicit glimpse of a normally concealed breast, but rather one of a purposefully revealed symbol of specific religious meaning (plate 7). Until the later half of the fifteenth century, the cone-shaped breast from which the Child is nourished seems even more explicitly not to be part of Mary's body, but an appendage (figure 8). Paintings of the nursing Virgin illustrate Jacobus de Voragine's statement in *The Golden Legend* (1255–66): "Such indeed was Mary's innocence that it shone forth even outside

of her, and quelled any urgency in the flesh of others. . . . Although Mary was surpassing fair, no man could look upon her with desire."[32]

There is little evidence that women identified with the Virgin's power. A delicate message was communicated, apparently effectively, by the dissonance between verbal and visual messages. While the latter emphasized the similarity of the Virgin and actual women, it was the contrast between actual women and the Virgin that dominated early modern sermons, theological writings, devotional manuals, and child-rearing manuals. In verbal texts, attachment to the Virgin was presented as an alternative to appreciation of and attachment to one's actual mother. This theme appeared as early as the twelfth century. Aelred of Rievaulx wrote of the Virgin: "It is she . . . who has given us life, who nourishes and raises us. . . . She is our mother much more than our mother according to the flesh."[33] Moreover, in the lives of monks, mothering was associated not only with the Virgin; Bernard of Clairvaux, the most influential late medieval author, assigned the role of mothering to the male Jesus, just as contemporary abbots described their role within monastic communities as one of providing spiritual care and nourishment.[34] Lady Julian of Norwich, the fourteenth-century English recluse, contrasted Jesus as Mother with earthly mothers in her *Showings:* "We know that all our mothers bear us for pain and for death. O, what is that? But our true Mother, Jesus, he alone bears us for joy and for endless life. . . . This fair, lovely word "mother" is so sweet and so kind in itself that it cannot truly be said of anyone or to anyone except of him and to him who is the true mother of life and of all things. To the property of motherhood belong nature, love, wisdom, and knowledge, and this is God."[35]

Theological descriptions of Mary or Jesus as ideal Mother use maternal images as a vehicle for drawing strong contrasts between ideal and real women. In fourteenth-century devotional texts, no comparable effort was made to curtail men's identification with the male Christ. The appearance of God in the male sex was understood as privileging that sex, making men less vulnerable to evil than women. The 1484 *Malleus Maleficarum* states that men are much less likely than women to associate with the devil because they belong to Christ's sex: "And blessed be the Highest who has so far preserved the male sex from so great a crime: For since he was willing to be born and suffer for us, therefore he has granted to men this privilege."[36] While men were encouraged to identify with Christ's maleness, women's identification with the Virgin's power was blocked by emphasis on the unbridgeable chasm between the ideal Virgin and actual women.

What messages were likely to have been given and received from images of the Virgin with one bare breast? Jane Gallop's suggestion that "the visual mode produces representations as a way of mastering what is otherwise too intense" offers a useful interpretive clue.[37] These images address a cultural situation in which, as we have seen, human life was extraordinarily precarious and vulnerable. Images of the nursing Virgin are *men's* images; as far as can be determined, not a single image of this type was commissioned or painted by a woman until the seventeenth century. Far from presenting a simple message encouraging viewers to greater affective piety, these paintings must have carried highly complex communications to people in stressful and anxious societies.

The nourishing breast may have simultaneously focused a pervasive, chronic anxiety over nourishment and assured the viewer of the divine provision of spiritual and physical needs. In a society in which a woman's milk was a practical, emotional, social, and religious issue, the nursing Virgin was likely to have evoked an intimate and volatile mixture of danger and delight. As sermons and child-rearing manuals demonstrate, the "extremely bad" breast—that of either the natural mother choosing not to nurse her infant or the irresponsible or incapable wet nurse—was an immediate personal and social threat.

Unlike actual women, who might or might not be acceptable mothers, the Virgin represented the fantasy of the "extremely perfect" breast. Called *mater omnium* and *nutrix omnium,* she could be counted on to nurse not only her son, but through him all Christians.[38] Depictions of physical nourishment at a woman's breast, the earliest delight of virtually all fourteenth-century people, evoked both sensual pleasure and spiritual nourishment. Mary's humility, obedience, and submissiveness in unquestioningly offering her body as shelter and nourishment for the infant Christ was part of the message intended by male commissioners, clergy, and painters. The Virgin was presented as a model—however unattainable—to actual women.

Images of the nursing Virgin also reminded viewers of women's terrifying power to give or to withhold nourishment. If the Virgin gained tremendous power by nursing her son, what was to prevent actual women from recognizing their own power, derived from the same source and irresistible to their adult sons? Images of the nursing Virgin signified the power to conceive, nourish, shelter, and sustain human life—a power that may well have been clearly understood as "the body's best show of power" by

fourteenth-century people threatened by plague, famine, and social chaos. As such, in a society designed and administered by men, it was a power that had to be firmly directed to socially desirable ends. The cultural work of the image was thus complex: women had to be guided to accept the model of the nursing Virgin without identifying with her power—a potential social and physical power derived from her body.

Did men have reason to be uneasy about women's social power? In late medieval towns, some women achieved economic independence, owned and managed businesses, and disposed of their own property without their husband's consent.[39] The cost of dowries had never been higher, indicating the importance of advantageous marriages for men's sisters and daughters—advantageous to the men, that is, whose wealth, power, and influence often depended on such marriages. Moreover, according to a 1427 Florentine census, women lived longer than men.[40] But these favorable conditions for women were soon to change, as women simultaneously lost legal rights and access to production in early capitalism.

PRODUCTION VERSUS REPRODUCTION: EARLY MODERN CAPITALISM

Historian Martha Howell, who has studied production in northern Europe as early modern societies replaced late medieval social arrangements, writes:

> In northern Europe during the late Middle Ages, the household was the most important center of economic production. Work both for the market and for subsistence often took place in the household itself, but even when it did not, as for some artisans and many merchants, the members of the household formed an economic unit by working to sustain themselves as a group. Often they performed closely related tasks, as when household members together raised crops or produced textiles for the market; at other times they performed distinct tasks, as when one person in a household made cabinets, another distributed goods imported from abroad, and a third helped to make clothing.[41]

A commonplace theory among Marxist and feminist historians pictures early modern capitalism as diminishing "women's roles in economic production by diminishing the family's role in market production."[42] This picture, however, reduces the complexity of late medieval production, which regularly combined market and subsistence production, moving easily back and forth between the household and the public sphere. Howell

has refined this interpretation: "While it is apparent that women did not lose access to market production because the 'family economy' was destroyed by 'capitalism,' it is possible that women lost access to *high status positions* in market production because the *family production unit* was destroyed by capitalism."[43]

In the market economy, rather than moving freely between household and public arenas, women increasingly came to perform their trades in the home: "Women were concentrated in food and clothing preparation and sale and they seldom undertook tasks which led them away from the home."[44] Indeed, "patriarchy in capitalist societies is achieved partly by excluding women from high-status positions in market production."[45] Along with economic agency, women also surrendered authority to men. Moreover, "as women lost labor status, they also lost legal status."[46] In short, Howell finds that in early modern Europe "the roles of women and the definitions of womanhood were changing . . . and women's lives were increasingly centered in a newly constructed patriarchal household . . . because the patriarchal order required it."[47] "The late medieval and early modern period . . . was an age of great uncertainty, even disagreement, about appropriate gender roles. By its end, the division between public and private had been newly and clearly drawn, and women . . . were firmly located in the private realm centered on the patriarchal nuclear family."[48]

Giovanna Casagrande describes a "circle of exclusions" experienced by women in early modern Western Europe: "Women could not gain access to any priestly office; a military career was precluded to them; they were excluded from civil, political, and administrative power, not to mention from university, and therefore, from intellectual work. What was left was family life and its limitations and conditions. When they could work outside the home they were often not given their full due; women did not or could not gain access to every sphere of artisanal or professional work."[49]

By the fifteenth century, Western European societies were in transition from traditional forms of trade to capitalism. Measured by "changes in economic activity, distribution of wealth, social mobility, political crisis, and constitutional reorganization," early capitalism also affected social values.[50] As women of all but the poorest classes were increasingly confined to their homes, it became rare for women and men to work together on common economic and religious projects, removing the daily interaction by which men could come to recognize women's skills and capabilities.

It is not sufficient, however, to detect changed roles for women. It is simultaneously more important and more difficult to examine *how these*

changes worked in concrete and practical ways. How were people's relationships adjusted and codified in social and religious institutions? Guilds and confraternities were two important organizations that formed and coordinated people's religious and economic energies in the public sphere. Both excluded women from any but ancillary roles.

GUILDS

While confraternities organized religious devotion, guilds monitored commerce and social life in the public sphere, though these were not, of course, separate or sometimes even distinguishable realms. Confraternities were often affiliated with a guild, with the same members participating in both. Late medieval and early modern guilds wielded considerable social control through training and regulating members. They provided the possibility of upward mobility for young men, who could be sent to apprentice with a master craftsman between the ages of ten and eighteen, for two or three years. In late medieval guilds, "the master had not only to teach the trainee the rules and skills of his craft but also to bring him up to be 'an honorable member of the craftsmen's guild.'"[51] In short, the master was responsible for his apprentice "body and soul," protecting him from exploitation and other dangers.

Early modern capitalism developed within guilds, transforming them into "hierarchical organizations, stratified along economic, social, and political lines."[52] The relationship of master and apprentice also changed; it became one of "capitalist entrepreneurs on the one hand and skilled wage workers on the other."[53] Girls and women, previously accepted as apprentices, began to be excluded in the fourteenth and fifteenth centuries as guilds focused on competitiveness and profit. With guilds providing training exclusively to young men, girls learned only in the home and thus were excluded from practicing most of the independent trades.[54] The result was often economic impoverishment: "In every case where it can be measured, women—usually single but very often widowed—made up a disproportionate share of the economic underclass of late medieval cities."[55]

Clearly, early capitalism, in which household production became market production, created a disadvantage for women. "Many of the positions men acquired, in brewing, weaving, and inn-keeping . . . once had been women's."[56] For example, women steadily lost high-status positions in the textile industry almost everywhere in northern Europe in the sixteenth century, even though women outnumbered men in most cities and textile production increased during that period.[57]

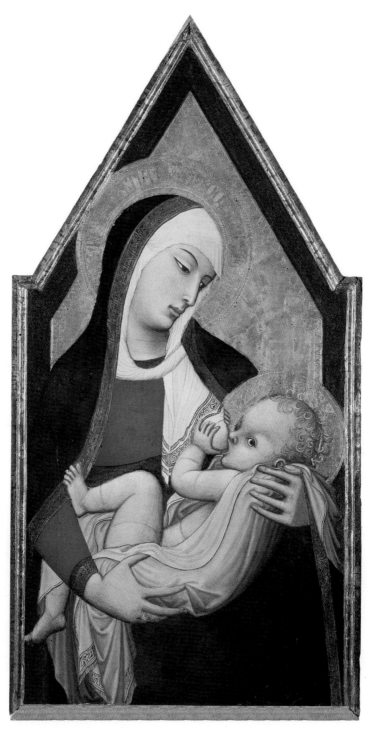

Plate 1. Ambrogio Lorenzetti (fl. c. 1311–48), *Madonna del latte,* before 1348.
Palazzo Arcivescovile, Siena (photo: Scala/Art Resource, NY).

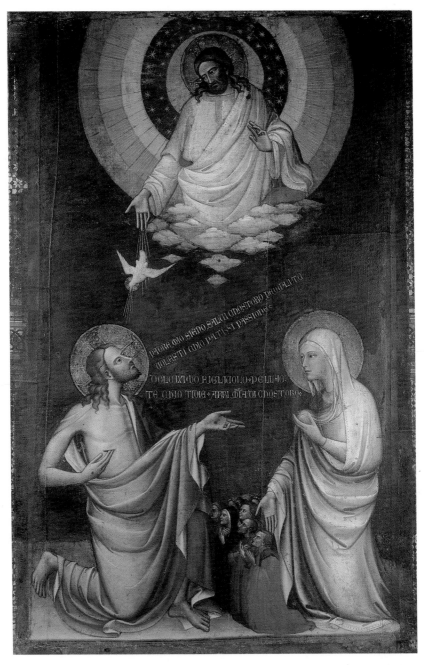

Plate 2. Attributed to Lorenzo Monaco (active 1390–1423/24), *The Intercession of Christ and the Virgin,* early 15th century. The Metropolitan Museum of Art, New York, The Cloisters Collection, 1953 (53.57) (photo © 1996 The Metropolitan Museum of Art).

AGNESSOREL

Plate 3. Anonymous, *Agnès Sorel, Mistress of King Charles VII of France,* 15th century. Private collection, Paris (photo: Bridgeman-Giraudon/Art Resource, NY).

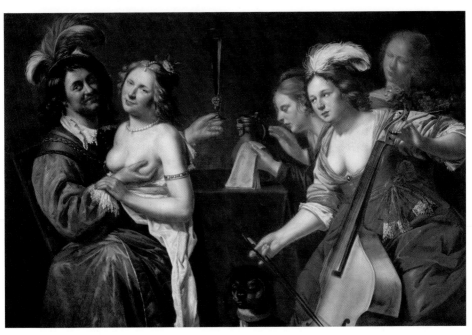

Plate 4. Johannes Baeck (d. 1655), *The Prodigal Son,* 1637. Kunsthistorisches Museum, Vienna (photo: Erich Lessing/Art Resource, NY).

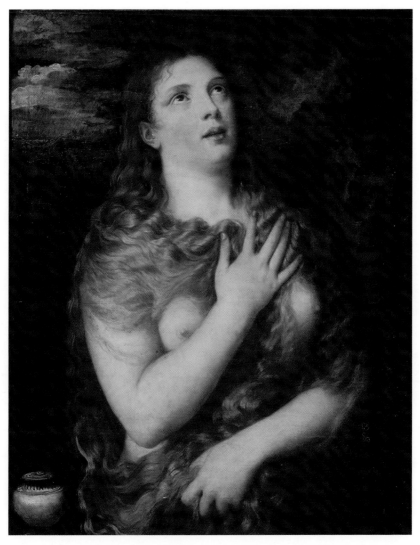

Plate 5. Titian (1488–1576), *Mary Magdalen,* c. 1535. Galleria Palatina, Palazzo Pitti, Florence (photo: Scala/Art Resource, NY).

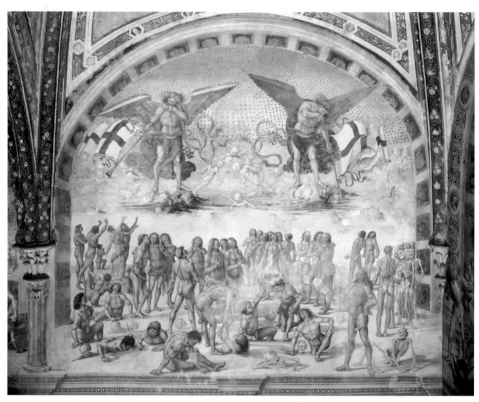

Plate 6. Luca Signorelli (1441–1523), *Resurrection of the Flesh,* c. 1500–1503. San Brizio Chapel, Orvieto Cathedral, Orvieto (photo: Scala/Art Resource, NY).

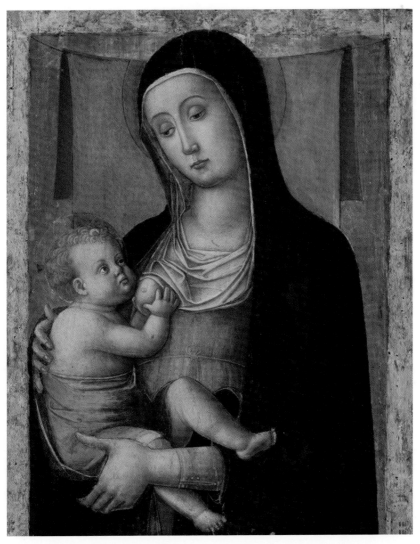

Plate 7. Francesco dei Franceschi, *Nursing Virgin,* 15th century. Ca' d'Oro, Venice (photo: Cameraphoto Arte, Venice/Art Resource, NY).

Plate 8. Master of the Magdalen, *St. Mary Magdalen and Stories of Her Life,*
1250–70. Galleria dell'Accademia, Florence (photo: Scala/Art Resource, NY).

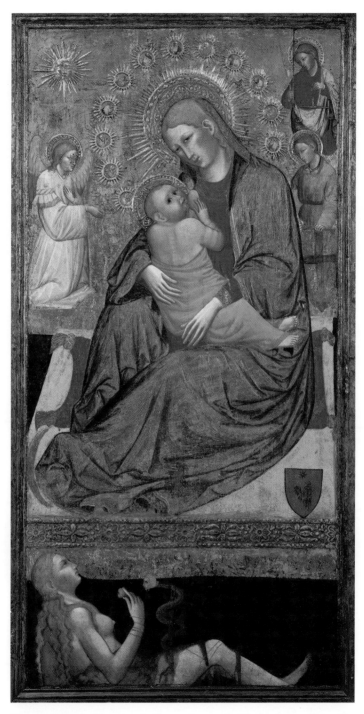

Plate 9. Carlo da Camerino (active 1396–c. 1425), *The Madonna of Humility with the Temptation of Eve,* before 1420. The Cleveland Museum of Art, Holden Collection 1916.795 (© The Cleveland Museum of Art).

Plate 10. Henri Beaubrun the Younger (1603–1677) and Charles Beaubrun (1604–1692), *Infant Louis XIV and His Wet Nurse, M. de la Giraudière,* before 1677. Châteaux de Versailles et de Trianon, Versailles (photo: Réunion des Musées Nationaux/Art Resource, NY).

Plate II. Artemisia Gentileschi (1593–c. 1651), *Madonna and Child,* c. 1609. Galleria Spada, Rome.

Plate 12. Lynn Randolph, *Father and Child,* 1984. Private collection, Houston (by permission of the artist).

Scholars have frequently interpreted the popular religious energy that was marshaled in lay confraternities as evidence that the church was losing its attraction for early modern people. Recently, however, Nicholas Terpstra has advocated a broader understanding of religion that puts into question this interpretation. Religion, he writes, "has such a complex range of dimensions and forms that focus on the formal hierarchy of the Catholic Church seems almost quaint, if not peripheral to an understanding of how faith animated local communities."[58] As late medieval Western Europe (roughly thirteenth and fourteenth centuries) became early modern Western Europe (approximately fifteenth and sixteenth centuries), religion was not only promoted by an institutional church and a professional clergy, but also by laymen who took leading roles in confraternities. Richard Trexler describes the shift in religious foci as a transition "from the stable to the mobile (i.e., from monks to friars), from the sacerdotal to the charismatic (from clergy to the unordained holy man), and from the ecclesiastical to the lay (from church to confraternity)."[59] Moreover, religious vitality was not incompatible with rapid secularization.

Confraternities were popular in the extreme conditions of plague, starvation, and war. In Bologna, for example, plague devastated the population in 1527–28; famines in 1558 and 1561 caused ten thousand people in the city and thirty thousand in its environs to perish; another cycle of famines arrived in 1588–89, 1590, and 1593–94; and catastrophic plague recurred in 1630. In these conditions, "smaller, closely-knit confraternities devoted to penitential flagellation" were broadly popular.[60] But confraternities also maintained their attraction to members through changing circumstances. Although these circumstances prompted changes within the confraternities themselves, Christopher Black notes that the organizations "remained a major part of Italian society until the eighteenth century."[61] The role of confraternities varied over time and from confraternity to confraternity, depending on external and internal pressures, but praying for souls was their most common and persistent work. They also cared for the poor, administered hospitals, and provided dowries for impoverished girls.[62] Educating members in "Christian doctrine and . . . the rituals that animated the doctrine and structured the community's life"—especially liturgy and the sacraments of confession and communion—was also a high priority of confraternities.[63]

Because of variations across geographical locations and time, it is diffi-
cult to generalize about women's participation in lay religious movements.
From the thirteenth century forward, women participated in the *laudesi*
(praise) confraternities whose mission was to provide mutual assistance to
their members in life and death. In early confraternities, women were "rec-
ognized as indispensable members of the local neighborhood with a role to
play in the neighborhood's public worship and charitable service."[64] But as
praise confraternities waned during the late medieval period and flagellant
(*battuti* or *disciplinati*) confraternities increased, women were excluded or
relegated to minor roles. They were not permitted to participate in the
administration of confraternities, or in the primary devotional practice,
flagellation (though they undoubtedly flagellated in private).[65] Women
members contributed to the fund of merit gathered by the members'
prayers, penitence, and charitable service, but only those who were active
members at the time of their death could draw on this fund (by being
buried in the confraternity's robes or being prayed through purgatory).[66]
Giovanna Casagrande concludes her survey of lay female religiosity in late
medieval and Renaissance Umbria: "Women were not excluded from all
forms of confraternal sociability, but extant documents do not put much
significance on their roles and duties."[67]

Flagellation was a devotion initiated by mendicant—especially
Capuchin—piety. It was practiced either in public processions or, more
commonly, within a confraternal liturgy in which flagellation began after
prayers and hymns in a darkened sanctuary. Barbed cords or leather strips
were used by the most dedicated flagellants; others used silken flails to
symbolize, rather than fully enact, the practice. Processions might include
as many as seven hundred people walking barefoot, flagellating them-
selves. But flagellation was practiced most frequently within a confrater-
nity rather than in public. Christopher Black comments: "The physical
and emotional commitment of such rituals, the attempt to distance one-
self from the secular world and status, confession in front of relatives,
neighbors, and those of different social backgrounds within the brother-
hood could lead to intense fraternity"—a fraternity from which women
were excluded.[68]

In attempting to understand flagellation, we might imagine that its pri-
mary purpose was to dramatize repentance in case the troubles experienced
by societies afflicted by natural disaster and war were sent by an angry God,
as many priests preached. But scholars who have studied the phenomenon
find much more emphasis on "imitative piety," a "demonstration of love

and solidarity with Christ," rather than "an act of individual purification or expiation."[69]

The practice may appear to us only to have increased the misery of suffering societies—and thus it may not seem a disadvantage for women to have been denied the privilege of public and/or liturgical flagellation. But to think like this is to think within twenty-first-century Western cultural values. Until nineteenth- and twentieth-century medical discoveries, it was not possible to alleviate or control pain, and historical people thought very differently about pain. Ariel Glucklich, in *Sacred Pain,* discusses historical and contemporary uses of pain for religious purposes.[70] It has been used as an instrument of passage and purification, a community builder, and a stimulant of ecstatic states, to name only a few of the uses Glucklich identifies. If we take seriously early modern women's religious commitments, we must acknowledge that they were likely to have experienced their exclusion from the most intense religious expression of their time as frustrating and constraining.

It is striking that images of the nursing Virgin were frequently painted in a time of great social, political, and religious change, when women were rapidly being marginalized from public life (figure 11). The image carried multiple communications, constituting a remarkably explicit objectification of one of the most pressing personal and collective anxieties of fourteenth- and fifteenth-century people—the uncertainty of food supply—while also specifying with precision women's primary role in society, that of caregiver and sustainer of life.

No direct evidence remains of how women understood and reacted to these images. And no simple resolution of conflicting messages can do justice to the complexity of the communities in which the images appeared. Rather, both visual messages that acknowledge women's power over life and death and verbal messages that deny the identity of actual women with the powerful Virgin must be considered if we are to represent accurately men's ambivalence toward women. The promise of the "extremely perfect" breast and the threat of the "extremely bad" breast both played powerful roles in Western societies. In the context of the cataclysmic events, changing social arrangements, and religious rhetoric of the societies in which they appeared, images of the Virgin with one bare breast both formulated and attempted to control the awesome power of women to bear and sustain new life.

Mary Magdalen's
Penitent Breast

A first task in the historical perception of a picture is . . .
that of working through to a realization of quite how
alien it and the mind that made it are; only when one
has done this is it really possible to move to a genuine
sense of its human affinity with us.

MICHAEL BAXANDALL
Patterns of Intention

THE FOURTEENTH-CENTURY ILLUSTRATED MANUSCRIPT *Meditations on
the Life of Christ* describes Mary Magdalen's uninvited appearance at a
dinner attended by Jesus and the disciples (figure 12): "She instantly threw
herself at [Jesus's] feet, her heart filled with both sorrow and shame at her
sins. Prostrate, with her face above those holy feet, she felt somehow confident
for she already loved him." Crying loudly, she proclaimed her penitence
for sins "above the number of sands in the sea."

> Her tears flowed freely, bathing and washing the feet of the Lord. . . .
> Finally she stopped crying and, judging it unsuitable that her tears had
> touched the feet of the Lord, she carefully wiped them with her hair. She
> did this with her hair because she had no more precious thing with her, and
> also because she had used it to satisfy her vanity and now wished to convert
> it to use, and also that she might not raise her face from the feet of the Lord.
> With increasing love she kissed them often and affectionately. And since the
> feet of the Lord were torn by his travels she anointed them with precious
> unguents.[1]

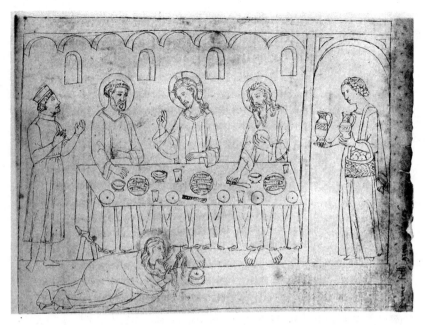

Figure 12. Anonymous, "Of the Conversion of St. Mary Magdalen," from *Meditations on the Life of Christ* (14th century). Bibliothèque nationale de France, Paris, Ms. Ital. 115 (photo: Bnf).

Jesus responded to Mary Magdalen's pleas: "Many sins are forgiven her, for she has loved much" (Luke 7:47). According to the *Meditations,* Mary Magdalen asked to be granted the privilege of preparing Jesus's feet for burial after his crucifixion. She once again washed his feet with her tears and for a long time would "devotedly wipe, embrace, kiss, wrap, and faithfully prepare them as best she knew and could."[2]

The *Meditations* exemplifies Mary Magdalen's role in medieval piety. Her figure modeled passionate love for Christ and strong emotion in the events of his life, death, and resurrection. The *Meditations* also illustrates the freedom with which medieval authors of devotional literature embellished gospel narratives in order to increase readers' engagement with the sacred figures. Yet few scriptural characters have been as imaginatively developed as Mary Magdalen. Her figure, in images as in devotional texts, was a colorful and complex composite.

The sixth-century pope Gregory I was the first to conflate three gospel stories of unnamed women to produce a figure highly attractive to medieval Christians. In a sermon preached on September 21, 591 C.E., at the

basilica of San Clemente in Rome, Pope Gregory said: "We believe that [Mary Magdalen] whom Luke calls a female sinner [Luke 7:37–50], whom John calls Mary [John 11:1–45], is that Mary from whom Mark says seven demons were cast out [Mark 16:9]."[3] Later Christian authors added the figure of Mary of Egypt, a legendary fourth-century saint who (according to tradition) went naked in the desert, covered only—but amply—by her flowing hair.[4] The result is a complicated and ahistorical figure, but one who appealed strongly to late medieval piety in Western Europe.[5]

An altarpiece by the mid-thirteenth-century Italian "Master of the Magdalen" combined these stories (plate 8). Around the central figure—a hirsute Magdalen, covered with hair from neck to ankles—are gospel narratives: Mary drying Jesus's feet with her hair, Jesus's appearance to her after his resurrection, her presence at the raising of Lazarus, and Mary preaching to a mixed audience. Scenes from Mary of Egypt's life are included: Mary being fed by angels in the desert, Mary receiving communion from a visiting priest, and her death and apotheosis. Although thirteenth-century viewers may have been mildly titillated by the knowledge that Mary Magdalen was naked under her covering of hair, no sexual signals within the painting invite erotic attraction. Two centuries later, Donatello, in his wood sculpture *The Magdalen* (1454, figure 4), similarly concealed her body with hair (though her legs remain uncovered to the knee). Donatello's *Magdalen* displays the physical cost of Mary Magdalen's penitence; her ravaged flesh and her tortured expression insistently direct viewers to her abjection.

According to medieval tradition, Mary Magdalen was a prostitute, a penitent, a preacher, and a contemplative. The "traditional patroness of penitent sinners and weepers," she was said to have fasted for thirty-three years.[6] Hymns from the eleventh and twelfth centuries praise her as an *apostola*. Because scripture describes her as the first to proclaim the resurrection, medieval preachers like Geoffrey of Vendôme (d. 1132) also called her a *praedicatrix*. Many psalters and prayer books carried illuminations of Mary Magdalen preaching. Preachers identified her with the Bride of the Song of Songs; Bernard of Clairvaux called her the "sister-bride" of Christ. Her saint's day, July 22, was celebrated with liturgies featuring readings from the Song of Songs. The twelfth-century Romanesque Church of the Magdalen in Vézelay, France, was the center of her medieval cult and a popular pilgrimage site; allegedly miracle-producing relics are in its crypt. In 1120, a fire broke out in the Church of the Magdalen on Mary Magdalen's feast day, burning to death 1,127 pilgrims.[7] In 1146, Bernard of Clairvaux preached the Second Crusade in the same church.

The cult of the Magdalen, immensely popular in the twelfth century, continued to attract many Christians until, under the influence of Renaissance scholarship that questioned the composite Magdalen figure, it declined in the sixteenth century.[8] In 1517–18, the French humanist scholar Jacques Lefèvre d'Étaples published a pamphlet titled "On Mary Magdalen," in which he argued that the figure of Mary Magdalen conflated three different scriptural women. The pamphlet provoked great controversy, so reluctant were medieval scholars to separate the strands traditionally woven into the figure of the Magdalen.[9]

In the twentieth century, Mary Magdalen turned respectable. The suggestion by novelists that Jesus was married to Mary Magdalen elicited great excitement; the film adaptation of Nikos Kazantzakis's *The Last Temptation of Christ* (1951), for example, attracted both outrage and fascination when it was released in 1988. Interest in Gnostic Christianity, in which Mary Magdalen has a larger role than she does in the canonical Gospels, also gave her a new importance. In 1969, the Roman Catholic Church ceased to refer to her as a penitent sinner, thereafter referring to her simply as a disciple.

Traditionally, Mary Magdalen was identified in paintings by two features: her long red hair and her alabaster jar. Christian leaders thought women's unbound hair to be dangerously seductive (to men) and repeatedly insisted that women cover their hair.[10] But according to an ancient convention predating Christianity, unbound hair and bared breasts signified grief. In the Magdalen the two meanings converged: her alleged former lust and her penitential grief were both signified by her flowing hair. Unbound hair and bared breasts continued to appear in depictions of the Magdalen despite other dramatic changes in her iconography brought about by pervasive revisions in the practice and social location of painting.

THE PROFESSIONALIZATION OF PAINTING

Two changes affected religious images in the sixteenth century: the professionalization of painting, and the Council of Trent's December 1563 decree banning "inappropriate" images in religious painting. These changes contributed strongly to the shift from the representation of the breast as a religious symbol to that of the breast as an object of male lust and/or medical scrutiny.

Italian Renaissance artists developed a new self-image in which they claimed autonomy, creativity, and intellectuality. They no longer primarily served clergy commissioners who dictated a painting's subject and the

artist's "mental image of the ideal."[11] As artists self-consciously revised their public image as craftsmen to one of participants in a liberal art, and as they began to exercise creative imagination and individuality, patrons began to act like collectors who were more concerned to have works by artists with reputations than to own works on particular subjects.[12]

In *Likeness and Presence: A History of the Image Before the Era of Art,* Hans Belting argues that "art," in the modern sense of the word, was invented by Renaissance artists. Before "the era of art," religious images were not valued for their aesthetic excellence, but for their ability to *act* religiously, that is, to comfort, challenge, or help.[13] "The image formerly had been assigned a special reality and taken literally as a visible manifestation of the sacred person. Now [in the Renaissance] the image was . . . made subject to the general laws of nature, including optics, and so was assigned wholly to the realm of sense perception."[14]

Artists' professionalization depended increasingly on their ability to render naturalistic bodies. Anatomical illustration fascinated painters like Leonardo da Vinci (1452–1519), Antonio del Pollaiolo (d. 1498), Pontormo (d. 1557), and Agnolo Bronzino (d. 1572). Sculptors like Michelangelo Buonarroti and Benvenuto Cellini (d. 1571) also found it essential to master the structure and motion of the human body. The earliest text discussing the artist as a practitioner of a scientific discipline, Leon Battista Alberti's *On Painting* (1435), describes a method for representing human bodies:

> First . . . sketch in the bones, for, as they bend very little indeed, they always occupy a determined position. Then add the sinews and muscles, and finally clothe the bones and the muscles with the flesh and the skin. But . . . there will perhaps be some who raise an objection, . . . namely that the painter is not concerned with things that are not visible. They would be right to do so except that, just as for a clothed figure we first have to draw a naked body beneath and then cover it with clothes, so in painting a nude, the bones and muscles must be arranged first, and then covered with appropriate flesh in such a way that it is not difficult to perceive the positions of the muscles.[15]

Together with "the optical sciences of perspective, light, and color, anatomical mastery of the human body supported Renaissance artists' and theorists' claim that the visual arts possessed their own basis in *scienza;* that is to say, in a recognized body of systematic knowledge which was akin to other disciplines of high intellectual standing."[16]

Artists' independence did not mean that they could create works of art that pleased only themselves, however. On the contrary, it meant that they

had to be even more sensitive to prevailing cultural interests and tastes than they had been as church artists, when they had operated within a predictable market. As biographies of sixteenth- and seventeenth-century artists attest, even the most respected and successful painters were concerned with keeping themselves and their families fed.[17]

We can expect, then, that in depicting breasts, artists adopted and interpreted tastes in topics and styles that circulated among their patrons and public. The Council of Trent's decree eliminating subjects considered inappropriate from religious art represented a further constriction. The professionalization of painting profoundly affected religious paintings by creating artists who sought to present their subjects in ways that depicted traditional figures in original and innovative ways. Mary Magdalen was one of the figures that fascinated Renaissance artists; her multiple roles and her traditional seminakedness combined to invite the exercise of their creativity.

MARY MAGDALEN'S TRADITIONAL ROLES

The Prostitute

Perhaps the most dramatic of the roles traditionally associated with Mary Magdalen—though one that lacks scriptural warrant—was that of a converted prostitute.[18] But medieval devotional manuals did not dwell on this aspect of the saint in any titillating detail. In fact, the Magdalen's activities as a prostitute were not portrayed graphically in text or image until the end of the twentieth century, in the film *The Last Temptation of Christ,* which begins with a scene in which a group of men wait to visit Mary Magdalen, who can be seen through semitransparent curtains engaging in intercourse with her current customer.

In chapter 4, I discuss the official tolerance toward prostitution in the medieval period as a necessary concession to male need. It was also, though this is not conceded by medieval texts, perhaps the only means by which impoverished women and women unsupported by family could manage to keep eating. Nevertheless, as early as the sixth century, the empress Theodora (d. 548), wife of the emperor Justinian I, established a renovated palace on the Bosphorus as a reformatory for prostitutes. Procopius, a contemporary historian with a heavy bias against Theodora, reported that the ascetic regime she arranged for the prostitutes was so rigorous that many of them threw themselves into the Bosphorus rather than comply.[19]

In early modern Western Europe, attitudes toward prostitution were less tolerant than they had been during the medieval period, and Mary Magdalen became the patron saint of reformed prostitutes. Cities attempted to banish prostitution, now considered an "evil." Prostitutes, commonly assumed to take great pleasure in their work, were equated with sinful lust—their own lust, of course; their clients' lust was not mentioned. Many institutions for the reform and rehabilitation of prostitutes sprang up in France and across Western Europe. Some of these establishments developed into religious orders. One of them, the Sisters of Saint Mary Magdalen, established in 1321 in the shadow of the Church of Saint-Sernin in Toulouse, adopted the Rule of St. Augustine.[20]

The Preacher

Another important feature of Mary Magdalen's traditional significance was drawn from scripture (John 20:1–18), in which Mary Magdalen, as first witness of the resurrection, was given Christ's direct authority to announce his resurrection to the apostles, to act as an *apostolorum apostola,* an apostle to the apostles.[21] According to legend, the Magdalen's evangelical activity took several forms, beginning with this announcement. *Meditations on the Life of Christ* weaves the narrative of Christ's first resurrection appearance together with instructions in how the reader should reconstruct, in her own mind and emotions, the dramatic moment in which Mary Magdalen, initially thinking Christ was the gardener, finally recognized Christ: "Look at her well, how with tearstained face she entreats him humbly and devoutly to lead her to Him whom she seeks; for she always hoped to hear something new about her Beloved. Then the Lord said to her, 'Mary.' It was truly as if she came back to life, and recognizing Him by His voice, she said with indescribable joy, 'Rabbi.' . . . And she ran towards His feet, wishing to kiss them." Christ, "wishing to elevate her soul to the things of heaven, so that she should not seek Him from then on earth, said, 'Do not touch me, for I have not yet ascended to my Father. But tell my brothers.'" But medieval piety could not accept Christ's prohibition of the Magdalen's touch. The anonymous author of the *Meditations* comments: "Although it seemed at first that the Lord held back from her, I can hardly believe that she did not touch Him familiarly before He departed, kissing His feet and His hands."[22]

The second-century Gnostic *Gospel of Mary* pictures Mary Magdalen interpreting Christ's teaching to the apostles when, after his ascension, the

disciples realized that they did not know exactly what he thought about some matters. Mary Magdalen clarifies Jesus's meaning, describing some of his private revelations to her. Peter is outraged at her presumption: "Did he then speak with a woman in preference to us? Are we to turn back and all listen to her? Did he not prefer us to her?"[23] But other apostles rebuke Peter, calling him irascible, and insist that he respect Mary's report.

According to tradition, the Magdalen's teaching ministry became a global mission. Medieval texts like Jacobus de Voragine's *Golden Legend* reported that Mary Magdalen and her companions "evangelized Gaul, preaching and converting the pagans to Christianity."[24] Numerous paintings of Mary preaching to groups of women and men also inspired some medieval women to imitate her. Women preachers, such as the Waldensian women described by Geoffrey of Auxerre, claimed the precedent set by Mary Magdalen for their own preaching activities.[25] Katherine Jansen comments: "[W]omen's speech was fair game for moralists and satirists in the Middle Ages. The example of Mary Magdalen, *apostola,* however, stood in stark contrast to the caricatured garrulous and gossipy woman who inhabited much of medieval discourse. The image of the *apostolorum apostola* thus served as an antidote to such gendered constructs and even provided a counterargument to them."[26]

I interpret the praise showered on Mary Magdalen somewhat more skeptically. Although it is unarguable that preachers noted the Magdalen's virtues as an *apostolorum apostola,* they noticed and emphasized more frequently and forcefully her reformed sinfulness. The preacher Mary Magdalen is still attractive to modern women; it is less easy for us to understand the fascination historical people felt for the penitent sinner.

The Penitent

Preachers offered Mary Magdalen as a model to actual women in her penitence and tears, not in her preaching. The common strategy of extolling an unusual woman (like the Virgin Mary) in order to emphasize the *difference* between her and actual women was evident in their praise of Mary Magdalen. In paintings and sculptures, her penitence was depicted quite variously. Donatello's haggard Magdalen (figure 4) and Orazio Gentileschi's voluptuous, plump Magdalen, whose primary attribute is perfect—if unrealistic—breasts (figure 13), have little in common.

Fascination with a "great sinner" who became a great saint was part of the late medieval interest in strongly felt emotions, for the journey from

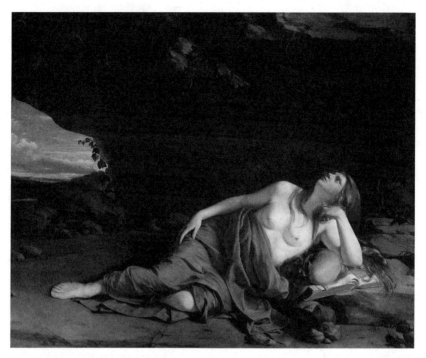

Figure 13. Orazio Gentileschi (1562–1647), *Mary Magdalen Repenting*, c. 1626. Kunsthistorisches Museum, Vienna (photo: Erich Lessing/Art Resource, NY).

sinner to saint was accompanied by oceans of tears.[27] In text and image, the Magdalen's tears were presented as a model for penitents: "Oh, if you could see the Lady weeping between these words, but with deep sobs, and the Magdalen frantic about her Master and crying with deep sobs, perhaps you too would not restrain your tears!"[28]

Tears played an important role in medieval devotion. The English mystic Margery Kempe (c. 1373–after 1433) enjoyed the "gift of tears," a gift much respected by her contemporaries, even when it annoyed them. An ale brewer and mother of fourteen children, Margery repudiated sex with her husband and went on many journeys to spread her mystical insights. Typically, she entered the marketplace of an unknown town and began to cry loudly. She always drew a crowd: "The crying was so loud and wonderful," she reported in her autobiography (titled simply *Book*), "that it made the people astounded."[29] The "cryings" often went on for two or three hours at a time. Clearly, in her time, tears were a mark of sainthood.

It is important to understand tears as medieval people did so that we do not assume a modern interpretation, which tends to view tears as symptoms

of pain, sadness, or depression. Late medieval and early modern cultures recognized several positive effects of tears. Perhaps most importantly, tears were evidence of true penitence. The witch-hunting manual *Malleus Maleficarum* claims that witches cannot cry because "the grace of tears is one of the chief gifts allowed to the penitent."[30] The sixteenth-century Spaniard Fray Pedro Malón de Chaide wrote: "[A]lthough the principal part of our penitence is the pain of our having offended God, with all this, the tears have their part, and a very great part . . . and they are the true evidence of the pain that we have for our sins; because with no other [evidence] can we prove so certainly that we are burdened and that we hurt as when we really weep for them." He waxed eloquent over the multiple benefits of tears: "Tears are money that cannot be counterfeited, our only refuge; they cleanse the stains of our sins, they appease the wrath of God, they obtain forgiveness, delight the soul, pay the debts, ward off demons, fortify the faith, increase hope, ignite charity, open the heavens; and finally, tears anoint, soften, pierce, move and force."[31]

Early modern people expected to be moved to tears in their devotions. The weeping Magdalen was not viewed as an abject and pitiable figure, but as one whose tears ensured her Christ's infinite love. Moreover, tears not only purged sins; they were also a way of showing compassion for Christ's suffering. If we are to take seriously historical Christians' characterization of their own devotional experience, we must even acknowledge the *pleasure* of tears. In the fourth century, Augustine referred to "the sweetness of groans, tears, sighs, and laments."[32] Twelve hundred years later, Teresa of Avila (1515–1582) wrote: "In thinking about and dwelling on what the Lord underwent for us, we are moved to compassion, and this pain and the tears that result from it are savory."[33]

Moreover, historical people shed tears when gripped by a range of emotions. Tears not only indicated penitence and compassion; people also cried when they were happy. Margery Kempe, for example, often cried "because heaven is so merry."[34] The perception of beauty likewise generated tears. Confraternities' processions, with their lavishly carved and clothed processional figures and their decorated floats, prompted floods of tears. These were not only penitential and compassionate, but they were also prompted by the consummate—to the eyes of spectators and participants—beauty of the spectacle. Confraternal commissioners instructed the artists who sculpted and painted processional figures to make them realistic and *therefore moving;* in other words, to make them *beautiful.*

In devotional practice, paintings of the crucified Christ, the sorrowing Virgin, or the penitent Magdalen did not function as "art," but as stimulants

for the viewer's tearful devotions. For those who found it difficult to visualize the events of Christ's passion internally, pictures were essential. No less a spiritual adept than Teresa of Avila acknowledged her devotional dependence on images: "I had so little ability to represent things in my mind, except for what I could see. I could profit nothing from my imagination, [unlike] other persons who can see things in their mind whenever they pray; . . . for this reason I was such a friend of images. Unhappy those who by their fault lose this good! It seems to me that they do not love the Lord, for if they loved him, they would delight in seeing his portrait, just as here one is still happy to see someone one loves dearly."[35] To medieval people, Mary Magdalen's copious tears modeled intense and highly admirable devotion.

The Contemplative

Mary of Bethany, sister of Martha and Lazarus, was amalgamated into the medieval Magdalen, and with her came the role of the contemplative. Luke 10:39 describes Mary of Bethany sitting at Jesus's feet, listening attentively to his words, while her sister bustles about preparing a meal; Mary, Jesus says, chose the "better part," feasting on spiritual rather than temporal food. Despite Jesus's praise for Mary, many medieval preachers did not describe the active and the contemplative lives as polarized and antagonistic; they taught that a combination of the two was necessary. However, the mystic and preacher Meister Eckhart (d. 1329) gave the passage another interpretation. He considered contemplation to be preliminary to, and essential preparation for, action: "Mary was in the process of becoming what Martha already was."[36] But for most medieval people, contemplation took precedence over action because contemplation could occur both in this life and in heaven, whereas action would cease when the present life ended.

It was perhaps images, rather than exhortatory sermons, that best assisted most people to practice contemplation. Taught to discern the state of the soul from attentive observation of the body, viewers had several models of contemplation in paintings of the contemplative Magdalen. These models ranged from great distress to calm trust. Artemisia Gentileschi's *Penitent Magdalen* (1617–20, figure 14) frowns and clutches her breast in active sorrow for her sins. Surrounded by a dark background, she is dressed in opulent silk and seated on an ornate embroidered chair. Her highlighted bare shoulder, chest, and foot and her flushed cheeks make her repentance visible.[37] Pieter van Slingelandt's *Mary Magdalen Penitent* (1657, figure 15)

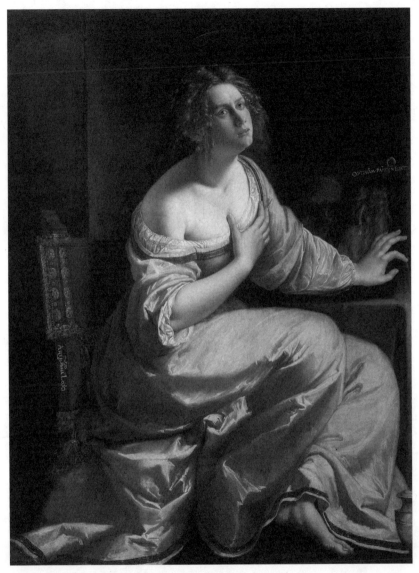

Figure 14. Artemisia Gentileschi (1593–c. 1651), *Penitent Magdalen*, 1617–20. Galleria Palatina, Palazzo Pitti, Florence (photo: Scala/Art Resource, NY).

suggests even more active penitence, as this bare-breasted figure gazes heavenward while holding a whip. Georges de La Tour's contemplative Magdalen (1636–38, figure 16), however, is seated before a table holding several hefty tomes, gazing calmly at a candle flame while she caresses a skull. It is not difficult to guess that she contemplates the shortness of life and its pressing

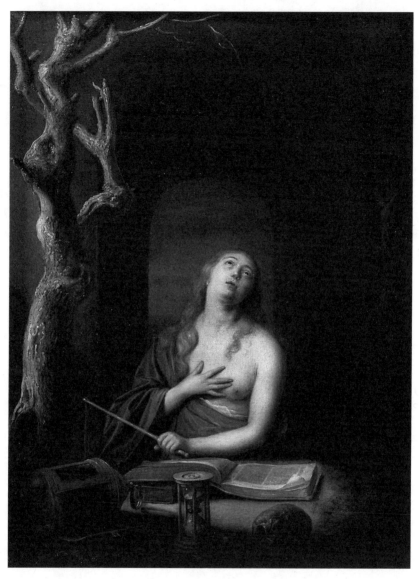

Figure 15. Pieter van Slingelandt (1640–1691), *Mary Magdalen Penitent,* 1657. Musée du Louvre, Paris (photo: Erich Lessing/Art Resource, NY).

immediacy. Her still, slightly slumped figure does not invite the viewer to action in the face of inevitable death, but to trusting acceptance of mortality. In Rogier van der Weyden's altarpiece fragment *The Magdalen Reading* (1440–50, figure 17), the contemplative Magdalen sits on the floor, leaning against a wooden cupboard. She is opulently dressed and her alabaster jar

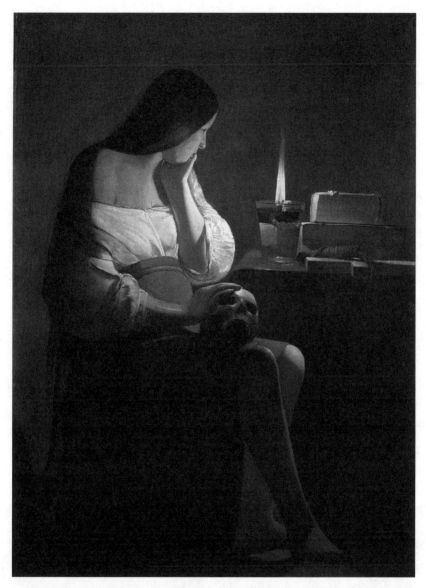

Figure 16. Georges de La Tour (1593–1652), *St. Mary Magdalen Meditating,* 1636–38. Musée du Louvre, Paris (photo: Erich Lessing/Art Resource, NY).

sits on the floor beside her. She reads a book, suggesting the development of a spiritual life.

The composite figure of Mary Magdalen is unique in that it contains elements of both the "extremely bad" breast (the prostitute) and the "extremely perfect" breast (the contemplative). Texts like *Meditations on*

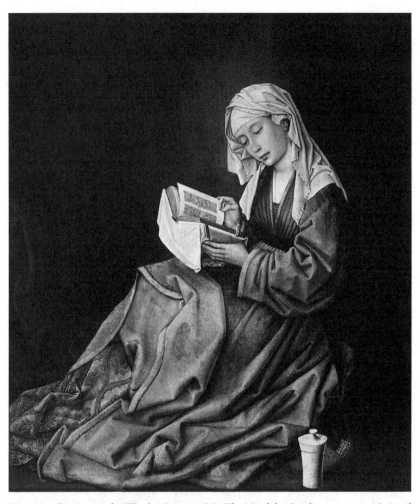

Figure 17. Rogier van der Weyden (1399–1464), *The Magdalen Reading*, 1440–50. National Gallery, London (photo: Alinari/Art Resource, NY).

the Life of Christ emphasized the repentant saint, but images often veered toward representing a character whose fleshly allure strongly suggested her alleged former career.

ICONOGRAPHY OF THE MAGDALEN

Mary of Magdala was the most flamboyant of saints. Her love for Christ was insistently physical; in crucifixion scenes, she is repeatedly depicted gesticulating wildly or reaching longingly for Jesus's feet, the feet she had

washed with her tears and dried with her hair. Although she was often the focus of a painting, she was not a "stand-alone" saint. Her passionate love for Christ, and her frenzied grief at his death, provided contrast with the huddled, dignified grief of the Virgin. The Magdalen represented visibly ardent commitment, while the Virgin supplied a model of quiet dedication. Unique among sacred figures, Mary Magdalen combined spiritual and physical passion for Christ.

Depictions of the Magdalen changed in the fifteenth and sixteenth centuries. She was no longer shown as a chaste figure completely covered by her hair (as in the images of the Master of the Magdalen, plate 8). A newly discovered and authenticated painting by Leonardo da Vinci (c. 1515) shows Mary Magdalen in full-frontal nudity to just above her pubic area. The top of her right leg is shown; her small rounded breasts are fully exposed, and she holds a sheer veil over her belly.[38] In the mid-sixteenth century, Titian painted the upper body of a smooth and lavishly fleshed Magdalen (plate 5). She has the flowing hair that identifies her as Mary Magdalen, but her hair parts to reveal the nipples of two fleshy and naturalistic breasts. The religious Magdalen is implied only by her eyes, which are raised to the skies; to twenty-first-century viewers, her body is unambiguously erotic.

Was Titian's Magdalen erotic to sixteenth-century viewers? Anne Hollander's method for identifying the period erotic eye can help address this question. Does her body resemble representations of clothed female figures of her time, which were characterized by small, high breasts and a short torso above a swelling belly? By this standard, Titian's Magdalen hardly approximates an erotic object, and it is likely that early modern people saw the depiction as a religious one. We must consider Hollander's method more carefully, however. It assumes a common culture in societies that may have been much more culturally differentiated according to social location, wealth, and class than are modern media cultures. Hollander's method favors those members of society that had the resources and the leisure at least to recognize fashionable dress, if not to dress fashionably. She ignores the "erotic eye" of most people whose interests did not include fashionable dress.

David Freedberg takes a different approach, arguing that naturalistic representation in devotional images always increased viewers' emotional attachment to the image. Realistic images arouse *because* they are realistic, he writes.[39] But his argument ignores Western European sixteenth-century elite culture, which found the *artificial,* not the "natural," beautiful. Whether in clothing, music, or literature, the intentionally constructed and carefully crafted object was thought to be the most beautiful. Perhaps, then,

we cannot think in terms of "Western European societies," but must expect that a range of different responses to an image existed within the same society.[40] Hollander's thesis may be accurate for the classes of sixteenth-century society in which "art" was likely to circulate; Freedberg may be our best guide to the responses of an emerging popular culture who found their images in fourteenth- and fifteenth-century churches, *sacre montes,* and other pilgrimage sites.

Susan Webster's analysis of sixteenth- and seventeenth-century penitential Holy Week processions in Seville supports Freedberg's argument that realism augmented emotional attachment to an image or sculpture. Designers and painters of processional sculpture used all the devices at their disposal to create realistic images for the express purpose of prompting devotion. They used resins and glass to simulate sweat and tears, bits of cork for coagulated blood, and shreds of painted leather to imitate torn flesh. The sculptures had real hair and were clothed with real garments.[41] Realistic representation was known to produce intensified devotion.

Another way to augment devotional attachment was to create a sense of erotic intimacy. Painters risked evoking sexual arousal in their depictions of Mary Magdalen, unlike images of the Virgin Mary, who could never inspire lust, according to Jacobus de Voragine. In contrast to the Virgin's carefully exposed breast, its religious meaning directed by nonnaturalistic representation, undisturbed clothing, and a maternal scene, representations of Mary Magdalen frequently reveal two realistically depicted breasts, often with disheveled clothing suggestive of the process of undressing (figure 18). Even when the contemplative Magdalen is fully clothed, her breast is usually referenced either by disheveled clothing slipping off her shoulder or by her hand clutching a breast. Is it possible that in the early modern religious imagination Mary Magdalen was not a figure in which erotic and religious passions clashed, but a composite of *eros* and spirit?

THEOLOGICAL CONSIDERATIONS

In her book *Venus in Sackcloth: The Magdalen's Origins and Metamorphoses,* Marjorie Malvern argues that historically the figure of Mary Magdalen flourished at times when dualism was strong in the dominantly Christian West. Her figure, Malvern claims, was used to communicate what she calls "simplistic dualism," a conflict between flesh and spirit. I disagree. I think that the Magdalen figure attracted precisely because it represented a human longing

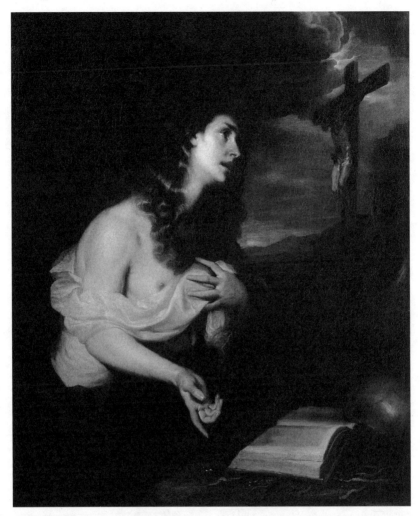

Figure 18. Mateo Cerezo the Younger (1639–1685), *Penitent Magdalen,* before 1666. Residenzgalerie, Salzburg (photo: Erich Lessing/Art Resource, NY).

for the integration of the spiritual and the physical—indeed, it suggested the impossibility of separating or sometimes even distinguishing between them. *The Descent from the Cross* (c. 1500, figure 19), by the Master of the Saint Bartholomew Altarpiece, shows Mary Magdalen cupping her left breast with her left hand, a gesture that—after the Council of Trent—would be used repeatedly by artists to reference the breast without displaying it. It suggests that she loved Christ passionately—both erotically *and* spiritually.

The Magdalen figure forces us to examine the assumption that the sexual and the spiritual are conflicting opposites. We cannot assume, as

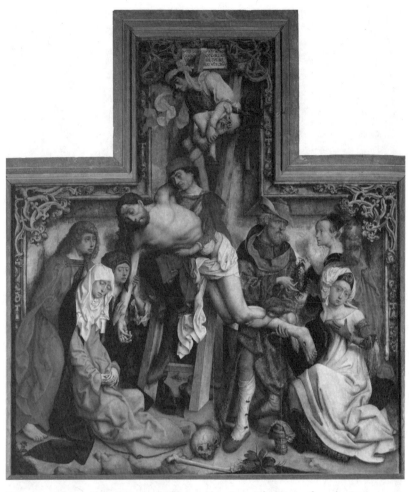

Figure 19. Master of the Saint Bartholomew Altarpiece, *The Descent from the Cross*, c. 1500. Musée du Louvre, Paris (photo: Erich Lessing/Art Resource, NY).

does Freedberg, that early modern people felt "the need to keep profane and sacred apart."[42] Just as viewers' erotic interests were deliberately engaged in late medieval and early modern paintings and sculptures of the Virgin and other female saints in order to provoke heightened religious affect, the literature of mystical experience of the time used overtly sexual language to describe powerful and fundamentally ineffable religious experience. Teresa of Avila offered a vivid description that conflates physical and spiritual experience: "The pain was so great that I screamed aloud; but at the same time I felt such infinite sweetness that I wished the pain to last forever. It was not physical but psychic pain, although it affected

the body as well to some degree. It was the sweetest caressing of the soul by God."[43]

The conflation of the spiritual and the erotic is evident as well in Louis Finson's 1606 copy of Caravaggio's lost painting *The Magdalen in Ecstasy.*[44] The Magdalen is seated against a dark background, her skin and disheveled clothing illuminated by a raking light. Her head is thrown back, her lips are parted, and her eyes are almost closed. Her left shoulder and chest are exposed to her left nipple. Hands clasped strongly enough to indent her flesh, she could be either mourning her sins or in the throes of sexual passion.

Mary Magdalen's love for Christ insistently refused abstraction; it was intensely erotic. *And* it was intensely spiritual. The difficult project of holding the two together is evident in paintings that either emphasize one at the expense of the other or attempt to maintain a balance. While Pieter van Slingelandt's *Mary Magdalen Penitent* features the Magdalen's realistic naked breast, Donatello's *Magdalen* allows little sensuality to distract from his penitential focus and Rogier van der Weyden's *The Magdalen Reading* pointedly emphasizes her spiritual and intellectual capacities, downplaying her erotic attraction.

The iconography of Mary Magdalen represents an ideal of human wholeness. She was presented not as a one-dimensional saint, but as a rounded human figure with whom people who knew themselves to be both sexual and spiritual could identify. Educated viewers of paintings attributing such a range of abilities and capacities to Mary Magdalen may have recalled Plato's understanding of erotic attraction as encompassing *all* delightful objects, an understanding of *eros* brought into Christian tradition by Augustine.[45] With the Magdalen figure, physical attraction was not sublimated in favor of the spiritual.

Although Christian authors frequently contrasted attention to sensible objects with spiritual aspirations, some Christian theologians advocated another attitude toward the sensible world. A description of this lesser-known tradition, which insisted on the essential unity of *eros* and spirit, cannot be attempted here.[46] An example must suffice. Bonaventure's *The Mind's Road to God* describes an itinerary that begins with attentive admiration of the sensible world: "The one who is not illuminated by such great splendor of created things is blind; the one who is not awakened by such clamor is deaf; the one who does not praise God because of these effects is mute; the one who does not note the first principle from such great signs is foolish."[47] The delight engendered by the beauty of the created world, according to Bonaventure, is both method and energy for the mind's journey to God. Since God is the

most delightful object, "We are led back to seeking [God] by all other delights." In stages, starting with enjoyment of objects in the world and capacities of the mind, we gradually progress to "contemplation of the blessed Trinity." But even the beatific vision is not the goal: when "these things are considered *all together*," the mind is overwhelmed by a "stupor of wonder."[48]

Only by ignoring the inclusive tradition within Christian theology can one interpret the late medieval and early modern figure of Mary Magdalen as a symbol of the dualistic opposition of *eros* and spirit. Whether washing Christ's feet and drying them with her hair, throwing her body at the crucified Christ's foot, or lovingly preparing him for burial, the (composite) Mary Magdalen loved Christ with an almost embarrassing passion. Her enthusiastic penitence for her presumed enjoyment of a life of prostitution was apparently seen (by artists) for several early modern centuries as sufficient to direct viewers to religious meaning, despite her naturalistic breasts. I suggest, however, that the increasing realism of Mary Magdalen's breasts may have alarmed the clerics who attended the Council of Trent and encouraged their prohibition of nakedness in religious painting. Ironically, even if *intended* to attract religious emotion, realistic paintings of naked breasts created a backlash against nakedness in religious art.

THE IMPLIED BREAST

It is difficult to assess how immediately and pervasively the Council of Trent's decree affected Western European painting. In highly visible locations like the Vatican, the effect must have been immediate and decisive. But in more remote locations, in parishes that were often protective of their accustomed images and with bishops disinclined to destruction, it is likely that the effects of the Council's edict were less dramatic. In the Vatican, the first target of Catholic reformation indignation was Michelangelo's *Last Judgment* in the Sistine Chapel. Despite overpainting to clothe the naked figures, the fresco was in danger of being destroyed under Pope Clement VIII (elected in 1605). After the Council of Trent, seventeenth-century popes had scruples against nudity in religious painting that "would have astonished sixteenth-century popes."[49] Several prominent artists disavowed their own earlier paintings that contained naked figures, and many artworks were destroyed. Art historian Emile Mâle observes that it was as if eyes that had seen only beauty in human bodies suddenly discovered their fallen nature.[50] He argues that the church "redirected" religious art away from naked bodies

after the Council of Trent but remained indulgent to classical art featuring naked figures. It sought, he says, to inspire rather than to tyrannize and alienate artists. For the Roman Catholic Church, art was an important part of the struggle against Protestantism, a vivid affirmation of features of the Christian tradition rejected or marginalized by Protestant reformers—the Virgin Mary, saints, martyrs, ecstatic mysticism, and angels.[51]

Yet even before the Council of Trent, a tradition existed in which the Virgin's breast was implied rather than exposed. The third-century Catacomb of Priscilla, Cubiculum of the "Velatio" shows an infant apparently suckling the mother's dress. In Duccio di Buoninsegna's *Rucellai Madonna* (commissioned in 1285), the infant Christ blesses viewers while touching his mother's right (clothed) breast. Raphael's *The Niccolini-Cowper Madonna* (1508) shows Christ reaching inside his mother's dress to touch her unseen left breast.

Representations of Mary Magdalen following the Council of Trent can be summarized by saying that the Magdalen was always penitent in seventeenth-century art.[52] Artists sought strategies for achieving increments of devotion with clothed figures, but echoes of the sensuous penitent remained.[53] In Artemisia Gentileschi's *Penitent Magdalen,* her right hand cups her covered left breast. Her clothing is in disarray, and her blouse bares her right shoulder.[54] Similarly, in Georges de La Tour's *St. Mary Magdalen Meditating,* her right shoulder is exposed and her blouse slips to suggest, but not reveal, her right breast. Her large belly, covered by a short red skirt, reminds us of Hollander's observation that "in the erotic imagination of Europe, it was apparently impossible until the late seventeenth century for a woman to have too big a belly."[55]

Depictions of the Magdalen's breasts did not disappear after the Council of Trent. Orazio Gentileschi's *Mary Magdalen Repenting* and Mateo Cerezo the Younger's *Penitent Magdalen* (before 1666, figure 18), as well as numerous other paintings, still placed the Magdalen's beautiful breasts front and center. Although Cerezo's Magdalen points to an open book and gazes at a crucifix, her disheveled clothing suggests that she was not to be seen unambiguously as a religious figure. Similarly, Gentileschi's Magdalen lies in a cave in a darkened landscape; her breasts are the focal point of the painting, highlighted by soft light from above.[56] These and other seventeenth-century paintings of the Magdalen were done by the new professional artists, not for church commissions, but to demonstrate the artist's imagination, creativity, and skill—they are "art." Not intended to produce religious compunction in a viewer, they are paintings of female

nudes that could, by the mid-seventeenth century, be counted on to provoke a wealth of associations, both religious and secular.

The figure of Mary Magdalen, more explicitly than any other female figure in Western Christian art, exhibits masculinist ambivalence about women. The Magdalen directly and simultaneously focuses men's fears, apprehensions, and attraction to a beautiful and flamboyant woman. In part 2, I examine the intensification of this ambivalence and its effects on actual women as late medieval societies were affected by new technological, religious, social, and institutional changes.

The Secular Breast

People know what they do; they frequently know why
they do what they do; but what they don't know is
what what they do does.

MICHEL FOUCAULT

All civilization is the product of a long struggle
against fear.

G. FERRERO

WOMEN LOST SOCIAL, ECONOMIC, and legal power in early modern Western Europe. Yet, as the French historian Jean Delumeau has observed and documented, an increasing male fear of women is evident in the sixteenth through eighteenth centuries.[1] From preachers' sermons to popular proverbs, a rhetoric vilifying women in newly aggressive and scatological terms pervaded Western European societies. Theologians, doctors, and legislators agreed that women's bodies were simultaneously ugly and seductive, an apparent contradiction, but one that was believed to hold great danger for men. The best-selling devotional manual for the "Christian soldier" by Erasmus of Rotterdam (c. 1469–1536), the *Enchiridion militis christiani*, identified "woman" as the enemy of the spiritual life. Nowhere in his manual did Erasmus acknowledge that a sexual relationship with a woman—even marriage—could be a format in which the "soldier" might develop and exercise his spiritual life. Rather, Erasmus reduced sex to lust and its effects.

> [This seductive disease] plucks away reputation, that most precious of possessions, for no vice's notoriety stinks worse than that of lechery. It drains away one's patrimony. It destroys at the same time the vigor and attractiveness of the body. It damages health and produces countless ailments, all of them disgusting. It deforms the flowering of youth and hastens a repulsive old age. It does away with the energy of talent, blunts the keenness of the mind, and ingrafts, as it were, a brutish mentality. It repeatedly calls one away from all honorable pursuits and wholly immerses the man, however great, in filth, so that he can think of nothing but the sordid, the base, the vile.[2]

"Woman" was repeatedly accused, by Erasmus and many other authors, of being an active threat to property and to physical and spiritual health. But it was actual women who felt the effects of misogyny.

79

Why did men fear women? A general answer can be suggested here; the chapters that follow offer a more precise and detailed picture. Throughout part 2, I discuss the primary arenas in which hostility toward women was expressed, legislated, and enacted. Chapter 4 examines the establishment of a (male) medical profession based in part on claiming an exclusive right to managing women's bodies, especially their reproductive capacities. Chapter 5 explores witch persecution and the "invention of pornography" as these contributed to the construction of the pornographic breast.

The existence of overwhelming fear within a society often prompts the creation of a *culture of fear* that directs attention away from real threats, toward more manageable imagined dangers. Certainly, late medieval and early modern people in Western Europe had many realistic reasons to fear. Plague was an unpredictable and nonnegotiable object of fear, but it was only the most evident one. Other causes of anxiety included the onset of a syphilis epidemic in the 1490s; a crisis of religious authority created by the sixteenth-century Protestant reformations; and profound changes in the structures of society that occurred with the emergence of early capitalism. In the face of such realistic fears, the fear of women functioned as a distraction or misdirection.

Even unrealistic fears have real effects, however. Witch persecution took the lives of an estimated thirty to sixty thousand victims, most of them women, over a period of about three hundred years in Western Europe.[3] Witchcraft cases increased steadily in the fourteenth and fifteenth centuries, reaching a peak of mass hysteria between 1550 and 1650. In the second half of the seventeenth century, the number of trials dropped sharply; by the end of the eighteenth century, they had disappeared entirely.

Why were most accused witches women? The *Malleus Maleficarum* (1486) describes women's "natural" affinity with evil: "All wickedness is but little to the wickedness of a woman. . . . What else is woman but a foe to friendship, an inescapable punishment, a necessary evil, a natural temptation, a desirable calamity, a delectable detriment, an evil nature, painted with fair colors. . . . Women are by nature instruments of Satan—they are by nature carnal, a structural defect rooted in the original creation."[4]

Witch-hunting manuals such as the *Malleus Maleficarum* differed from devotional literature like Erasmus's *Enchiridion* only in that they

acknowledged women's attractiveness. Erasmus apparently allowed himself to see only women's treachery and deceit. It is impossible not to wonder what it was in Erasmus's experience that prompted him to picture all sexual activity as ugly and demeaning: "Imagine to yourself just how ridiculous, how completely monstrous it is to be in love; to grow pale and thin, to shed tears, to fawn upon and play the cringing beggar to the most stinking tart, to croak and howl at her doors all night, to hang upon the nod of a mistress, to endure a silly woman's dominating you, bawling you out, flying at you in rage, and then to make up with her and voluntarily offer yourself to a strumpet so she can play upon you, clip you, pluck you clean!"[5] Clearly, men who took this rhetoric seriously were encouraged to suspect all women of seeking to control them, treat them with disdain, and "pluck [them] clean." The absence from the text of any *other* kind of love relationship renders Erasmus's advocacy for the spiritual life doubly problematic. In fact, witch persecution, religion, and early modern pornography shared some common assumptions about women.

The impression given by the existing evidence is not, however, that of uncontested misogyny, but—even more problematic—strong ambivalence. Hostility was the response. Protestant territories did not differ substantially from Roman Catholic areas in attitudes toward women. Although Protestant reformation literature elevated women's domestic work to a vocation, equal in importance to that of magistrates and preachers, the respect that might have resulted was overbalanced by images and rhetoric that emphasized women's weakness, fallibility, and vulnerability to evil. Across Western Europe, "woman's" collaboration with evil became an ideology.

Slavoj Žižek writes: "An ideology is really 'holding us' only when we do not feel any opposition between it and reality—that is, when the ideology succeeds in determining the mode of our everyday experience of reality itself."[6] Gendered ideologies, for example, are normalized by social arrangements. Within early modern societies, few questioned the necessity of socialization to gendered roles; however, at least a few sixteenth-century men blamed women's socialization for their apparent weakness. William Bercher, in *The Nobility of Women* (1559) wrote:

> I have noted in some women learning, in some temperance, in some liberality . . . and I have compared them with men who have been endowed with like gifts and I have found them equal or superior. The upbringing of

women is so strait and kept as in a prison, that all good inclination which they have of nature is utterly quenched. We see that by practice, men of small hope come to good proficiency so that I may affirm the cause of women's weakness in handling of matters to proceed from the custom that men have appointed in their manner of life, for if they have any weak spirit, if they have any fickleness or any such thing, it cometh of the divers unkindness they find in men.[7]

The seventeenth-century Frenchman François Poulain de la Barre, who was trained as a Catholic priest, agreed. He questioned the "natural" right of men to dominate women, arguing that "this domination had not been ordained by nature, rather that since it was common practice, it was assumed to be natural." "We usually confuse nature with custom," he wrote in *De l'égalité des deux sexes* (1673).[8] However, male defenses of women's intelligence and strength were rare in early modern Europe.

THE BREAST

The infant's experience of delight and frustration at a woman's breast, described by Augustine, seems to have continued to inform men's efforts to design social arrangements in order to achieve maximal satisfaction while minimizing frustration. The infant's effort to cope with anxiety by splitting the breast into the "extremely bad" and the "extremely perfect" breast (discussed in chapter 1) is nowhere more evident than in Carlo da Camerino's *The Madonna of Humility with the Temptation of Eve* (before 1420, plate 9). The picture plane is divided into three spheres. A heavenly scene shot through with sparkling gold appears in the top sphere. Angels flank a large nursing Virgin, who sits on a rug on the floor of the middle sphere, her upper body extending into the top sphere. The Child holds a tiny round breast (that emerges from undisturbed clothing) while twisting around to catch the viewer's eye. In the bottom sphere, the smallest area of the painting, a tiny Eve lies in a black, grave-like rectangular space, a snake coiled around her leg. Her long red hair reveals a naturalistic breast as she strains to see the Virgin and Child above her.

The figures of the heavily shrouded Virgin and the naked Eve clearly identify the "extremely perfect" and the "extremely bad" breast. Despite her monumental bulk, Mary is disembodied, placed in a heavenly setting, with only enough body to protect (hands) and nourish (breast) the infant Christ.

Eve, on the other hand, *is* body. Her plane is earth; plants grow at her eye level. Her naked body—her realistic breast, her flowing, wavy hair and shapely thigh—signals her sinfulness. She is the woman who brought sin into the world, precipitating the sufferings of the human race.[9] The *Malleus Maleficarum* states: "For though the devil tempted Eve to sin, yet Eve seduced Adam, and as the sin of Eve would not have brought death to our soul and body unless the sin had afterwards passed on to Adam, to which he was tempted by Eve, not by the devil, therefore she is more bitter than death."[10]

Beginning in the fifteenth century, and throughout the sixteenth and seventeenth centuries, interpretations and associations of the breast were contested, implicitly rather than explicitly. It was never a subject of public debate; one must read images in order to detect the shifting identities of the breast. As the cultural authority of Western Europe moved away from competing churches that could no longer claim exclusive and reliable access to truth and toward newly formed secular and political institutions, the breast increasingly lost its religious significance, simultaneously acquiring secular meanings.

Profound changes in Western European societies interacted with changed images of the breast in early modern culture. As early as 1481, in *Virgin of Melun,* Jean Fouquet adopted the pose of the Virgin with one bare breast to paint Agnès Sorel, mistress of King Charles VII of France, with her child (figure 20). But the artist altered the conventions that directed viewers to religious meaning. In many religious paintings, the Virgin Mary's cone-shaped breast protrudes—often at an unnatural location and angle—from her perfectly composed garments, and her covered breast is flat. The so-called Virgin of Melun's uncovered breast is high and round, the standard erotic breast in her culture; her clothing is disheveled and pushes upward her equally rounded covered breast. Fifteenth-century people, accustomed to viewing paintings of the nursing Virgin, must have been startled by the alteration of these details. Another painting of Agnès Sorel, by an anonymous sixteenth-century artist, depicts her in a dress unlaced to reveal her left breast (plate 3). The child is absent, and Sorel holds a book in which she marks her place with a finger. Perhaps the artist sought to show that despite her physical beauty, Sorel was to be esteemed for her intelligence.

Classical and allegorical subjects with bared breasts became more frequent in the fifteenth and sixteenth centuries. Titian's *Venus at the Mirror*

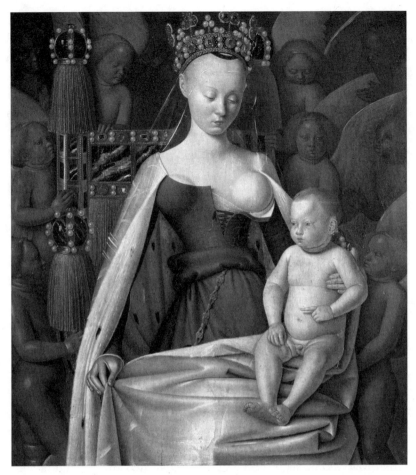

Figure 20. Jean Fouquet (c. 1415–1481), *Virgin of Melun,* before 1481. Koninklijk Museum voor Schone Kunsten, Antwerp (photo: Scala/Art Resource, NY).

(before 1576, figure 21) emphatically rejects the strategies artists had employed for displaying the religious breast. Although the figure's breasts are too fleshy to meet the criteria of the erotic period eye, her body does reveal the plump arms and rounded belly considered erotic at the time. Johannes Baeck's *The Prodigal Son* (1637, plate 4) pictures the son's decadence as a brothel scene in which he cups the exposed breast of a prostitute while someone plays the viola da gamba.[11]

The religious breast did not disappear in the fifteenth and sixteenth centuries, but it shared the cultural field with new technology whose printed products associated the breast with professionalized medicine and

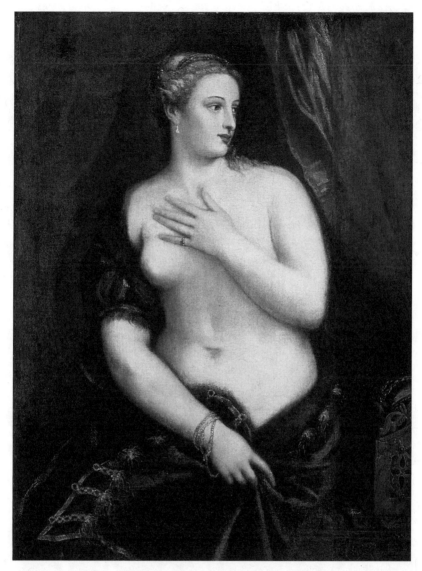

Figure 21. Titian (c. 1488–1576), *Venus at the Mirror,* before 1576. Ca' d'Oro, Venice (photo: Cameraphoto Arte, Venice/Art Resource, NY).

the nascent pornography industry. Robert Darnton writes: "Sea changes in attitudes cannot be dated precisely, nor can they be assigned exact causes."[12] But by the mid-eighteenth century, the terminus of our study, the breast had been appropriated by these new social powers; it was no longer used—nor could it be used—to convey a religious message.

FOUR

The Anatomical Breast

The internal organs have a rational loveliness more
beautiful than all that gives pleasure
to the eye in the outward form.

AUGUSTINE
The City of God

ANDREAS VESALIUS'S INFLUENTIAL ANATOMY *De humani corporis fabrica* (1543) established a collaboration between physicians and artists. Jan Steven van Calcar, a Netherlandish artist who had apprenticed in Titian's Venice studio, did the anatomical drawings for the book. Depictions of flayed, dissected, and exposed bodies must have been startling to their first viewers. In Vesalius's anatomy, and in the many anatomies that soon followed, human bodies, no longer understood as the site and symbol of religious subjectivity, yielded the secrets of their structure and operation. These bodies were material objects, devoid of subjectivity.

At least to some men, anatomies suggested a new interpretation for the ancient inscription on the Temple of Apollo at Delphi: "Know thyself." Even though these bodies did not suggest religious meaning, they could be seen as evidence of the skill of their Creator; bodies were "divine machines." Philip Melanchthon (d. 1560), Martin Luther's friend and successor, wrote: "Anatomical learning must not be neglected in understanding why it should be so useful to know about the fabrication of the human body. . . . They formerly told of an oracle, 'Know thyself,' [which means] that we should examine all that is admirable within ourselves and that constitutes the source of many of our actions. . . . Since true wisdom is the recognition of God and the consideration of Nature, one must admit that

Figure 22. Anatomical model of a woman (known as the "Venus of Medici"), 1785. Institut für Geschichte der Medizin, Vienna (photo: Erich Lessing/Art Resource, NY).

one must learn anatomy, through which the causes of many actions and changes are made visible."[1]

Martin Kemp and Marina Wallace suggest that the visual quality and detailed workmanship of medical illustrations, as well as of ivory and marble three-dimensional anatomical models (figure 22), also suggests religious interest: "[T]he stylishness and the rhetoric of presentation were absolutely integral parts of the images if they were to function effectively within their given contexts of communication. They were not simply instructional diagrams for the doctor-technician, but statements about the nature of human beings as made by God in the context of the created world as a whole. They were about the nature of life and death."[2]

Nevertheless, even though it seems likely that anatomical representations continued to reflect religious interests (or to be rationalized as such), they also made it possible to see human bodies simply as inert objects. As the secrets of bodies were explored and mapped in detail, God was admired as a skillful craftsman, a watchmaker. Eighteenth-century Deists pictured a God who created the universe and set it in motion, then departed to let it develop without further interference. Changes in the conceptualization of bodies accompanied and interacted with the establishment of professionalized medicine in early modern Western Europe.

In order to understand the complex interactivity of interpretations of the breast and social change, in the next several sections I will temporarily place in abeyance a direct focus on the breast in order to sketch several factors that contributed to its secularization. I aim for what the anthropologist Clifford Geertz has called "thick description."

THE PROFESSIONALIZATION OF MEDICINE

In the mid-900s, the School of Salerno emerged as a center of medical learning. Dissections of animals were conducted at the school for the first time since antiquity. In about 1225, a manual of anatomy was published in Paris. Dissection of human bodies began to be practiced at the end of the thirteenth century. In Venice, the Great Council decreed that the College of Surgeons was to provide instructive public dissections at least annually. The church did not specifically prohibit dissections in medical colleges, but its prohibitions against dismembering and boiling human bodies tended to discourage anatomical activity outside university medical schools.[3] The human body, understood as God's creation, could not be reduced to an object for study.[4]

In the eleventh to thirteenth centuries, Arab medical knowledge was brought to the West and, along with the rediscovery of Aristotle, became influential in medical theory and practice. Two different, but not incompatible, pictures of bodies' interior operations existed. These were articulated by Hippocrates and Galen, for both of whom the practice of medicine was an art. Hippocrates envisioned the outer body as a shell, within which humors, in constant flux and in need of constant cleansing, circulated. Bodies were healthy if there was a balance between humors entering the body and those exiting it. Disease was caused by blockages that prevented the circulation of humors, so healing meant "getting rid of the viscous and hardening matter" inside the body in order to restore the normal "flux" of secretions and excretions.[5] This theory of disease was so commonly accepted that in the seventeenth and eighteenth centuries, patients often sought to heal themselves by bloodletting without consulting a physician.[6]

Galen adopted "Aristotle's model of the body as a system of solid organs," a view that dominated medical therapy long after his theory had come into question.[7] "Galenic doctrine emphasized the hygienic, preventive role of medicine—'good government of the body'"—rather than remedial medicine. In this conception of medicine, ordered living and good diet were paramount.

Over the course of three and a half centuries, physicians, barber-surgeons, and apothecaries created a professional medical establishment that laid claim to scientific knowledge and methods of healing. Vesalius's anatomy was part of this development. Medicine achieved professional status at least in part by restricting the right to practice, excluding unlicensed traditional healers such as midwives and women healers, women's traditional medical practitioners. With the invention of forceps in 1720, barber-surgeons claimed superior professional competence for assisting childbirth. Undeniably, the use of forceps for delivery speeded up the long process of labor, and barber-surgeons argued that shorter labor was less tiring to mother and child.[8] This "progress," however, occurred at the cost of greater danger of injury to mother and infant.

New medical techniques were only one feature of the establishment of the medical profession. A revision of traditional assumptions and negotiations between patients and doctors was also involved, in which fundamental assumptions about the doctor-patient relationship were reversed. Gianna Pomata, studying the records of the Bologna Protomedici, a board that originated in the sixteenth century to adjudicate complaints against various kinds of healers, found that most of the cases heard by the board were brought by patients who "believed that their healer had broken a basic rule of fairness . . . [namely] that the healer should be paid for his service only if the treatment was effective"—and the *patient* decided whether or not the treatment had been successful.[9] Moreover, the sick, the elderly, the poor, and women and children were thought of as handicapped by their condition and thus were accorded special legal rights, protections, and privileges—*privilegia infirmorum*. In other words, medical services existed in a buyer's market.

The principle by which the patient hired and controlled her/his cure can be traced to fifth- or sixth-century Visigothic law; it was overturned slowly and with difficulty between the sixteenth and eighteenth centuries.[10] Throughout medieval Western Europe, written contracts between healers and patients specified a deadline for recovery and the price the patient would pay for recovery. If the patient was not cured by the deadline, the healer forfeited his fee. Furthermore, the longer the time required for achieving a cure, the less the patient paid. By the second half of the sixteenth century, all such contracts were regarded as invalid.[11]

The "suppression of the traditional view that regarded . . . medical services as similar to a craftsman's labor and thus compensable upon successful completion" was essential for the professionalization of medicine.[12] But if the comparison of medical practitioners to craftsmen was no longer

appropriate, it was not clear how medical healers were to be seen. Were they, perhaps, analogous to priests? If healing was thought of as a spiritual gift, however, remuneration for healing became the sin of simony—the buying or selling of spiritual benefits. Rather, medicine came to be understood as a professional scientific practice. From this perspective, "medical practitioners deserve to be paid because they are licensed members of a profession, and . . . payment does not depend upon the patient's satisfaction."[13]

A more fundamental change from late medieval medical assumptions and practices cannot be imagined. This change, which clearly favored the medical practitioner, was resisted. In the latter half of the seventeenth century, the custom of "paying only a deposit during treatment, with the balance due at the end" was still alive.[14] It was not until the mid-nineteenth century that "a fragmented clientele of patients belonging to various social classes faced a medical community solidly united by shared professional and scientific interests."[15]

Pomata studied the practice of medicine in Bologna, a city whose university had a long tradition of medical learning. Although Bologna may not be entirely typical of all Western European cities, other Italian cities were likely to have had similar processes. When medical practice was thought of as an art, medical practitioners included folk healers, barber-surgeons, apothecaries, midwives, and physicians. The establishment of a requirement that these assorted healers be trained, examined, licensed, and monitored led to the development of a three-tiered medical hierarchy; folk healers were at the bottom, barber-surgeons in the middle, and physicians at the top. Each had specific duties and restrictions. The primary responsibility of physicians was oversight of the patient's "diet," a word with a much broader meaning at that time than in modern usage: "It implied regulating not only food and drink but life in general—the balance between sleep and activity, rest and exercise, and *retenta et excreta* (what entered and what came out of the body), as well as control of the emotions and passions that affect physical health. Diet was seen therefore as the fundamental remedy, the cornerstone of all therapies . . . [and] only the [physician] was supposed to oversee the treatment of the entire body."[16] As Nancy Siraisi states: "Emphasis on dietary regulation as the key to health is one of the most ancient components in medicine."[17]

The physician also directed the use of lesser remedies, such as drugs or surgery. Only the physician could prescribe oral drugs, which were then dispensed by apothecaries. Barber-surgeons treated the exterior of the body, which was considered less important than the body's interior. A 1557

statute of the barber-surgeon's guild states that "a barber's practice does not merely imply shaving, washing, and cutting hair, but also pulling teeth, and drawing blood." They also performed surgical procedures, set broken bones, treated wounds, and applied leeches.[18]

Efforts to control illegal practitioners continued and intensified in the seventeenth century. In Bologna, criminal proceedings were brought against the following unlicensed popular healers: charlatans, barbers, women, grocers, distillers, herbalists, priests, and friars. The most effective strategy for eliminating unlicensed practitioners was a decree issued in 1614 by the Roman medical authorities that stipulated that all unlicensed practitioners "forfeited their right to a fee." By removing their right to payment, medical authorities effectively and definitively undermined the practices of popular healers.[19]

MIDWIVES

Control of midwives, the primary providers of gynecological and obstetrical services to women, was a critical feature of the establishment of medicine as a scientific profession. In describing a process in which medical authorities were established and women healers excluded from medical guilds and regulated, I do not claim to know whether any group of physicians planned or intended this result; I seek rather to understand how this result occurred.[20] *Effects* can be described, not intentions, which remain perennially opaque to the historian.

The extent of this change from earlier practices can be seen in the fact that in the thirteenth and fourteenth centuries the term *medica* referred to a woman doctor—that is, the term for "doctor" was not exclusively the male *medicus,* as it was in subsequent centuries.[21] And women physicians' practices were limited neither to obstetrics nor to women patients. Siraisi reports that twenty-four women surgeons and fifteen women practitioners have been identified in Naples between 1273 and 1410.[22]

There were also a few women who wrote authoritative medical texts in Latin—for example, the twelfth-century abbess Hildegard of Bingen, author of encyclopedic treatises on women's physiology and medical treatments. However, as early as the twelfth century, women physicians and healers were excluded from advanced education in university medical faculties and thus from the more prestigious and lucrative kinds of medical practice.[23] By the end of the sixteenth century, women healers were prohibited from a range

of activities reserved for members of the medical guild. There were no guilds of women physicians and no midwifery guilds.[24]

Nevertheless, women healers were still needed for monitoring reproductive functions and for treatment of female diseases. For even if a physician was called to attend a childbirth, he did not "see his patient, examine her in any direct way, or apply any remedies or therapies himself. . . . The physician would wait in an adjacent room, giving instructions to the midwife or her assistants, or possibly to the pregnant woman's husband, on what to do next. It was normal in a lifetime of practice for a physician never to see or examine the genital organs of a female patient."[25] Barbara Duden writes: "Touching was culturally permitted along the boundaries of gender: women examined other women; the midwife examined and reported to [the physician] what she felt, [and] he acted on the basis of what the patient said and what he could find out in further conversation."[26]

Physicians and the women they cared for often did not even meet face to face; rather, recommendations for treatment and reports of progress—or its lack—were carried by intermediaries. Records of the seventeenth-century German physician Johann Storch, studied by Duden, reveal that he never met some of the patients he cared for, even if he cared for them over a period of years. One can only imagine the frustration of an experienced midwife who was obliged to follow the orders of a doctor so distanced from his patient.

There was one exception to the rule that a male physician could not examine or touch his female patient: wet nurses had to submit to examination by a physician. "Their breasts and milk were no longer their own," but were supervised by state and medical authorities.[27] The medical appropriation of authority over the nursing breast was a pivotal moment in the secularization of the breast.

Although they were excluded from the medical hierarchy, it was impossible to prohibit midwives from practicing, since physicians were dependent on midwives for hands-on treatment of women's diseases and reproductive processes. In response to this uncomfortable dependence, physicians disparaged midwives as healers in their own right, instead describing them as dependent on physicians. Girolamo Mercurio, for example, writes in his midwifery manual *La commare:* "My goal was to be useful, seeing how often the birth process was made more dangerous for mother and child because of the scant knowledge of midwives and other assistants—since it is extremely rare that a physician is called on these matters. I was determined to give light to instructions for the midwife so she would

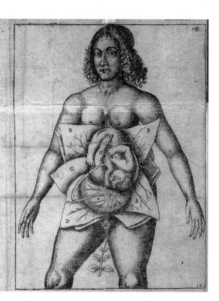

The Figure Explained:

Being a Diſſection of the WOMB, with the uſual manner how the CHILD lies therein near the time of its Birth.

B B. The inner parts of the *Chorion* extended and branched out.

C. The *Amnios* extended.

D D. The Membrane of the Womb extended and branched.

E. The Fleſhy ſubſtance call'd the *Cake* or *Placenta*, which nouriſhes the Infant, it is full of Veſſels.

F. The Veſſels appointed for the Navel ſtring.

G. The Navel ſtring carrying nouriſhment from the *Placenta* to the Navel.

H H H. The manner how the Infant lieth in the Womb near the time of its Birth.

I. The Navel ſtring how it enters into the Navel.

Figure 23. Anatomical drawing of a woman and her unborn child, from Jane Sharp, *The Midwives Book, or, The Whole Art of Midwifry Discovered* (London, 1671). British Library, London (photo © British Library/HIP/Art Resource, NY).

be better able to do her job."[28] Certainly, midwives had varying degrees of competence, ranging across the continuum from ignorance to years of attentive experience. A 1671 manual for midwives written by an English midwife, which explains the physiology of reproduction, demonstrates how knowledgeable some midwives were (figure 23). In physicians' manuals, however, all midwives were described as grossly incompetent.

The myth that all midwives were ignorant and dangerous served the medical profession well. The French philosopher Laurent Joubert (Lorenzo Gioberti in Italian translation) wrote in his *Erreurs populaires:* "[T]hey know nothing about the art of curing their patients, [and] they run to the doctor asking his advice and then misapply it, causing great danger to the mother and her unborn child."[29] When problems arose with a birth, he charged, midwives waited too long to call the doctor and then blamed him for being unable to save the mother and/or the child. Midwives' quaint home remedies, he argued, were no substitute for professional expertise.[30]

Midwives were brought under the supervision of the Roman Protomedicato (medical governing board) in 1686. They were required to pass an examination and "to take an oath never to draw blood or to administer oral remedies."[31] Forceps, invented in 1720, "enabled medical men to extend the domain of medicine into what had previously been seen as a

natural territory presided over by women."[32] "Hands of iron" (forceps) replaced "hands of flesh."[33] The use of forceps brought the risk of "tearing delicate membranes, or injuring the child," but they could also "result in the live birth of otherwise undeliverable children."[34] Barber-surgeons claimed that obstetrics should be considered a surgical practice and attempted (successfully in some areas, unsuccessfully in others) to take away from midwives the prerogative of assisting childbirth.[35] Moreover, in the second half of the seventeenth century, the authority to establish a woman's virginity—"a quality very important to her social status—was taken away from the midwives and given to the surgeons."[36]

The discrediting of midwives and the limits placed on their practice were not the only reason women were increasingly assisted by members of the medical hierarchy during birth; it was also the result of cultural fashion or peer pressure. When Louis XIV employed a surgeon to oversee his mistress's labor, "the all-male medical profession used this change in tastes to discredit the midwives, dismissing their methods as non-scientific and proclaiming their ignorance of 'anatomie uterine.'"[37] In 1680, Protestants were forbidden to be midwives in France as the state tightened its control over the body of the mother.[38]

RELIGION AND MEDICINE

Medical men faced an almost overwhelming challenge in their effort to overturn an agreement that had been in place for a thousand years, namely, that the doctor-patient relationship was controlled by the patient. We have seen that one critically important strategy for creating a medical profession was to prohibit and/or control unlicensed healers. Medical authority was also gathered by appropriating the church's traditional role as healer of body and soul. In Western Europe, the early modern centuries were especially fraught with suffering, increasing people's need for healing.

At all times, suffering people want their religion to heal them; beliefs and doctrines are less important than relief of pain. By appropriating the church's function, namely, healing people for whom cures were mysterious and, moreover, only remotely possible, the medical profession appropriated a measure of religion's social authority. For example, we have seen that a physician's chief responsibility was prescribing "diets," which included controlling all aspects of a patient's life and behavior, an authority traditionally exercised by the church. In the seventeenth century, physicians issued certificates that

exempted patients from the mandatory fasts of the liturgical year. "One might argue," Pomata writes cautiously, "that [physicians'] increased role in the control of diet was one of the ways in which early modern physicians strengthened and legitimized their social authority."[39]

The new medical profession also appropriated vocabulary, metaphors, and images traditionally used by the church. In an effort to diagnose patients and prescribe for them in a way that their patients could understand, medical practitioners used language already made familiar by the church. Christianity was the source of the language of cleansing, purging, and healing that pictured physical and spiritual health as intimately intertwined. In fact, writes Duden, "the language of humors was the language of the soul," adapted to describe physiology.[40] Augustine urged spiritual cleansing in the same terms used later by physicians advocating the balancing of physical humors: "You must be emptied of that of which you are full, in order to be filled with that of which you are empty."[41]

Physical healing was considered at least partly a spiritual matter, so conflicts regularly arose over whether a priest or a physician should be called to confront an illness. Moreover, it was not unusual for clergymen to practice medicine, prompting attacks from physicians, who argued that the spheres of religion and medicine were separate and did not involve the same knowledge and skills. Indeed, in the early stages of his ecclesiastical career, Petrus Hispanus, who was elected Pope John XXI in 1276, "publicly taught, wrote on, and practiced medicine."[42] But the first distinctions between religion and medical practice came from the side of religion. As early as the twelfth and thirteenth centuries, church councils forbade clergy to practice surgery and prohibited cloistered clergy from practicing medicine unless they also had a medical degree.[43] The chief concern of church councils was not medical knowledge or practice as such, nor were they concerned about untrained practitioners harming patients; rather, they were against "avarice and absenteeism on the part of professed religious."[44] Exorcism was a special case, however; clergy were expected to exorcize victims of illnesses thought to be caused by demon possession until the Catholic Church discouraged its use in the late sixteenth century. Yet confusion of medical and religious spheres of authority continued. Hospitals, originally monasteries that attended to pilgrims' medical needs, were still the site of healing miracles in the sixteenth and seventeenth centuries. They were experienced as sacred places, "revealing the twofold character of therapeutic expectations—medical and religious, natural and supernatural, earthly and heavenly—deeply rooted in this culture."[45]

In short, medical and ecclesiastical establishments shared and competed for social authority for several centuries. In circumstances in which no known medicine could "alter the course of acute, life-threatening, or serious chronic illness," people routinely appealed to both religion and medicine for cures.[46] Typically, medical treatises opened with expressions of piety and devotion, but then proceeded to discuss physical matters without further allusion to religion.

In the seventeenth century, debates between medical men and clergy focused on the relationship of body to soul. William Harvey, discoverer of the circulation of blood, believed that the soul flowed into and enlivened the blood, but it was soon recognized that this theory either made the soul dependent on matter, or assumed that it was itself matter.[47] It is striking that clergymen largely ignored or rationalized the materialist basis of medicine, even though an otherwise comprehensive anti-atheistic literature existed.[48] Medical men's "formal and perfunctory obeisance to religion" may have prevented theological attacks, but unaddressed problems remained: "the materialist basis of medical treatment could always be interpreted as being in conflict with the religious belief that illness was God's punishment, and that healing lay in the hands of God." But "the church developed the position of compromise that the means of cure . . . although material, were God-given and efficacious only through the particular exercise of God's power."[49]

SOCIAL ARRANGEMENTS

Early modern women in Catholic societies were obliged to choose—or have chosen for them—"either a man or a wall," either marriage or the convent.[50] Physical risks accompanied either choice. Marriage often brought the risks of childbearing and domestic violence. Becoming a nun removed a woman from those risks but substituted another: breast cancer was called "nuns' disease" because of nuns' particular susceptibility to it. But for a girl to simply remain in the home of her family of origin was equally unsafe. Giovanni Boccadiferro, a Bolognese notary, remarked: "[G]irls should not stay in their paternal houses, risking to lose their honor not only with foreigners, but also with valets of the house, and (which is worse) even with their brothers and perhaps even with their own fathers."[51] Wars and plague created a dangerous world for both women and men, but women had fewer choices and more constricted roles than men.

Any of the choices a young woman faced required that she remain in one home or another. Sixteenth-century nuns were strictly cloistered for the first time. Although strict enclosure for nuns was introduced by Pope Boniface VIII in 1298, *clausura* was not generally applied until it was decreed by the Council of Trent in 1563. The rationale for this ruling was provided a hundred years earlier by the monk Denis the Carthusian (d. 1471), who wrote: "Women are especially and naturally very unstable, fragile, soft and weak on their rational side; so it is really very dangerous that nuns circulate among lay people, particularly among men, that they appear in public and in conversations, that they are seen by men, that they speak and listen to them."[52]

This view of women justified the restriction of personal liberty "as a means of 'protection.'"[53] But it was not only women's "natural" instability that prompted the decision to enforce *clausura*. Although clergy differed at the Council of Trent about whether nuns should be enclosed, they finally agreed that *because most nuns did not choose a religious life freely*, they frequently flaunted the rules, causing scandals. The Council's minutes record the delegates' recognition that "the large majority of nuns enter religion because they are compelled to by threats or reverential fear of parents or relatives."[54] Girls were frequently placed in nunneries so that they would forfeit their inheritance, thus increasing that of their brothers and sisters.[55]

Following the Council's *clausura* decree, it was not until late in the seventeenth century that St. Vincent de Paul was successful in founding an order, the Daughters of Charity, in which nuns were permitted to work outside the cloister. *Clausura* was enforced for most nuns until 1789; in Italy, it remained in effect until the twentieth century. What did nuns themselves think about *clausura*? Evidence reveals that it was deeply unpopular. They were, however, powerless to resist it.

French nuns at Port-Royale provide a cautionary tale about the treatment of nuns who sought to design their own vocation. In 1629, the abbess decided to make the position she held, appointed by the French king, an elective one. Moreover, seeking the reform of church and society, the Port-Royale nuns embraced the strict theology of Jansenism (which would be condemned by the pope in 1653) and were thus drawn into theological controversy. Persecuted repeatedly by church authorities, the nuns were finally expelled from the abbey in 1709. In 1710, on order from the king, the buildings at Port-Royale "were destroyed and the nuns' graves desecrated."[56]

Amidst the dramatic social change described throughout these chapters, it is not surprising that social arrangements were also changing. The infant's experience of delight and frustration at the breast was evident

in men's efforts to maximize their satisfaction and minimize their frustration, and control of women's roles and functions in domestic and institutional arrangements was seen as key to realizing this goal. Indeed, in anxious times these efforts increased. In the following section, I examine the social arrangements by which misogyny was "normalized," that is, converted into an invisible ideology that pervaded everyday experience in early modern Western Europe. Women who did not enter a convent were controlled by marriage, childbirth, and wet-nursing practices.

SEX AND MARRIAGE

By the early fourteenth century, the Western European population had reached 65 million people and food scarcity became an imminent threat. A terrible mid-century plague acted as a form of population control, but by the sixteenth century the population had largely recovered and there was renewed danger of overpopulation. A policy of delayed marriage was crucial for managing population growth, but delayed marriage created, as well as solved, problems. Because marriage without financial security was impossible, rivalry for wives arose between young men and older, better established, men. Many young men, deprived of legitimate sexual activity, acted out their frustration. Raucous *charivaris* protested marriages between young women and older men, and an estimated twenty gang rapes occurred each year in medium-sized cities.[57] Women slaves also functioned as sexual outlets for "the satisfaction of the master's sexual needs, those of his sons who married late, or of family friends."[58]

Beginning in the fourteenth century, municipal authorities endeavored to preclude disruptive and unruly activities by creating municipal brothels.[59] Brothels were provided only for bachelors; priests and married men were not permitted to use them.[60] Municipal brothels were restricted to certain parts of the city, and prostitutes were supervised closely for disease. Historian Leah Otis has suggested that, far from signifying moral decline, the creation of institutionalized prostitution indicated "increasing concern with sexual morality" and efforts to protect "honest women" from rape and sexually motivated disturbances. Even though brothels were thought to play an important role in maintaining order, prostitutes themselves were resented. In societies in which women's reproductive role exhaustively defined their significance, it was believed that prostitutes could not conceive because they were clogged with filth. Prostitutes were pictured as drains or sewers enabling

"the social body to excrete the excess of seminal fluid that causes her stench and rots her."[61]

Toward the end of the fifteenth century, attitudes toward concubinage, adultery, and fornication changed. The change had been slow in coming, however. Church authorities had attempted to legislate sexual behavior since the twelfth century, objecting to the double standard encouraged by both German and Roman law—lax for men, strict for women. The Fourth Lateran Council's 1215 legislation against behavior that threatened marriage was repeated by local fifteenth-century councils. Divorce was rejected, and male adultery was denounced; concubinage, a practice the church had formerly accepted—even if reluctantly, and only if the partners were not married to others—was declared cause for excommunication. By the end of the fifteenth century, legislation by which legitimate sex was limited to marriage drew support from secular as well as ecclesiastical apologists.[62]

An institution that can control sexual behavior has a very intimate grip on the lives of its members. In the sixteenth century, both Protestant and Roman Catholic reformations targeted sexual practices for reform. Reformation of doctrine was also, of course, central to the reformers' agenda, but reform of doctrine and reform of morals were understood to be related and interdependent. The preservation and support of marriage and the family was a priority of sixteenth-century societies.

George Huppert summarizes a typical scenario for early modern marriage. It was, he writes, "a partnership established . . . to battle against hunger and solitude": "It will be broken up by the death of one of the partners within ten years or so. Just time enough to have a baby in the first year and several others, at two-year intervals—four or five children in all. One or two of these will die of a contagious disease, aided by chronic malnutrition and unsanitary surroundings. When the mother herself dies, often in her early thirties, and usually from complications following childbirth, the widower is left with two or three orphaned children in his care. Almost instantly he finds a new wife."[63]

Due to the risks accompanying pregnancy and childbirth, many sixteenth-century men outlived three wives; women rarely outlived men. "Until late in the nineteenth century, most women did not live to see their forty-fifth birthday."[64] A large number of women did not survive their first childbed. However, if complications during delivery required saving the life of either mother or child, "the life of the mother was almost always chosen over that of the unborn child."[65] The child would be extracted in pieces after a hole was drilled in the child's cranium, killing it. Prayers were the only preparation for women facing the risks and dangers of childbirth.

Early modern medical practitioners' interest in women's bodies lay almost entirely in their reproductive capacities, that is, in young women. Western gynecological tradition followed the teachings of the first-century physician Soranus of Ephesus, until Arabic medical knowledge and Aristotle's *De animalibus* were translated in the later thirteenth century.[66] These authors, together with Galen, were the basis for encyclopedias that disseminated information about conception and birth to a wider public than physicians.

It was believed that conception occurred only when both partners achieved orgasm because it was considered necessary for both man and woman to ejaculate seed. According to this theory, women's sexual pleasure was very important to the function that was considered the reason for their creation—reproduction. Nevertheless, there is little evidence that breasts were understood to play an important role in a woman's pleasure. Only Avicenna mentioned caressing a woman's breasts as erotic foreplay.[67] And the clitoris was not included in medieval anatomies; Gabriel Fallope claimed to have discovered it in 1559, though it seems highly likely that women had discovered it many centuries before![68]

The most widely published sex manual of the seventeenth and eighteenth centuries, *Aristotle's Masterpiece,* appeared in several languages and was repeatedly reissued. It continued to emphasize that conception occurred only when the woman experienced an orgasm. It also insisted that female sexual pleasure required clitoral stimulation. However, in the eighteenth century, several widely publicized cases in which unconscious women were impregnated revealed that a woman's orgasm was irrelevant to conception. When it was recognized that conception could occur even when a woman was completely passive, the importance of women's sexual pleasure disappeared in medical accounts of conception.

Other aspects of female bodies and reproductive processes were equally poorly understood in late medieval and early modern Western Europe. Menstrual blood was thought of as a foul substance that was "blamed for preventing seeds from germinating, for turning grape mash bitter, for killing herbs, for causing trees to shed their fruit, for rusting iron and blackening brass, and for giving dogs rabies."[69] It was believed that the gaze of a menstruating woman could darken a mirror. Yet after menopause women became even more dangerous: "excess humors no longer eliminated by menstruation now exited through the eyes."[70] A postmenopausal woman was thought to be able to poison an infant by gazing at it.

Galen, the primary medical authority in the West until the seventeenth century, was known only through other authors until his *De usu partium* was translated in the fourteenth century. Galen taught that male and female sexual organs were mirror images of each other: male sexual organs turned outward, while female organs turned inward. Galen wrote:

> Consider first whichever ones you please . . . think of the man's turned in and extending inward between the rectum and the bladder. If this should happen, the scrotum would necessarily take the place of the uteri *[sic]*, with the testes lying outside, next to it on either side; the penis of the male would become the neck of the cavity that had been formed; and the skin at the end of the penis, now called the prepuce, would become the female pudendum itself. . . . In fact, you could not find a single male part left over that had not simply changed its position; for the parts that are inside in the woman are outside in the man.[71]

The oddity of Galen's understanding of female bodies is a reminder that sex, no less than gender, is "made" by cultural construction. Thomas Laqueur writes: "No particular understanding of sexual difference historically follows from undisputed facts about bodies."[72] By the eighteenth century, however, "the female body came to be understood no longer as a lesser version of the male's (a one-sex model), but as its incommensurable opposite (two-sex model)."[73]

Anatomical representations of female bodies focused on their reproductive organs, endeavoring to explain the mysteries of pregnancy and the formation of the embryo (figure 24). Confirmation of pregnancy was usually the prerogative of the woman herself, attested by "quickening," the woman's first experience of the fetus's movement.[74] Midwives could establish the fact of pregnancy only when it was evident in a swollen uterus or by examination of the mouth of the cervix. A midwife's "second opinion" became important only in cases of women condemned to execution; pregnancy would postpone execution until after the birth of an infant so that "innocent life would not be destroyed along with the guilty."[75]

Women outside the convent had few ways to avoid the dangers of pregnancy and birth. Methods of birth control, episiotomies, drugs to increase contractions, and (until the eighteenth century) forceps were unknown. Abortion and infanticide were forbidden by both ecclesiastical and secular courts on pain of death.[76] The charge of infanticide was valid in the secular courts only when quickening had occurred,[77] but the church decreed that the embryo was a living being after it had been in the womb for forty days.[78]

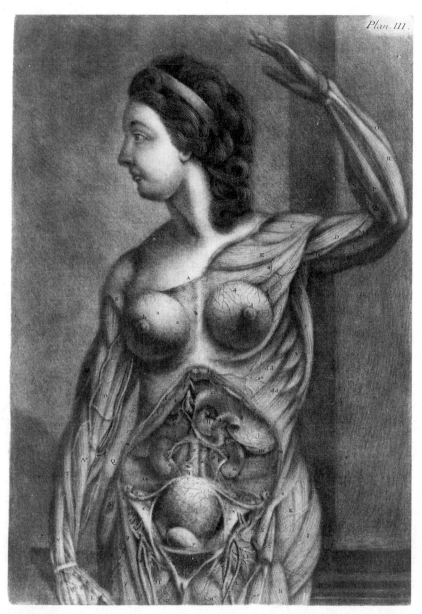

Figure 24. Jacques Gautier-d'Agoty, anatomical drawing of a woman, from *Anatomie des parties de la génération de l'homme et de la femme* (Paris, 1773) (photo: Snark/Art Resource, NY).

Early modern concern with protection of the family, continuity of the family possessions, and the welfare of children seemed to fathers and husbands to require that women, who were responsible for the home and for the children's training, should be closely supervised. Numerous male lay

and clerical authors agreed that "female fidelity was the only way to ensure the legitimacy of progeny and that a husband's control over his wife's body was the only means of ensuring his paternity. . . . [But] the obligation of fidelity was considered binding only for the wife."[79] Male anxiety was generated not only by the possibility of adultery; evidence suggests that men were also obsessed with "the possibility that women might give birth without [male] participation."[80] Laqueur comments: "Until the mid-nineteenth century when it was discovered that the union of two different germ cells, egg and sperm, constituted conception, it was perfectly possible to hold that the father mattered very little at all." Therefore, immense effort was spent in proving not only a male role in conception, but that, in fact, "the male contribution is the more powerful one."[81]

NURSING

By the mid-fifteenth century, the practice of sending an infant to a wet nurse *(balia)* or hiring a live-in wet nurse was the dominant practice in Florence and other Italian cities. A live-in wet nurse was a luxury requiring a higher salary, so most infants were sent to a nurse in the countryside at some distance from the family home. Despite its popularity, the practice was surrounded by controversy. Preachers chided women for not nursing their own infants, urging husbands to insist that they do so. Citing mothers' "selfishness," preachers and manuals said that a mother's failure to nurse was caused by her desire for more free time to pursue pleasurable activities. They considered "mercenary milk" dangerous.[82] But although mothers were blamed for the decision not to nurse, fathers officially made that decision, as numerous contracts for wet-nursing show.

Interestingly, given the many fears surrounding menstruation, breast milk was thought to be blanched menstrual blood. Laurent Joubert, one of the great medical popularizers of the sixteenth century, asked rhetorically: "And is it not the same blood, which, having been in the womb is now in the breasts, whitened by the vital spirit through its natural warmth?"[83] An anatomical drawing published in 1492 by Leonardo da Vinci shows veins leading from the upper uterus to convey menstrual blood to the breast.[84]

But the blood/milk by which the child was fed was not the most important blood in the child's veins. In societies organized by lineage, children belonged to the father and his kinship group, and it was *his* blood, believed to be transmitted at conception, that determined the child's status.

His blood was considered superior to the milk with which the mother or the nurse nourished the child.[85] The father, responsible both materially and spiritually "for assuring the development of his seed,"[86] thus determined whether a wet nurse was employed, "supervised all aspects of the progress of the breast-feeding, and determined when it should end."[87] Although it is possible that the mother had an informal role in such decisions, contracts for breast-feeding services were made by the infant's father and the wet nurse's husband, the *balio.*

What characterized a good wet nurse? The nurse was frequently the mother of a child who had died, but often the nurse's own infant was sent to another wet nurse so that its mother's milk could earn a high salary from a wealthy family. Contracts specified that the *balia* was to nurse only one child at a time. The "abundance" and "youth" of her milk were critical factors. One fifteenth-century mother recorded her preference that her child's nurse "has the use of both eyes, and that her milk should have started within the last two months or less."[88] If the nurse became pregnant or ill, or if the child failed to flourish, the contract was broken and the father found another nurse. On average, infants remained with the same nurse only ten months.

Infant Louis XIV and His Wet Nurse, M. de la Giraudière (before 1677, plate 10), by Henri Beaubrun the Younger and Charles Beaubrun, shows the ideal nursing breast—high, round, and apparently bursting with milk. Perhaps in imitation of paintings of the Virgin with one bare breast, the wet nurse's covered breast has little definition and her clothing is undisturbed. But unlike paintings of the nursing Christ child, here the child king stares to the side, out of the picture frame, meeting no one's gaze.

Usually wet nursing was successful; most children who were given to a nurse were returned to their parents weaned.[89] But 17.9 percent of infants sent to a wet nurse died, eighty-five percent of them due to sickness and fifteen percent by suffocation, usually as they slept in their nurse's bed.[90] The practice of wet nursing continued to be fraught with contradiction and controversy throughout the early modern period. One of the effects of the practice was to encourage the separation of childbearing from childrearing, thus limiting mothers to a reproductive role: "A woman carried her husband's child and gave it life ... [but] the child belonged to its father and to the paternal lineage."[91]

In the early modern centuries in Western Europe, ownership of a married woman's breast passed back and forth between her infant children and her husband. In seventeenth-century France, the duty of sexual intercourse was considered a higher priority than that of childcare. Wives were urged

to send their infants to a wet nurse so they could resume sexual relations with their husbands sooner; it was believed that mothers could not both breastfeed and have intercourse with their husbands because "sperm entered the breasts through the bloodstream and polluted the milk."[92] With the breast thus associated with men's sexual pleasure, and with this function taking precedence over the nourishment of an infant, another step was taken away from the religious meaning of the breast, toward erotic meaning. Either way, however, the bearer of the breast was not its owner.

The objectification of the breast in early modern Western Europe began with medical authorities' supervision of wet-nurses, when the nursing breast became a commodity. Within several centuries, states and physicians' guilds supervised and controlled the entire female body. In France, the regulation of midwives enabled the state to "take control of an area that had previously been outside its jurisdiction": "for the first time it had direct control over the body of the mother."[93]

ANATOMIES

Both Renaissance painting and early modern medical practice benefited from the bodies of executed criminals. Painters learned to paint naturalistic human bodies and physicians learned the functions of organs, muscles, and bones by dissecting criminals' cadavers. Considered part of the criminal's punishment, dissection after execution was specified when a condemned person was sentenced. Anatomical drawings often show a dissected corpse with the rope by which he had been hanged still around his neck. Nevertheless, an adequate supply of victims was always a problem. Vesalius, the "father of anatomy," admitted to resorting to grave robbing and stealing bodies from gallows to obtain cadavers.[94]

Leonardo da Vinci combined an anatomist's interest in bodies with that of a painter. His *Notebooks* describe his fascination with anatomy and the skills involved in anatomical drawing:

> To obtain a true and perfect knowledge of [veins] I have dissected more than ten human bodies, destroying all the other members, and removing the very minutest particles of the flesh by which these veins are surrounded, without causing them to bleed . . . until I came to an end and had a complete knowledge; this I repeated twice, to learn the differences. And if you have a love for such things you might be prevented by loathing, and if that did not prevent you, you might be deterred by the fear of living in the night

hours in the company of those corpses, quartered and flayed and horrible to see. And if this did not prevent you, perhaps you might not be able to draw so well as is necessary for such demonstration; or, if you had the skill in drawing, it might not be combined with knowledge of perspective. . . . patience may also be wanting, so that you lack perseverance.[95]

Dissection of human bodies was practiced as early as the thirteenth century at the University of Bologna. By the fifteenth century, dissections, staged as public events in special theaters, were open both to physicians and to "curious non-specialists."[96] In the sixteenth century, the printing press allowed anatomical information to be circulated so that it could be tested and refined by repeated dissections. Vesalius's anatomy revived Galen's teachings, but once it was printed and circulated among medical faculties and students, the Galenic corpus was "subjected to critical scrutiny [that revealed] discrepancies between data and description."[97] Medical students were no longer presented with a single authoritative corpus of texts that they were expected to learn and then to transmit in turn to future generations. Instead, they were confronted by alternative views that forced a reassessment of the evidence and encouraged further checking of data against description, leading to the overhaul of inherited ideas.[98]

In Vesalius's anatomy, women's sexual organs are depicted as male organs turned to the inside (as Galen had taught). In short, "the vagina is imagined as an interior penis, the labia as foreskin, the uterus as scrotum, and the ovaries as testicles."[99] As in classical antiquity, there was only one "canonical" body, and that body was male.[100] Although women had been dissected since the fourteenth century, the first drawings of distinctive female skeletons would not appear until the mid-seventeenth century.[101] In part, this may be explained by the shortage of female cadavers: since most executed criminals were male, female cadavers were difficult to obtain.[102] (However, the title page of Vesalius's *De humani corporis fabrica* shows a surgical theater crowded with men, dogs, and a monkey, all observing the dissection of a woman [figure 25].[103]) In Britain, the Anatomy Act of 1836 would make the bodies of paupers available for dissection, but before that, the only likely prospects for female dissections were the cadavers of common prostitutes and executed women. The torture and execution of accused witches, at its peak in Western Europe in early modern societies, apparently did not produce medical knowledge. Although some alleged witches were hanged, the most frequent method of execution was burning, leaving no body for dissection.

Anatomical illustrations helped to create a new perspective on human bodies. No longer dependent on patients' reports, physicians claimed to

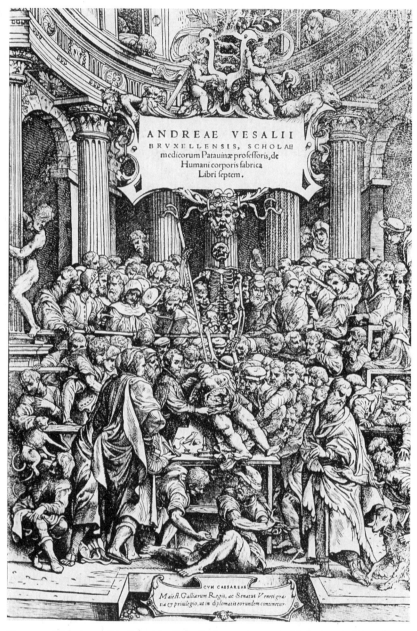

Figure 25. Title page of Andreas Vesalius's *De humani corporis fabrica* (1543). Bibliothèque nationale de France, Paris (photo: Image Select/Art Resource, NY).

understand the nature of a patient's pain better than the patient herself. The human body, source of experience, knowledge, and feeling, was objectified— cut, measured, and drawn. The breast also participated in this development, as the following account reveals.

The minutes of the Royal Society of London, established in the sixteenth century for the communication of medical knowledge, record the case of a young woman with monstrous breasts. The report, brought by Dr. William Dursten, was accompanied by precise and detailed measurements of these breasts: "I mean, from the further end of the one to the other . . . you'l [sic] find *three feet two inches and a half* . . . and another measure showing the Circumference of the breasts long-wise, *viz. four foot.*" Roy Porter comments: "Such reports clearly did not contribute, in any tangible way, to medical 'progress,' or even to changing the face of medicine."[104] Why, then, this interest? I speculate that at least part of the fascination was based on exploring a new way of relating to bodies as quantifiable objects for observance and study.

THE DISEASED BREAST

Breasts, source of nourishment and delight and bearer of multiple meanings were (and are), for women, a source of anxiety due to their susceptibility to disease. One seventeenth-century woman, Anne of Austria, mother of Louis XIV of France, described in her journal her experience with breast cancer.[105] Although her treatment may not be entirely typical of that of most women in her time, Anne's story illuminates the experience of a woman of her social niche. Acclaimed for her beauty, Anne lived at a time when the breast was highly eroticized. Court fashion decreed that women's dresses have tight bodices with plunging necklines, supported by corsets that pushed the breasts high and close together, "revealing every square inch of flesh above the areola."[106] In 1663, Anne found a lump in her breast. She ignored it for several months, before finally consulting physicians at the University of Paris.

A deeply religious Catholic who spent considerable time visiting her religious friends at the convent of Val-de-Grâce, Anne had seen the end stages of breast cancer at first hand and had a particular horror of the disease. On one occasion, while visiting the convent infirmary, Anne saw a dying nun whose cancer had "destroyed one side of [her] torso, allowing a peek into her chest cavity."[107] The diseased tissues emitted a terrible odor.

Anne's doctors believed that cancer was caused by an imbalance of humors—specifically, a surplus of black bile—and they recommended daily enemas, bleedings, and frequent purges.[108] These remedies were applied, but Anne's condition worsened. Her surgeon then attempted to remove the tumor, cutting out chunks of her breast over a period of more than five months. Anne considered her sufferings as penance for the pleasure she had formerly taken in showing off her breasts in low-necked gowns. "God wishes to punish me," she said, "for having loved myself too well and for having cared too much about the beauty of my body."[109] She died on January 20, 1666, believing that her suffering guaranteed her salvation. Her interpretation of her horrifying pain—that it had a significant spiritual purpose and reward—was a common belief in a time when there was little capability to alleviate suffering.[110]

Why was breast cancer called "nuns' disease"? Why were nuns at a heightened risk of premenopausal breast cancer? As we now know, childless women face a greater risk of breast cancer than women who have given birth and nursed their infants.[111] Nursing interrupts estrogen production, "saving the breast from the monthly tissue changes undergone during menstruation." A typical premodern married woman with six or seven infants spent ten to fifteen years nursing infants.[112] Nuns, who may have entered religious life at least in part to escape the fate of many childbearing women, escaped that danger only to increase their risk of breast cancer. Throughout the early modern period, there was speculation on the causes of "nuns' disease." In the eighteenth century, this speculation increased as Galen's theory of the humors fell into disrepute and other explanations for cancerous growths were proposed. In 1713, Bernardino Ramazzini attributed breast cancer in nuns to lack of sexual activity. Ironically, breast cancer in sexually active women was generally believed to be the result of too-vigorous sexual activity.

The professionalization of medicine created a new social authority in early modern Western Europe. This chapter has discussed three changes that contributed to the establishment of medical authority: the traditional relationship of healer and patient was reversed; the church's language of salvation and healing was appropriated; and women healers were excluded from the medical guild. Everyone must have been affected by these changes, but women were affected profoundly. Unwilling to be examined by a male physician, women frequently lacked effective medical advice. But the emergence of the anatomical breast is only a part of the picture of the breast's secularization. In the following chapter, I discuss the technological and social factors that led to the emergence of the pornographic breast.

The Pornographic Breast

Beautiful indeed are breasts that protrude but little
and are moderately full . . . restrained, but not
compressed, gently bound so that they are not
free to jounce about.

HUGH OF FOUILLOY
in a sermon on the "Song of Songs"

THE HEIGHT OF WITCH PERSECUTION, between 1550 and 1650, coincided
with the period during which the breast was eroticized by the circulation
of printed illustrated narrative pornography. The German artist Hans
Baldung's *Three Witches* (1514, figure 26) shows what witches were thought
to look like: a young witch displays the high, round breast of fashionable
taste, while an old witch, by contrast, has slack breasts. The message, in
brief, is that any woman could be a witch. According to the Christian the-
ology of the time, witches had made a pact with the devil in return for
specific powers, among them the ability to make men impotent.

In the ninth century, Pope Boniface VI had declared that belief in
witches was unchristian. Tenth- and eleventh-century bishops also
repeatedly inveighed against belief in witchcraft. But the later Middle
Ages saw a reversal in the attitudes of clergy and theologians. Pope Inno-
cent VIII's bull *Summis desiderantes,* of 1484, a "milestone in the legiti-
mation of witchcraft theory and witch persecution," together with the
publication of the *Malleus Maleficarum* of 1486, written by the Domini-
can inquisitors Heinrich Kramer and James Sprenger, created the theo-
logical world view that rationalized the execution of alleged witches,
some as young as eight years old.[1]

Figure 26. Hans Baldung (1484–1545), *Three Witches*, 1514. Albertina, Vienna (photo: Erich Lessing/Art Resource, NY).

The *Malleus Maleficarum* was one of the first books to be printed on the recently invented printing press. Written in Latin, the common language of educated Europeans, it appeared in fourteen editions before 1520 and at least sixteen between 1574 and 1669.[2] By the beginning of the seventeenth century, it was widely believed that only one with an unsound mind could *disbelieve* in witches. In fact, no evidence of witch cults or practices has been found in the late medieval and early modern centuries, when witch persecution was most virulent. How did a phenomenon that had no reality become so self-evident as to be virtually unquestioned among the educated and uneducated alike? To begin to address this question, we must first explore a new technology that expedited vastly increased communication in early modern Western Europe—printing.

PRINTING

Originally imported from Asia, paper began to be produced in Spain in the twelfth century and in Italy in the thirteenth century. By the first decade of the fifteenth century, there were paper mills in most Western European countries, producing large quantities of relatively cheap material.[3] The invention of the printing press at the end of the fifteenth century is attributed to Johannes Gutenberg of Mainz. It is impossible to exaggerate the rapidity of the spread of printing. By the beginning of the sixteenth century, there were forty-five printers in France, sixty-four in Germany, and nearly eighty in Italy. The accessibility of printed material contributed to increased literacy, which in turn produced a broader audience for printed works. Within a generation, printing was established in Western Europe.

The first products of the printing press, now extant only in scraps, were a German poem, an astrological calendar, and a printed papal indulgence (with a blank space for the recipient's name). There were no copyrights at the time; publishers printed whatever they thought would sell, at best reimbursing the author with an agreed-upon number of his books. Most often, popular works were printed and reprinted across Europe without the author's knowledge or approval.[4]

Printing made it impossible for ecclesiastical authorities to control the circulation of ideas and thus was critical to the secularization of Western Europe. Hand-copied heretical (Protestant) and erotic works had been relatively easy to search out and destroy, but this was not the case with works produced on the printing press; there were now simply too many copies for

bishops and inquisitors to track. In short, "the control of opinion by churches whether Protestant or Catholic was . . . frustrated by the printed book."[5]

The effects of the printing press were already pervasive in the sixteenth century. Scholars debate the extent to which the printing press was responsible for the Protestant reformations and for witch persecution, but whether or not printing had the major responsibility for these phenomena, all agree that its effects were substantial. Printing also permitted the codification, refinement, and circulation of medical information, as we have seen. And it changed scholarship by giving scholars access to many more books than had previously been available, so that ideas and information could be compared, criticized, and synthesized. Historian Elizabeth Eisenstein writes: "Printing gave the 'great boost' which led researchers to surpass the ancients and move toward new frontiers for the first time."[6] Scholars were freed from scribal labors to ponder alternative evidence and interpretations.

Printing was also increasingly a democratic tool, offering the possibility of authorship to enterprising artisans and a numerically noticeable diverse group of women, including, Eisenstein notes, "Louise Labé, the ropemaker's daughter, . . . Nicole Estienee, printer's daughter and physician's wife . . . and the midwife Louise Bourgeoise. . . . Bourgeoise wrote on her art, believing herself the first woman to do so. Her wide practice, she claimed, would show up the mistakes of physicians and surgeons, even of Master Galen himself."[7] There were a few secular women of letters—for example, Christine de Pisan, whose *Cité des dames* was published in 1404–5—but most women who wrote were religious, such as Margery Kempe, Julian of Norwich, Catherine of Genoa, Teresa of Avila, and Marguerite Porete. Writing was an established tradition among educated women, allowing them to circulate their ideas to a larger audience despite being tied to the home and largely excluded from the public sphere. It also got some of them in trouble, however: roughly two centuries before the invention of the printing press, Marguerite Porete was executed for the allegedly heretical ideas contained in her sixty-thousand-word *Mirror of Simple Souls*. Writing became even more dangerous following the advent of printing, as circulation increased. Teresa of Avila was investigated (but not prosecuted) several times by the Spanish Inquisition.

The late medieval church was initially tolerant of the vernacular Bibles that were published on early presses. The first German Bible was published in Strasbourg in 1466, approximately twenty years before the birth of Martin Luther (1483–1546), and other translations followed. (By 1520, all the major European languages had multiple Bible translations.) In 1485, however, troubled

by the poor quality of the translations, the archbishop of Mainz required that all vernacular translations be approved and licensed. In 1515, even before Luther's revolt, a more sweeping censorship decree prohibited vernacular Bibles, declaring the Latin Vulgate the only acceptable version. Some forty years later, in 1557, the first papal Index of Forbidden Books censored both Bible printing and Bible reading, an interdict that was repeated in all subsequent lists. In Catholic territories, "the post-Tridentine Church put an end to serious Bible translations . . . for the next 200 years."[8] For both Catholic and Protestant reformers, the place of scripture in devotional life and interpretation of the Bible were pressing issues. Erasmus of Rotterdam, who was sympathetic to the reforming agenda but remained within the Catholic Church, argued that scripture was difficult, puzzling, and opaque to the ordinary reader. Advocates of vernacular Bibles, however, argued that in the Catholic Church knowledge of the Bible was hidden from people by "experts"—canon lawyers and university professors who claimed an exclusive ability to biblical interpretation. Luther claimed that the central message of scripture was clear as day, accessible to anyone who read it; Bible reading was considered the primary devotional practice of Protestant Christians, generating pressure for literacy. In Protestant territories, publication of vernacular Bibles, prayer books, and catechisms was a major initiative.

As early as the mid-sixteenth century, a distinction existed between publishers and printers, between books and cheap illustrated literature.[9] Publishers printed Bibles and religious books (including liturgical books), law books, and textbooks; printers produced pamphlets and broadsheets, often illustrated with woodcuts. Printers reached a much broader population than did publishers. By the 1520s, printers circulated two newly popular genres throughout Western Europe: Protestant reformation pamphlets and pornography.

A tremendous volume of Protestant propaganda poured from the new printing presses and flooded Western Europe in the 1520s and 1530s. Reformation historian Steven Ozment identifies almost ten thousand pamphlet titles that were in print before 1550. Most pamphlets were short (fewer than twenty pages), "many were sermons, and quite a good many were illustrated." But he does not find the printing press responsible for Protestant reformations because, he argues, sixteenth-century culture was still "overwhelmingly oral." About ninety percent of people "relied exclusively on the spoken word, not print, for their knowledge and information."[10] However, without printing presses, Ozment concludes, Protestant reforms would have been very different.

Pamphlets are historians' primary evidence for the arguments heard and read, not by learned theologians, but by the hundreds of thousands of people who became Protestants in the sixteenth century. Pamphleteer Heinrich von Kettenbach, a former Franciscan from Ulm, offered a typical list of "abuses" in traditional church teachings: "papal authority over Scripture; clerical superiority to the laity and freedom from secular taxation and rents; the power of priests to judge the sins of the laity and to subject them to penances; the power of the pope to canonize saints and promulgate church doctrine; popular religious practices requiring the payment of fees, particularly the selling of indulgences and anniversary Masses; and such external acts of piety as burning candles, revering images, and adoring the host (the doctrine of transubstantiation)."[11]

Ozment comments that pamphlet rhetoric often gives the impression that "the ordinary layperson was not the bold, perceptive knight of faith depicted in the pamphlets and woodcuts of the 1520s, but rather one who had to be carefully weaned and cajoled away from the old to the new, inclined in his or her innermost self to cling tenaciously to tradition and custom."[12] Not all readers were disinclined to accept new ideas, however. Carlo Ginzburg has vividly reconstructed the worldview of a sixteenth-century Italian miller, Menocchio, demonstrating how an ordinary reader collected heretical and incendiary ideas from a few printed texts. Menocchio's ideas were not traceable to a single text or to the writings of a heretical group; rather, he combined ideas he had read with oral folk beliefs. He was tried twice for heresy, fifteen years apart, and was executed on this charge in 1600. In his first trial, Menocchio described his worldview:

> In my opinion, all was chaos, that is, earth, air, water, and fire were all mixed together; and out of that bulk a mass was formed—just as cheese is made out of milk—and worms appeared in it, and these were the angels. The most holy majesty decreed that these should be God and the angels, and among that number of angels, there was also God, he too having been created out of that mass at the same time. . . . [God's son was sent to earth and] he let himself be crucified, and he who was crucified was one of the children of God, because we are all God's children, and of the same nature as the one who was crucified and he was a man like the rest of us, but with more dignity just as the pope is a man like us, but of greater rank, because he has power.[13]

Menocchio's unorthodox cosmology might have been ignored except for the fact that his ideas were not purely metaphysical. He attracted the attention of the Inquisition for incendiary statements criticizing the

Catholic Church's authority and legitimacy, for rejecting the sacraments, and for advocating the equality of all religions. He lived in a time when reading was dangerous; even the act of reading or the ownership of books brought a person under suspicion.

Menocchio also exemplifies the consummate seriousness with which early modern readers read. To say that Menocchio did not read with critical judgment is to understate the situation. Rather, for him and for others for whom the effects of reading can be traced, print provided access to privileged knowledge and guaranteed truth. Menocchio identified with the knowledge he got from books; he staked his life on that knowledge, and he died rather than renounce it.

WITCH PERSECUTION

Printing presses provided the means of circulating heretical ideas— pornographic, philosophical, and theological. They also allowed the publication of broadsheets—the first newspapers—which reported the trials and executions of alleged witches. Eisenstein argues that without printing presses, witch persecution on a massive scale would not have occurred; she calls the witch craze "a by-product of Gutenberg's invention."[14] Crude woodcuts showed people what witches looked like, while broadsheets and witch-hunting manuals (like the *Malleus Maleficarum*) described the damage they caused: "[Witches] raise hailstones and hurtful tempests or lightning; cause sterility in men and animals; offer to devils or otherwise kill the children they do not devour. They can see absent things as if they were present; turn the minds of men to inordinate love or hatred; make of no effect the generative desires and even the power of copulation. They cause abortions, kill infants in the mother's womb by a mere exterior touch. They can at times bewitch men and animals by a mere look without touching them, and cause death."[15]

When people were repeatedly told that their problems, from crop failures to impotence, were caused by witches, they were disinclined to explanations that assumed chance or coincidence; they learned to attribute the cause of their ever-present miseries to women familiar to them. Amidst a culture of fear that sought scapegoats, people began to notice witches everywhere. Eisenstein writes: "Given the continental publication date of 1486 for the first edition of the *Malleus,* given the time required for importing and domesticating its contents, given the need for decades of 'pounding in,' it would seem plausible to correlate the new press output with the

remarks of officials such as Bishop Jewel who, in 1559, asserted that during the previous reign 'the number of witches and sorcerers had everywhere become enormous. . . . this kind of people within these last few years are marvelously increased.'"[16] Even if the printing press was not the sole *cause* of witch persecution, it played a large role in convincing people that witch-craft was a reality.

From crude woodcuts to etchings by reputable artists, the iconography of witchcraft taught communities what witches looked like and what they did. Hans Baldung's *Three Witches* depicts women possessed by a ferocious and fearsome energy, contorted in their production of an evil spell. The fleshy young witches suggest sexual frenzy, their smooth bodies a vivid contrast to that of the old witch. Yet *all* women's bodies are defective, says the *Malleus Maleficarum:* "There was a defect in the formation of the first woman, since she was formed from a bent rib. . . . through this defect, she is an imperfect animal, she always deceives."[17] Baldung's witches offer the viewer scatological pleasure combined with fear; any woman could be a witch who practiced the harms cited in the *Malleus Maleficarum.*

Local variations make it difficult to generalize about witch persecution. In Germany, for example, there were 26,000 deaths; in Ireland, there were four. Yet it is clear that women were disproportionately targeted. In some loca-tions, seventy-five to eighty percent of those accused of witchcraft were women, and up to ninety percent of those executed as witches were women. Men accused of witchcraft were predominantly poor peasants and artisans.[18] Social class, age, and gender all played a large role in targeting those who were accused and brought to trial. Steven Katz speculates that witch hunting became a mass hysteria after 1500 *because* it was directed primarily at women, providing a socially approved outlet for men's fear of women.[19] Post-menopausal women, perhaps widowed and living either independently or as dependents of their relatives, were the most frequent targets of accusations, women over fifty comprising a solid majority of those accused of witchcraft.

It is tempting to see witch persecution as a war of men against women, given that men acted as prosecutors, judges, torturers, jailers, and execu-tioners. Robin Briggs counters that suggestion, however:

[T]he stigmatizing, victimizing, and murdering of accused 'witches' is more accurately seen as a collaborative enterprise between men and women at the local level. . . . Misogyny . . . was not reserved to men alone, but could be just as intense among women. [Most accusations] originated in conflicts that normally opposed one woman to another, with men liable to become

involved only at a later stage as ancillaries to the original dispute. . . . Most informal accusations were made by women against other women [and only] leaked slowly across to the men who controlled the political structures of local society.[20]

It should not surprise us that large numbers of women testified against other women in witchcraft trials. Women lived within the same conceptual worldview as men, even though they did not, to any significant degree, design that worldview. A few intrepid individuals—like Ginzburg's Menocchio—constructed alternative worldviews, but to do so was to place oneself in mortal danger. Not many people in any age create a worldview independent of their socialization, social location, and the common beliefs of their community. To do so during times of witch persecution was suicidal.

In fact, women had more incentive than men to accuse others in order to protect themselves. For example, recent research refutes the claim that midwives were especially likely to be accused of witchcraft. "Being a midwife actually decreased a woman's chances of being charged. . . . Midwives were more likely to be found helping witch-hunters than being victimized by them."[21] Nevertheless, the *Malleus Maleficarum* states that "the greatest injuries to the faith as regards the heresy of witches are done by midwives." Citing the "confessions" of condemned witches, it describes midwives who had killed numberless children as they emerged from the womb.[22] Midwives, living with the fear of being accused of witchcraft, like many women, helped witch hunters in order to protect themselves.

One of the few to speak out against witch persecution in the early seventeenth century was a Jesuit priest, Friedrich Spee, who was a confessor to those who were condemned as witches and awaiting execution. Spee wrote, anonymously, the *Cautio criminalis* (1631), which contains a tract on "The Methods of the Witch-Persecutions." He urged a rethinking of witch persecution, emphasizing, rightly or wrongly, that support for witch persecution came largely from the populace. Officials, he wrote, were initially unwilling to act on witch accusations until prompted to do so both by the populace and by princes. If a magistrate confessed ignorance of how to proceed, an inquisitor, who often acted hastily and presumptuously, was sent to the town. As soon as an alleged witch was identified, arrested, and tortured, Spee wrote, nothing she said or did prevented her condemnation. Everything worked against her: "Either [she] has led a bad and improper life, or she has led a good proper one. If a bad one, then, say they, the proof is cogent against her. . . . If, however, she has led a good one, this also is none

the less a proof; for thus, they say, are witches wont to cloak themselves and try to seem especially proper." Repeatedly tortured and questioned, "both she who confesses and she who does not perish alike."[23] It is possible that in Würzburg, where Spee functioned, this was the case. However, Robin Briggs states that about half of all convicted witches were given sentences short of execution, such as excommunication, penances, or imprisonment, and that conviction rates were about the same for both sexes; the other half of those convicted were killed by hanging or burning.[24]

THEOLOGICAL CONSIDERATIONS

Anxiety created by the sixteenth-century crisis of religious authority must be seen as one of the factors that led to Western Europe's mass witch-hunting hysteria. In geographical locations where religious authority was relatively unquestioned, witch persecution was slight. Nachman Ben-Yehuda argues that "only the most rapidly developing countries, where the Catholic Church was weakest, experienced a virulent witch craze (for example, Germany, France, Switzerland). Where the Catholic Church was strong (Spain, Italy, Portugal) hardly any witch craze occurred."[25] Witch hunting lost its fervor after the 1648 Peace of Westphalia calmed religious strife by legitimating religious pluralism.

Although the Catholic Church has frequently been accused of instigating witch hunts, the vast majority of alleged witches were condemned in secular courts. And secular courts, not ecclesiastical courts or the Inquisition, adopted the suggestions of the *Malleus Maleficarum* for interrogating and torturing the accused.[26] In fact, the legal procedures recommended by Kramer were immediately rejected by the Inquisition, and Kramer himself was censured by the church a few years after the *Malleus* was published.[27]

However, theologians played a substantial role in fostering witch beliefs. In his book *Demon Lovers: Witchcraft, Sex, and the Crisis of Belief,* Walter Stephens proposes an explanation for the intensity of witch persecution. He argues that a close reading of witchcraft treatises reveals their authors' *lack* of firm belief in demons. Because of their own doubt, they made strenuous efforts to overcome it—both in themselves and in others. Theologians of no less stature than Thomas Aquinas, Stephens writes, were "intensely worried, for they were striving to resolve contradictions that, for them, threatened the credibility of witchcraft, demonology, and Christianity itself."[28] What was at stake in witchcraft beliefs—and, not incidentally, in the trials and

executions of actual women—was "the credibility of the entire world of spirit."[29] In short, theologians were the real "demon-lovers."

Stephens relates the urgency of theologians' demon beliefs to the Fourth Lateran Council's declaration of the doctrine of transubstantiation in 1215. According to the Aristotelian science of the time, a cause was defined by its *effects*, and the effects of the sacraments could not be demonstrated. Thus, the claim that the Eucharistic elements became Christ's literal body and blood required a firm belief in a spiritual world in which sacramental words have real effects. Stephens suggests that the Council used the term "transubstantiation," "not as a scientific term with a precise definition, but rather as an approximate description of something that necessarily had to remain a mystery."[30] But by the sixteenth century, a changed worldview prompted more literal interpretations, both by Protestants, who rejected Roman Catholic sacramental theology, and by witchcraft theorists, who rejected nuanced interpretations. The existence of demons guaranteed the existence of a spiritual world. Thus, witchcraft theorists hoped to demonstrate that witchcraft energies were of the same kind as sacramental energies but produced opposite effects.[31]

The doctrine of transubstantiation stuck in the craw of ordinary Catholics as well as learned theologians. The frequency with which transubstantiation was emphasized in sermons indicates that many people found it difficult to believe that bread and wine were changed in substance into Christ's body and blood. New devotions aimed at making transubstantiation more comprehensible, such as the colorful Corpus Christi processions, developed. Popular hymns summarized the complexities of the doctrine, emphasizing the importance of faith to bridge the gap between what could be seen and what must be believed:

> So, the Christian dogma summeth,
> That the bread his flesh becometh,
> And the wine his sacred blood:
> Though we feel it not nor see it,
> Living faith that doth decree it,
> All defects of sense make good.[32]

No single explanation is sufficient to explain the tragic suffering and loss of life involved in witch persecution. Fear of women, religious anxiety, exclusion of women from production and the public sphere, and the circulation of cheaply produced pornography—all of these conditions contributed to the mania for identifying and punishing alleged witches.

In the 1520s and 1530s, while printers were churning out Protestant propaganda and broadsheets with illustrated accounts of witch trials and executions, another kind of popular literature was beginning to appear. Within a century after the establishment of printing, Europe was flooded with illustrated pornography. The word "pornography" appeared much later, as the title of a 1769 treatise about prostitution by Restif de la Bretonne. It was included in the *Oxford English Dictionary* only in 1857. For several centuries, the word connoted narratives located in brothels—whether the brothel was a place of prostitution or an imaginary convent. "Pornography" in the modern sense became a category only in the nineteenth century, when librarians began to discard books they considered "dirty."[33] Lynn Hunt has suggested that the word "pornography" in fact names a site of contestation and argument, not a definable entity.[34]

Erotic, obscene, and pornographic images and narratives were not distinguished in early modern societies, nor will I attempt to differentiate them here. These images exist on a continuum, from naked bodies at one end to depictions of violent aggression at the other. Within the middle range, subtle differences between erotic and pornographic images are perennially in the eye of the beholder.

Renaissance pornography was prompted by the rediscovery of the lusty tales of Roman antiquity—Ovid, Lucian, Petronius, and the obscene writings of Martial, Juvenal, and Catullus. Classical images of naked women and satyrs with huge erections also stimulated early modern pornography. Printing commodified "images formerly confined to humanist circles and the inner recesses of the courts, and popularized an erotic discourse initially designed for an elite audience."[35] Authors—usually anonymous—began to write for a public that demanded to be amused, aroused, and intrigued, not elevated.[36]

By the sixteenth century, the center of Western European culture had moved from Rome to Paris, which became the Western European capital of artistic excitement and the prime international location for the distribution of illicit books.[37] The so-called father of pornography was a sixteenth-century Italian, Pietro Aretino (1492–1556), "one of the first writers to make a living from his pen" and the author of many popular religious tracts, saints' lives, plays, letters, *and* pornographic narratives.[38] Jacob Burckhardt calls Aretino the "father of journalism" as he was the first to take advantage of print technology to address a popular audience.[39]

Aretino objected vociferously to the naked figures in Michelangelo's *Last Judgment* in the Sistine Chapel. He called the figures obscene and said that perhaps they were appropriate in a "voluptuous bathroom, but not in the choir of the holiest chapel." He claimed that his own pornographic dialogue *Nanna* was more modest than Michelangelo's figures.[40] It is striking that even before the Council of Trent prohibited nakedness in religious art, the pornographer Aretino saw pornographic rather than religious meaning in nakedness. The "eye of the beholder" was at work; naked bodies were losing their status as the site and symbol of religious meaning.[41]

Aretino frequented the papal court and was almost made a cardinal. During his lifetime, opinion was strongly divided about him and his works. Some called him "the divine Aretino," but one of his contemporaries claimed that he was the "possessor of the most horrible, vituperous, and ribald tongue ever born."[42] He outdid Ovid "by celebrating copulation and the language of lust in print."[43] But Aretino not only wrote pornography; he also created a genre. Robert Darnton writes: "Aretino's *Sonetti lussuriosi* and *Ragionamenti* set standards and established themes—the sixteen classical 'postures,' the provocative use of obscene words, the interplay of text and illustrations, the use of the female narrator and of dialogue, the voyeuristic tours of brothels and convents, the stringing out of orgies to compose a narrative line— that made him famous as the father of pornography."[44]

Early modern pornography also initiated conventions that have persisted to the present. One of the most significant of these conventions is its repetitious definition of gendered attitudes, roles, and expectations. As Linda Williams has observed: "Pornography as a genre wants to be about sex. On close inspection, however, it always proves to be more about gender."[45] Williams's analysis of the gendering of twentieth-century pornography applies also to early modern pornography. Pornography's use of voyeurism, its "frenzy of the visible," Williams writes, is "blind to the subjectivity of women" and thus ill equipped to represent female pleasure.[46] Pornography is for men, creating and shaping male desire.

The dedication of Aretino's illustrated *Sedici Modi* (*Sixteen Postures*, 1524, figure 27), to a physician friend, Battista Zatti of Brescia, typifies the rebellious spirit of early modern pornography: "I dedicate this lewd memorial to you, and let the hypocrites take a flying leap; I'm sick of their thieving justice and their filthy traditions that forbid the eyes to see what most delights them."[47] Pornographers were not rebellious only about sex; rather, "they expected sex to serve as a vehicle for attacks on the church, the crown, and all sorts of social abuses."[48] Priests and nuns, and kings

Figure 27. Marcantonio Raimondi (1480–1527/34), *I modi, Position 1*, 1524. Engraving after Giulio Romano. Bibliothèque nationale de France, Paris (photo: Bnf).

and their mistresses, are the regular protagonists of early modern best-selling pornography. The not-so-hidden agenda was the unmasking of hypocrisy and pretension among those who held power in society, with sex serving as the great equalizer.

The church fought back. The Index of Forbidden Books established by the Council of Trent in 1557, intended primarily to prohibit heretical writings,[49] also prohibited "books which professedly deal with, narrate, or teach things lascivious or obscene." In 1558, Aretino's pornography was placed on it, and it remained there throughout the early modern period. However, the effect of this prohibition of "forbidden books" was simply to make pornographic literature more alluring to readers.[50]

THE EARLY MODERN (MALE) EROTIC EYE

Erotic, obscene, and pornographic literature and images objectify bodies—indeed, both male and female bodies—for male pleasure. Early modern pornography assumed heterosexuality; Aretino's "positions" all display sex between a man and a woman. Women were also frequently depicted as

sexual partners with one another for the pleasure of the male viewer. But erotic literature's most characteristic device was the figure of the voyeur/eaves-dropper who spies on and narrates a sexual scene. The reader/viewer is invited to participate by identifying with the voyeur. It is worth noting that a version of this device had for centuries been used in religious paint-ings in which one of the painted figures gazes out of the scene to catch the beholder's eye, inviting her into the sacred scene. As discussed in chapter 2, this can be seen in paintings and sculptures of the nursing Christ in which the child turns from the breast to gaze at the worshipper, inviting him to share the Virgin's milk.

What did early modern men consider erotic? Twenty-first-century erotic tastes, shaped by a media culture that fetishizes breasts, make it difficult to concede that breasts could have had associations *other than* erotic or med-ical ones at that time. Early modern men delighted in parts of the female body that modern erotic tastes ignore. For example, the first narrative pornographers were much more likely to linger over detailed descriptions of plump arms than to fetishize legs. And good teeth "stand out every-where" in pornography, Robert Darnton writes, "probably because of the prevalence of rotting jaws and stinking breath in early modern society."[51] Moreover, Darnton writes, early modern pornographers, "fancied fat, fat in general and fat in particular places—on arms, and in the small of the back. Back fat produced dimples at the *chute de reins,* a sensuous spot just above the buttocks."[52] I think it is not likely, however, that early modern pornographers and their readers thought of themselves as enjoying "fat"; rather, they loved *flesh,* and more, not less, of it. What may, to the modern viewer, look like "fat" (with all the negative connotations the word is freighted with today) was, to the early modern male viewer, healthy, beau-tiful, and sensuous flesh.[53]

Fashions are a key to identifying the erotic tastes of a society, and early modern Italian and French fashions exposed a good deal of the breast. But fashions also specify what is beautiful within a particular culture. In terri-tories in which Protestantism was established, women wore dresses with high collars and a double skirt. Even in Spain, Roman Catholic reformation prudery dictated that female bodies appear sexless. The sixteenth-century Countess of Aulnoy wrote: "Among [Spanish women] it is a *sign of beauty* to have no bosom, and they take early precautions to prevent it from appearing. When the breasts begin to appear, they place little plates of lead on it and bind themselves up like the children we swaddle. They have a bosom in one piece, almost like a piece of paper."[54] Given the discomfort

involved in preventing the growth of breasts, it is striking that after 1540, except in Italy and France, Spanish fashion dominated Western Europe until the beginning of the eighteenth century. The Countess gave the only adequate explanation, that is, that the appearance of having no breasts was considered "a sign of beauty."

In short, an erotic response is always contextual; whether an image is considered arousing, erotic, or pornographic is determined by the viewer's socialization. David Freedberg writes that an erotic response "is dependent on the prior availability of images and prevailing boundaries of shame. If one has not seen too many images of a particular kind before, and if the particular image infringes some preconception of what should not be or is not usually exposed (to the gaze), then the image may well turn out to be arousing."[55] Identification of a "period erotic eye," then, depends on reconstructing visual associations and identifying a social consensus on what was considered erotic. People "catch" a sense of the erotic from their neighbors and from the communication media of their society. Individual tastes refine and nuance common tastes, but they do not (often) overturn them.

"PHILOSOPHICAL BOOKS"

During the "golden age" of pornography—from 1650 to 1800—publishers referred to illicit volumes as "philosophical books." These cost twice as much as ordinary books, but were still within the purchasing power of a broad spectrum of the Western European population. "Philosophical books" received free advertising throughout Europe by means of widely circulated printed lists of prohibited books.

The rubric "philosophical books" was not merely a euphemism, for in these books long philosophical debates accompanied detailed descriptions of sexual activities. For example, the title of one "forbidden best-seller" of pre-revolutionary France, *Thérèse philosophe* (1748), references an early Enlightenment work, *Le Philosophe* (1743), which "defined the ideal type of the worldly, witty freethinker, who held everything up to the critical light of reason and especially scorned the doctrines of the Catholic Church."[56]

Until the second half of the eighteenth century, erotic literature was not created simply for purposes of erotic arousal and masturbation. Books that, as Jean-Jacques Rousseau put it, "one can only read with one hand" were an afterthought of the invention of pornography.[57] Early modern forbidden literature was forbidden not for its sexual content

primarily, but because, as we have seen, its potential for social disruption was feared—because it attacked the church, the crown, or public morals. Its recognized danger to the state and society is demonstrated by the fact that, between 1600 and 1756, more than eight hundred authors, printers, booksellers, and print dealers were incarcerated in the Bastille for writing and/or circulating pornographic literature.[58] Indeed, in the earliest works of pornography, "it is impossible to separate sex from religion" and philosophy.[59]

In *Thérèse philosophe,* sexual and metaphysical education are intertwined. Thérèse spies on Abbé T. and Mme. C. as they "philosophize and masturbate deliciously together," agreeing that pleasure is the highest good: "How could we fear to offend God in relieving our needs by the means He has afforded us, the objects of His creation, especially when these means in no way disturb the social order?"[60] Their philosophizing goes beyond the rationalization of sex play, however. Robert Darnton summarizes their (overheard) conversation: "Nature was nothing but a concept invented by the founders of religion to separate God from the source of suffering. No, God did not hide behind nature. He was everywhere—but if everywhere, nowhere; for everything could be reduced to matter in motion, leaving 'God' as an empty word and morality as a utilitarian calculus based on pleasure and pain."[61]

Early modern people considered sex "good for thought," in Darnton's apt phrase: "sex and philosophy go hand in hand."[62] Although by the mid-eighteenth century many pornographic novels existed solely for the purpose of arousal, the age of Enlightenment still held together sex and thought. The French verb *denaiser* meant "to lose one's silliness by gaining carnal knowledge."[63] That concept needs further exploration.

Darnton argues that the metaphysical message of *Thérèse philosophe,* formed by the mechanistic philosophies of the seventeenth century, was that "everything was matter . . . spirit did not exist."[64] I disagree with his conclusion. "Philosophical books" insisted that bodies (matter) and thought (spirit) were *both* essential; intellectual liberty (free-thinking) and sexual liberation (free living) depended on one another for conviction. Reacting against centuries of sexual prohibition, *Thérèse philosophe* could certainly have advocated physical ecstasy as an alternative to the spiritual ecstasy of Gian Lorenzo Bernini's *St. Teresa* and *Ludovica Albertoni* of the century before (figures 5 and 6). But Abbé T. and Mme. C. also received a great deal of pleasure from their revolutionary ideas, perhaps experiencing their thoughts as physical sensations.

Many seventeenth- and eighteenth-century people appear to have thought that sexual pleasure, taken seriously, reveals something of the first importance about human life, something so powerful that it could override the fear of hell, for centuries the punishment for indulging sexual appetites. A little-known by-product of the eighteenth-century Enlightenment was the awareness that pleasures of the flesh, experienced with attentiveness, produce insight. Aristotle objected to sex on the grounds that one can't *think* well while engaged in sex; in effect, early modern pornographers insisted that sex *is* food for thought.

The question implicitly addressed by "philosophical books" was larger than their authors acknowledged. For two thousand years, since Aristotle first raised the issue, the central problem for Western philosophy and theology was the relationship of spirit and matter, soul and body. Philosophers and theologians sought simultaneously to *distinguish* spirit and matter and to hold them together. They distinguished them because they feared that each would contaminate the other if they were "mixed."[65] Yet the very urgency with which thinkers sought to hold spirit and matter together suggests that they began with an initial suspicion that spirit and matter may be not only distinguishable, but separate.

Within Christianity, questions concerning the relationship of spirit and matter took on a special flavor. On the one hand, doctrines of creation, incarnation, and the resurrection of body insisted on the consanguinity of spirit and matter. The sacraments also depended on both a spiritual and a material component. Yet ambivalence about material bodies, their vulnerability and their desires, was evident in the medieval assumption that serious full-time Christians must be celibate. Erasmus's *Enchiridion Militis Christiani* (1519) offers a sixteenth-century version of an ancient Christian theme: "Spirit makes us godlike; the flesh, brutish. The soul makes us men: spirit makes us good men, flesh makes us vile men. . . . The spirit lifts us toward heaven, the flesh pushes us downward toward hell. . . . Whatever is carnal is base, whatever is spiritual is perfect."[66]

Paintings of naked breasts offer an alternative interpretation of the relationship of spirit and matter, namely, the intimate dependence of each on the other. The gradual disappearance of the religious breast removed a strong symbol of the compatibility—indeed, the interdependence—of spirit and matter. Breasts, a complex delight that provided *both* physical nourishment *and* the spiritual nourishment of loving care essential to the infant's well-being, were relocated within secular arenas. In pornography and anatomical illustration, "[b]odies were atomized, stripped of their

appearances and qualities, thus rendered knowable only by virtue of their size, shape, motion, and weight."[67] In Protestant territories where the role of the Virgin Mary was minimized and saints no longer served as intercessors, naked breasts appeared primarily in paintings of two subjects: Eve and witches. In both, naked breasts evoked sin, sex, and death—not nourishment, care, and primordial bliss.

It is not accidental or incidental that most alleged witches were women. Women, their bodies objectified, their skills excluded from public life, became a vulnerable population in early modern Western European societies. There was, of course, a long Christian history of identifying women with Eve, the prototypical woman who introduced sin into the world. But in the early modern period, the dominant worldview aligned them with evil intent and effects more explicitly and insistently than at any earlier time.

Pornography was at the center, not the periphery, of early modern culture. It provided images that facilitated women's exclusion from public life, encouraging men to think of women as sexual objects rather than subjects of their own abilities and desires. As women were excluded from guilds, the location of production in early capitalism, and as women's bodies were objectified in medical literature, pornography presented female bodies as material vehicles for male pleasure. In part 2, I have sketched a broad social, philosophical, technological, and religious arena within which representations of breasts acquired new kinds of attention. Breasts were no longer solely, or perhaps even primarily, seen as the source of infants' essential nourishment and as symbolic of a universal provision. The secular breast emerged.

A Complex Delight

We are answerable for what we learn how to see.

DONNA HARAWAY
"The Persistence of Vision"

Progress is gain without corresponding loss.

R.G. COLLINGWOOD
The Idea of History

I HAVE SKETCHED THE INTERACTION of an art historical and religious phenomenon with the intellectual, religious, social, and economic history and technology that created a Western European early modern world vastly different from its late medieval predecessor. I have traced changes in representations of the breast that marked its development from a religious symbol to an object of voyeuristic pleasure and medical scrutiny. R. G. Collingwood's ironic definition of progress as "gain without corresponding loss" makes it evident that unambiguous "progress" seldom occurs in human affairs; rather, both gains and losses must be acknowledged. Increments in medical knowledge, more efficient communication media, economic gain, more effective state institutions: these must be weighed against significant losses. The secularization of the breast must be counted as one such loss. Women seem to have fared somewhat better when images of the breast reassured and reminded people of the providence and provisions of a loving God.

A culture's symbolic repertoire is a sensitive barometer of its religious, political, and social arrangements. In the societies of late medieval and early modern Western Europe, the breast was so symbolically resonant that the location of shifting social power can be traced by identifying in

what contexts the breast was represented and interpreted. In brief, late medieval interpretation of the breast was solidly within the church's portfolio. By the seventeenth century, images of the breast circulated in medical anatomies and in the illustrated pornographic literature that flooded Western Europe within a century of the invention of the printing press. A search of Art Resource in New York, the largest image collection in North America, produced not a single image of the Virgin with one bare breast after 1750.

The history of the second half of the eighteenth century—the age of Enlightenment, the individual, empiricism, scientific discovery, and the rise of nation-states (begun in the seventeenth and consolidated in the eighteenth century)—is too complex to sketch here. It is, however, interesting to note in passing that the representation and interpretation of the breast continued to be a key to shifting social power and authority. Several nations adopted bare-breasted or draped female figures as symbols of national identity; the United States' Statue of Liberty and France's Marianne are two examples (figure 28).[1] Gathering centuries of symbolic meaning, these painted and sculpted breasts served to reinforce an idea that was still weakly developed at the beginning of the eighteenth century, namely, the idea of a national community or *patria,* "to which all sections of society owed their prime allegiance."[2] National symbols provided a visual embodiment of the nation. Referencing centuries in which the religious breast symbolized God's provision and care, they were intended to communicate the state's generosity and abundance, its trustworthy ability to provide, and its concern and care for its "children."

Between 1350 and 1750, the fortunes of the breast were part of the secularization of Western European societies. Secularization should not be taken to imply a diminishment of religion, however. Religious zeal had never been at a higher pitch than in early modern Europe—if religious wars, a church split into many contentious particles, and the martyrdom of many believers should be so interpreted. Nevertheless, one of religion's losses was a monopoly on the representation and interpretation of the breast. It is striking that Christians, whose earliest rites featured baptism of naked adults in the full congregation, consented to the loss of the female breast as a symbol of God's provision and care. Vast and pervasive social and institutional changes supported the silent, virtually uncontested, emergence of the secular breast. In the period of our study, interpretation of the breast changed hands, as it were, from churchmen to physicians, medical illustrators, and pornographers.

Figure 28. Eugène Delacroix (1798–1863), *Liberty Leading the People,* 1830. Musée du Louvre, Paris (photo: Erich Lessing/Art Resource, NY).

As images of breasts proliferated in secular discourses, these images lost both their connection to the nursing breast and their ability to communicate a singular meaning. Walter Benjamin has pointed out that symbols are inherently and inevitably theological; they assume and require a transcendent realm that directs their meaning. Their theological aspect encourages stability, but although they may retain meaning across centuries, Benjamin also acknowledged "the historical fluidity of perception and symbolizing processes."[3] Indeed, although the symbolic breast was relatively stable across several centuries, it was also ultimately vulnerable to social and cultural changes. In a word, in the period of our study, images of breasts lost their status as religious symbols. They did not, however, become signs devoid of any connection to their material base. Rather, images of breasts were detached from their religious understanding and transposed to secular meanings based on other perspectives. The hegemony of the religious symbol was effectively challenged and alternatives were proposed and broadly communicated by the new print medium.

The lives of women changed as the breast became secular. In order to begin to understand the sensitive interactivity and mirroring of symbolic and social changes, I have explored shifts in institutions, attitudes (insofar as these left recoverable traces), and social arrangements. These shifts included such apparently disparate arenas as early capitalism, in which production moved from the household to the public sphere governed by guilds and city governments; the establishment of a medical profession with claims to scientific knowledge; the invention of the printing press, with its vastly increased ability to circulate information and propaganda; plague; witch persecution; and Protestant and Roman Catholic reformations.

Changes in artistic styles also contributed to the breast's secularization. In late medieval iconic paintings of the nursing Virgin, nonnaturalistic bodies pointed to a spiritual world beyond the senses and everyday experience. By the mid-fifteenth century, heightened realism simultaneously stimulated viewers' attraction to saintly figures and threatened to collapse that attraction into the erotic. Renaissance artists no longer worked exclusively for ecclesiastical patrons, and images became "art"—self-conscious creative inventions. When images became "art," naked bodies with their poignant vulnerability became "nudes," objects posed to attract the voyeuristic eye.

Moreover, when images became art, a different viewing experience was prompted. In communion with a religious image, the eye was thought to *touch* the image through its visual ray; the image, in turn, moved back up through the visual ray to implant itself on the soul.[4] Worshippers, trained to see a world of emotion in the slight tilt of a head, a reaching hand, or a delicate nipple, now became viewers who marveled instead at the artist's innovative execution of a scene, the skill of his perspective, the lifelike realism of his landscape. Art required "a new kind of beholder who reads and interprets, rather than looks and feels."[5] This viewing experience gave way to more distanced pleasures—in a word, to "art appreciation."[6] In Renaissance paintings, the beholder is offered "a virtual world that is less a space for experience than a space for viewing."[7]

Looking beneath the rich surface of Christianity's symbolic resources, we notice an even more profound loss, namely, the incremental disappearance of human bodies as symbols of religious subjectivity. The Christian doctrines of creation, incarnation, and resurrection each pointedly and emphatically identify bodies as both locations of, and symbols for, Christian truth.[8] Christians participate in the "body of Christ," and the sacraments contain both a material and a spiritual element. Yet in the symbolic imaginary of the

dominantly Christian West, "woman" was associated with bodies, while "man" signified rationality. "The body"—that nonexistent entity that no one has ever seen or touched—was usually represented visually as a female body.[9] The loss of the female breast as site and symbol of religious meaning was a significant moment in a gradual shift within Christianity, from the affirmation of bodies—both male and female—as essentially engaged in religious commitment, to the female body as object and spectacle. Bodies, naked, vulnerable, and poignant, lost the cultural conversation in which they had signified physical presence with engaged senses.

THE SUBJECTIVE BREAST

Chapter 1 began with Augustine's description of the infant's experience of first bliss and first frustration at the breast. The twentieth-century psychoanalyst Melanie Klein extended Augustine's observations, describing the mechanisms by which the infant (gendered male) attempts to render his highly ambivalent experience manageable: He splits the breast into the "extremely perfect" breast and the withholding or "extremely bad" breast. He projects onto his mother/nurse his destructive rage at the withholding or "extremely bad" breast and then fears the withholding breast's retaliation. He can then experience his rage and aggression as self-protective.

Writ large, the infant's desperate effort to attain the "extremely perfect," nourishing, and delighting breast can be seen as the informing moment for Western social arrangements. From this perspective, patriarchal societies are extensions of the infant's devices of splitting and projection. In a man's world, women, representatives if not owners of the breast, are either, like the Virgin Mary, "extremely perfect" or, like witches, "extremely bad." The masculinist cultural project is to manage women in such a way that men retain access to the delight, limiting or eliminating the frustration.

There are problems with this theory, however. For example, the caregiver is always gendered female, while the infant is gendered male. Is there really only one possible psychic position for men, with one (reactive) position for women? What about girl infants? Where does father enter this incestuous picture? Psychoanalyst Jessica Benjamin has recently taken up the challenge of revising Klein's scenario (which built on Freud's psychology in ways too complex to investigate here). Benjamin makes an important distinction between two subjects recognizing each other and one subject regulating another.[10] She writes: "Nursing and going blissfully to

sleep . . . is an instance of having oneself dramatically transformed by the other's ministrations. It is quite different from facial play where the essential experience is *with* the other." Within a few weeks after birth, the infant has learned that he can expect to be fed when he is hungry, so that hunger "may be less pressing than his interest in his mother's face."[11]

Consider Benjamin's distinction between managing the other and experience *with* the other in relation to paintings of the nursing Virgin. The nursing Christ gazes at his mother or twists around to catch the viewer's eye, thus establishing essential relationships. Artemisia Gentileschi's beautiful *Madonna and Child* (painted circa 1609, when she was nineteen; plate 11) depicts such a moment of engagement. Her Madonna of Humility is seated on a plain wooden chair, with her bare feet resting on a rough floor. She supports the Child with her left arm, leaning forward to offer, with the first two fingers of her right hand, a delicate virginal nipple. Her plain pink dress is undisturbed; she has merely lowered the neckline of her dress to raise her left breast out of the garment. Her right breast is covered by her hand and shadowed as she leans forward. This Madonna is not a diminutive figure; her bulk fills the painting, and her hands and feet are large. Her facial expression and closed eyes indicate languid intimacy and quiet pleasure.[12] The Child sits on the Madonna's large knees, enveloped in her body's warmth, with his back to the viewer. He is clothed only in a white cloth loosely sashed around his body, revealing a fleshy left buttock, leg, and two bare feet, seen from beneath. The Child's facial features resemble Mary's, but his expression is alert as he ignores the proffered breast to gaze into his mother's face. Light glows on his exceptionally high forehead. He raises his dimpled left arm to place his hand on Mary's neck, in the traditional chin chuck that symbolizes erotic attraction.[13] Clearly, his interest in his mother is not based on his need for physical nourishment (he ignores the nipple), but on his fascination with her face.[14]

Every attentive parent is aware that an infant needs recognition in order to develop her/his abilities and to take pleasure in them. Benjamin insists, however, that *mutual* recognition is essential to the child's development. If the mother does not assist the child to recognize her as a separate being with her own needs and desires, he will imagine her simply as the object of *his* urgencies. Later, he will extend that relationship in his love relationships. Supported by cultural assumptions and gender socialization, he will, throughout his life, commit "the original sin of denying recognition to the other."[15]

In the absence of mutual recognition, relationships of domination and submission emerge, not only in personal relationships, but in culture.

Benjamin writes: "Male domination, like class domination, is no longer a function of personal power relationships . . . but [is] something inherent in the social and cultural structures, independent of what individual men and women will."[16] Ultimately, the infant must sacrifice the illusion of omnipotence, the illusion that the mother is an extension of his body, that she is his slave, or a figment of his imagination. Paintings in which mother and child gaze at each other seem to record the moment in which the child realizes that he must adjust his impression, based on prenatal "experience," that he and the mother are one body, the moment in which he recognizes that they are *two* beings. His reward for doing so is the pleasure of relationship with the mother as other.

Benjamin uses the term "intersubjectivity" to describe the mother's and child's mutual recognition. I suggest that this term may not serve Benjamin's theory well, as it seems to imply an abstract consciousness of the other. Rather, the gaze of mutual recognition between mother and child is based on a fundamental *intercorporeality*, an erotic recognition of the other's *body*. Subjectivity is utterly reliant on bodies, a reliance that may seem too evident to require acknowledgment.[17] The religious breast symbolized the possibility of relationship predicated on mutual recognition, on intersubjectivity based on intercorporeality.

The eyes have a privileged role to play in recognition of the other. The gaze of mutual recognition is fundamental not only to acknowledging the other, but also to forming the self. Self and other configure in the same activity, the activity of looking.[18] "To see is to see Others. We cannot, in fact, readily escape seeing Others; we can only readily escape acknowledging them. . . . the simple act of looking has the power to . . . structure the nature and dynamics of what is a virtually inescapable intercorporeality."[19]

What about the girl infant? Benjamin's analysis of mutual recognition as the fundamental gesture of intersubjectivity offers a theory in which both boys and girls experience identificatory love with both parents—with the nourishing, caregiving mother and with the father, who represents the exciting outside world and protects the child while encouraging her to explore that world. Both provisions are necessary for the child's development. "At present," Benjamin writes, "the division between the exciting outside father and the holding, inside mother is still embedded in the culture."[20] These gendered roles are repetitiously reinforced in the symbolic repertoire of Western cultures.

But the long-standing binary oppositions of Western societies can be disturbed; indeed, they *are* presently being disturbed. The most significant

factor creating change in traditional gender roles is women's slowly increasing economic capability. In societies in which economic provision and care giving can be done by either parent, gendered roles need not be fixed on the male and female parents. Caring, nourishing, nurturing, encouraging, and stimulating: these roles can circulate between the parents.

In short, there is no necessity for care to be gendered female and equated with the nourishing breast (as in images of the nursing Madonna).[21] The symbolic repertoire lags behind changing social arrangements, however. It is striking that Christians' belief in a providing and caring (gendered male) God has not prompted images of a father's care, but has focused almost entirely on picturing a mother's care. Because images enable thought, making ideas concrete, Plato said, "I strain after images."[22] Yet thousands of Western paintings of mother and child have not been balanced by depictions that encourage us to picture fathers as providers of nurturing care. The importance of such images cannot be exaggerated. In Lynn Randolph's *Father and Child* (1984, plate 12), the nurturing father holds the baby girl with great tenderness and support, but in a way that enables her own movement. Surrounded by a vaguely menacing and dark background, father and daughter nevertheless gaze out fearlessly at the future, at the world beyond the picture frame.

I have said that I consider the religious breast one of the losses of early modern Western Europe. I must now nuance that statement. The religious breast was neither owned nor constructed by women, but served the symbolic repertoire of the Christian church. Undoubtedly, both women and men found the Virgin's breast a powerful and beautiful symbol, but let us consider whether it is possible to revision a symbolic breast owned by women, a breast capable of functioning as a symbol of a woman's subjectivity?

A problem appears immediately. Breasts are ubiquitous in twenty-first-century media culture—as objects. Is it possible in the face of such overdetermined meaning to imagine a subjective breast? What would its characteristics be? It is easy to say what the subjective breast is not: It is not primarily provided for an infant's nourishment, nor is it an object of medical scrutiny. The subjective breast is erotic because of its sensitivity, not because it is displayed for men's erotic stimulation. Both the delight of a lover's or an infant's touch and the harsh fear of disease need to be included in any construction of the subjective breast. Although a reconstruction of the breast as symbolic of women's subjective experience is not this book's aim, recognizing past and present objectifications of the female breast is a first step toward that project.

Augustine, attentive observer of infant behavior, also offered a shrewd analysis of flawed adult relationships. He suggested that the fundamental structure of human relationships is each person's attempt to *use* the other for gratification. We "eat each other up," he said, "as people do with their food."[23] He described the alternative as *enjoyment* of the other *as* other—as "enjoying one another's beauty for itself alone."[24] However, he pictured the absence of needy urgency that allowed for beauty, pleasure, and enjoyment as occurring in a time and place beyond present life, in the resurrection of body. "There," he wrote, women's bodies will not exist for (male) *use* (he mentions intercourse and childbearing), but will be "part of a new beauty *(decori novo).*"[25] Augustine described relationships of pleasure and delight as occurring when *eros* and spirit are irreversibly bonded in "spiritual bodies"— not spirits, he insisted, but real bodies.

Perhaps the composite figure of Mary Magdalen was an attempt to picture such a blending of the erotic and the spiritual. And paintings that sought to augment devotional engagement by increasing erotic attraction may also demonstrate recognition that the spiritual and the erotic are closely aligned. Erotic attraction is ambiguous. It can seek to dominate and possess, or it can desire the loved one's good. It can become the basis for conflict and violence as each individual struggles to acquire goods that are in short supply,[26] or it can fund a passion for intimate knowledge of the unlimited universal good that Plotinus and Augustine called the "Great Beauty."

Augustine, it seems, was not able to picture sexual relationships grounded on *mutual* recognition and enjoyment. He was aware that dominance and submission are gendered, their respective and complementary power relations imbedded not only in personal relationships, but also in societies.[27] But he thought that unequal power and agency were inevitable, simply a fact of life in both public and private arenas in human societies. Although he could imagine other relationships, he did not advocate taking the next step of *practicing* them in a less-than-ideal world. By identifying the quality of mutual recognition as "enjoyment of one another's beauty," however, he provided an invaluable clue. Seeing the other as beautiful transcends the artificial separation between erotic and spiritual attraction.

How can we create relationships based on seeing the other's beauty, we who do not have adequate models and who live in unjust societies? No doubt there are many methods, only one of which can be suggested here.

Paintings teach that beauty can be enjoyed and *loved* without prompting the desire to dominate or possess. Or, as Augustine said: "By use of the bodily eyes, everyone possesses all that he delights to see."[28] Attentive looking, in which intellect and emotion are invested, is a spiritual discipline that one can learn. Many or most of us learned it as infants, gazing at the faces of those who held us and gazed at us. But as adults, most of us have been redirected to a different discipline of looking. Flooded with images, we are trained to look critically, skeptically, without emotional engagement. In our society, this is important training. But why not choose images we want to be shaped by, images that might expand and refine our emotional palette, and recover the ability to gaze at them as medieval people looked at their religious images? Seeing the powerful and moving beauty of a painting is a detachable skill; from gazing at bodies in paintings whose subjectivity is revealed in their bodies, stances, and gestures, we can learn to see the subjectivity of others *revealed* with perfect accuracy by their bodies.

Training oneself to see the specific and particular beauty of bodies, painted and actual, is a profoundly countercultural act. In media societies in which cameras define beauty, it is the work of a lifetime. The German feminist Frigga Haug writes: "Our aim is to reach a point at which we no longer see ourselves through the eyes of others."[29] To see beauty is not to make an aesthetic judgment, but to experience the person we meet as beautiful *at the level of perception*. Moreover, willingness to invest in training oneself and encouraging others to see beauty requires faith that change in society begins with change in individuals.

Twenty-first-century media culture designates which breasts are beautiful more repetitively and efficiently than did late medieval paintings and early modern print culture. Most women experience dissatisfaction over the size and shape of their breasts, making surgical procedures for breast augmentation or reduction commonplace. In this situation, is it possible to see *all* breasts as beautiful? To see breasts of vastly different ages and appearances as beautiful would be to see them as perfectly reflecting a woman's subjectivity, the wealth of her experience, and her unique personhood. No culture has managed this easily. Early modern painters were fond of contrasting the small, high breasts they thought beautiful with the sagging breasts of witches and old women. As long as breasts are objectified, every society will consider some breasts beautiful and others ugly. But the breast, perceived as subject and symbol of a woman's life and experience, is always beautiful, to her own eye, and to the other's loving eye.

NOTES

PREFACE

The epigraph is from "The Sparkling Stone," in *Late Medieval Mysticism,* ed. Ray C. Petry (Philadelphia: Westminster Press, 1957), 308.

1. Paul Tillich, *Systematic Theology* (Chicago: University of Chicago Press, 1951), 1:239.

2. Paul Tillich, *Dynamics of Faith* (New York: HarperCollins, 2001), 47–50.

3. Augustine, *Confessions,* 1.6; trans. Rex Warner (New York: Mentor, 1963).

4. Ludwig Wittgenstein, *Tractatus Logico-Philosophicus,* trans. C. K. Ogden (London: Routledge and Kegan Paul, 1922), 4:1212.

ACKNOWLEDGMENTS

1. Anne Hollander, *Seeing Through Clothes* (New York: Avon, 1975), 186.

CHAPTER 1 : The Secularization of the Breast

The epigraph is from Michel Foucault, *The Use of Pleasure,* trans. Robert Hurley (New York: Pantheon, 1985), 9.

1. Augustine, *Confessions,* 1.6; trans. Rex Warner (New York: Mentor, 1963). Although Augustine does not say so, it is likely that the infant he observed so attentively was his own son, Adeodatus.

2. Augustine, *Confessions,* 1.7.

3. Ibid.

4. Melanie Klein, "The Psycho-Analytic Play Technique," in *The Selected Melanie Klein,* ed. Juliette Mitchell (New York: Free Press, 1987), 52.

5. Juliette Mitchell, Introduction, in *Melanie Klein,* 19.

6. Klein, "Envy and Gratitude," in *Melanie Klein,* 217.

7. Ibid., 211.

8. Ibid., 215.

9. Ibid., 228.

10. Augustine, *Confessions,* 4.1.

11. Augustine, *Enarrationes in Psalmos,* 130.9.11; *Sancti Aurelii Augustini: Opera Omnia* (Paris: J. P. Migne, 1841). Trans. adapted from *An Augustine Synthesis,* ed. Erich Przywara (New York: Harper and Brothers, 1958), 283.

12. Klein, "Notes on Some Schizoid Mechanisms," in *Melanie Klein,* 182.

13. Augustine, *Confessions,* 6.6. Such is the inevitable ambiguity of metaphor that the sixteenth-century Protestant reformers who advocated the accessibility of scripture to the ordinary reader read Augustine's metaphor of the nursing infant differently. They complained that the two Testaments had been seen as the breasts of the Church for infants in the faith and that sophisticated biblical interpretation had been reserved for the "experts," canon lawyers and university professors. They advocated that all Christians should have the privilege of interpreting scripture.

14. Augustine, *Confessions,* 9.7.

15. Clifford Geertz defined "culture" as "an historically transmitted pattern of meanings embodied in symbols, a system of inherited conceptions expressed in symbolic form by means of which men communicate, perpetuate, and develop their knowledge about and attitudes towards life"; *Interpretation of Cultures* (New York: Basic Books, 1973), 89. To extend a theory of individual development to a "theory of culture" would be to show how individual experience informs cultural patterns.

16. Documentation for the persistence of the objectified breast in our own time is too abundant to cite. An example from this morning's newspaper will suffice. Columnist Bob Herbert, deploring a general lack of attention to the fact that girls were selected for slaughter by a gunman at a rural Pennsylvania Amish school, writes: "[T]he relentless violence against women and girls is linked at its core to the wider society's casual willingness to dehumanize women and girls, to see them first and foremost as sexual vessels—objects—and never, ever as the equals of men." Herbert quotes a message on a women's T-shirt for sale at Abercrombie & Fitch: "Who needs a brain when you have these?" *New York Times,* October 16, 2006, A23.

17. The terms "secularization" and "religiosity" can seldom be clearly differentiated in concrete phenomena; the distinction almost always lies "in the eye of the beholder."

18. Elizabeth Eisenstein, *The Printing Press as an Agent of Change: Communications and Cultural Transformation* (New York: Cambridge University Press, 1980), 131.

19. Hans Belting, *Likeness and Presence: A History of the Image in the Era before Art,* trans. E. Jephcott (Chicago: University of Chicago Press, 1994), 472. I accept Belting's critical distinction, acknowledging its importance by referring to pre-Renaissance paintings as "images" rather than "art." See also Francis Ames-Lewis,

The Intellectual Life of the Early Renaissance Artist (New Haven: Yale University Press, 2000), 273; and Mitchell B. Merback, *The Thief, the Cross, and the Wheel: Pain and the Spectacle of Punishment in Medieval and Renaissance Europe* (Chicago: University of Chicago Press, 1998), 279.

20. Wilhelm Dilthey summarized Luther's view: "The sphere of faith's works is worldly society and its orders"; quoted by Owen C. Thomas and Ellen K. Wondra, *Introduction to Theology*, 3rd ed. (Harrisburg, Penn.: Morehouse, 2002), 209.

21. For a description of the change of attention from vision to hearing in Protestant reforms, see my *Image as Insight: Visual Understanding in Western Christianity and Secular Culture* (Boston: Beacon, 1985), chapter 5, "Vision and the Sixteenth-Century Protestant and Roman Catholic Reforms."

22. Jessica Benjamin, *The Bonds of Love: Psychoanalysis, Feminism, and the Problem of Domination* (New York: Pantheon, 1988), 16. Compare Plotinus: "If my soul and your soul come from the soul of the All, and that soul is one, these souls must also be one, allowing us to feel one another's feelings. We do share each other's experiences when we suffer with others from seeing their pain and feel happy and relaxed [with others] and are naturally drawn to love them: for without a sharing of experience there could not be love." Plotinus, *Ennead* 4.9.3 (Cambridge, Mass.: Harvard University Press, 1984).

23. Benjamin, *Bonds of Love*, 53.

24. This device was frequently used in Renaissance art. The figure that turns away from the painted scene to establish eye contact with the viewer is called the *festaiuolo*. It is discussed by Michael Baxandall, *Painting and Experience in Fifteenth Century Italy* (New York: Oxford University Press, 1972), 75–76.

25. David Chidester, *Word and Light: Seeing, Hearing, and Religious Discourse* (Chicago: University of Illinois Press, 1992), 3.

26. "Late medieval" and "early modern" are not precise terms. Throughout the fifteenth and sixteenth centuries, different societies were in different stages of transition. The technical and social developments discussed throughout the book created and marked the shift from "late medieval" to "early modern."

27. I discussed images associated with Protestant reformations in *Carnal Knowing: Female Nakedness and Religious Meaning in the Christian West* (Boston: Beacon, 1989).

28. Benjamin, *Bonds of Love*, 45–46.

29. Anne Hollander, *Seeing Through Clothes* (New York: Avon, 1975), 199.

30. David Freedberg, *The Power of Images: Studies in the History and Theory of Response.* (Chicago: University of Chicago Press, 1989), 192–245.

31. In the Vatican's Sistine Chapel, Michelangelo's *Last Judgment* (1541) was repeatedly overpainted to clothe its naked figures. The original figures cannot be recovered because the plaster on which they were painted was chipped away and fresh plaster was laid for the overpainting; Fabrizio Mancinelli et al., "The Last Judgment: Notes on Its Conservation History, Technique, and Restoration," in

The Sistine Chapel: A Glorious Restoration, ed. Pierluigi De Vecchi (New York: Harry N. Abrams, 1994), 239. Michelangelo's pupil Daniele da Volterra did the first overpainting only five years after the fresco was completed. Further covering of painted bodies occurred in 1572, 1625, 1712, and 1762; Ludwig Goldscheider, *Michelangelo: Paintings, Sculptures, Architecture* (New York: Phaidon, 1963), 20. Interestingly, Pietro Aretino (1492–1556), who is "credited" with being the "father of pornography," protested Michelangelo's naked bodies—before the fresco was even completed; *The Invention of Pornography: Obscenity and the Origins of Modernity, 1500–1800,* ed. Lynn Hunt (New York: Zone Books, 1993), 51.

32. Johannes Baeck's *Prodigal Son* (1637) displayed the subject's decadence by showing him touching a woman's naked breast.

33. As in William Hogarth's orgy scene from his moralizing *The Rake's Progress* (1734).

34. Barbara Duden, *The Woman Beneath the Skin* (Cambridge, Mass.: Harvard University Press, 1991), 178.

35. The term "invention of pornography" is from the title of the book *The Invention of Pornography,* edited by Lynn Hunt.

36. Spanish artists and patrons seem to have especially favored paintings of the nursing Virgin, which continued to be made both in Spain and in the "New World" much longer than in most of Western Europe. See, for example, Pedro Machuca's *The Virgin with the Souls of Purgatory* (1517), which shows the Virgin with two breasts spurting milk. Alonso Cano's *St. Bernard and the Virgin* (mid-seventeenth century) depicts the Virgin expressing breast milk into St. Bernard's mouth. Christóbal de Villalpando's *Virgin and Child* (late seventeenth century) shows the Virgin expressing milk into a saint's mouth.

37. See Caroline Walker Bynum, *Holy Feast and Holy Fast* (Berkeley: University of California, 1987), 403, note 21. Bynum quotes Simone Weil's objection to the post-Freudian practice of confining sexual love to genital sexuality: "To reproach mystics with loving God by means of the faculty of sexual love is as though one were to reproach a painter with making pictures by means of colors composed of material substances. We haven't anything else with which to love." *The Notebooks of Simone Weil,* trans. Arthur Wills (1956; reprint, London: Routledge and Kegan Paul, 1976), 2:472.

38. Freedberg, *Power of Images,* 398.

39. I will be guided by Michael Baxandall's useful suggestions concerning the recovery of the "period eye" in his *Painting and Experience in Fifteenth Century Italy,* and by Anne Hollander's suggestions regarding identifying the erotic eye of historical societies in her *Seeing Through Clothes.*

40. For analysis of a painting's "intention," see Michael Baxandall, *Patterns of Intention: On the Historical Explanation of Pictures* (New Haven: Yale University Press, 1985), 109. During the Protestant reformations of the sixteenth century, iconoclastic Protestants removed paintings and sculpture from churches and violently (usually by mob action) destroyed them. In the iconoclasm of the

French Revolution, however, religious paintings and sculpture were simply removed from their ecclesiastical settings and placed in museums. It was apparently thought that separating images from the worship context would be sufficient to destroy their power. See also Freedberg's discussion of art housed in museums (outside the worship context) that has inspired violent attacks; *Power of Images*, 407–21.

41. Processional sculptures are an exception. Susan Webster has described the audience response to the life-size painted wooden sculptures carried in Holy Week confraternity processions in sixteenth- and seventeenth-century Seville; *Art and Ritual in Golden-Age Spain* (Princeton: Princeton University Press, 1998).

42. Quoted by Howard Hibbard, "Ut picturae sermones: The First Painted Decorations of the Gesù," in *Baroque Art: The Jesuit Contribution,* ed. R. Wittkower and I. B. Jaffe (New York: Fordham University Press, 1972), 30.

43. The former is in the Cornaro Chapel, S. Maria Vittoria, Rome, the latter in San Francesco a Ripa, Rome. Ludovica Albertoni's gesture in the latter work— she presses her breast with her right hand—is mirrored in Bernini's last portrait sculpture, *Bust of Gabriele Fonseca* (1668–75, San Lorenzo in Lucina, Rome).

44. Roland Barthes, *Image, Music, Text* (New York: Hill and Wang, 1977), 39.

45. As, for example, Leo Steinberg did in *The Sexuality of Christ in Renaissance Painting and in Modern Oblivion* (New York: Pantheon, 1984). Steinberg's interpretive texts were sermons preached in the papal court between 1450 and 1521.

46. Robert Darnton, *The Forbidden Best-Sellers of Pre-Revolutionary France* (New York: W. W. Norton, 1995), 57–58.

47. Leon Battista Alberti, *On Painting and On Sculpture,* ed. and trans. C. Grayson (London: Phaidon, 1972); quoted in Baxandall, *Painting and Experience,* 60.

48. Baxandall, *Painting and Experience.*

49. Ibid., 46–48.

50. Hollander, *Seeing Through Clothes,* 98.

51. Duden, *Woman Beneath the Skin,* 2.

52. Walter Stephens, *Demon Lovers: Witchcraft, Sex, and the Crisis of Belief* (Chicago: University of Chicago Press, 2002).

53. Stanislav Andreski, "The Syphilitic Shock," *Encounter* 52 (1982), 7–26. On fear/hatred of women, see also Jean Delumeau, *La Peur en Occident, XIVe–XVIIIe siècles* (Paris: Fayard, 1978).

54. Of course, the "work" of culture is precisely to make culturally specific assumptions, attitudes, and experience seem "natural."

55. Julia Kristeva, *The Powers of Horror* (New York: Columbia University Press, 1983), 10.

56. Alleged witches' confessions are an example of "cooperation" with dominant beliefs, even though these beliefs harmed the accused. Confessions are usually explained by the torture undergone by alleged witches. However, even in England, where alleged witches were not tortured, confessions of witchcraft,

intercourse with demons or the devil, and flying on broomsticks to witches' sabbaths were frequent.

57. Teresa of Avila, *Life,* 11.6; quoted in Carole Slade, *St. Teresa of Avila: Author of a Heroic Life,* (Berkeley: University of California Press, 1995), 27.

58. This assumption may not, in fact, be accurate even for modern Western societies, but that possibility must be explored elsewhere.

59. Michel Foucault, *The History of Sexuality,* vols. I and II (New York: Pantheon, 1978).

60. Judith Butler, *Gender Trouble: Feminism and the Subversion of Identity* (New York: Routledge, 1990), 24–25; Thomas Laqueur, *Making Sex: Body and Gender from the Greeks to Freud* (Cambridge, Mass.: Harvard University Press, 1990).

61. I use the term "queer eye" to refer to the practice of setting aside conventional interpretations in order to approach the evidence with critical questions about how a particular phenomenon "worked" in a society, whom it served—politically and socially—and its *effects,* rather than the explicit or inferred intentions of its designers. See Rosemary Hennessy's discussion of queer theory in *Profit and Pleasure: Sexual Identities in Late Capitalism* (New York: Routledge, 2000), 52–55.

62. Plato, *Symposium,* 210a–212b; *Plato: Collected Dialogues,* ed. Edith Hamilton and Huntington Cairns, trans. Michael Joyce (Princeton: Princeton University, 1961), 561–63.

63. "By use of the bodily eyes everyone possesses all that he delights to see"; Augustine, *De trinitate,* 14.19 (my translation); *Sancti Aurelii Augustini: Opera Omnia* (Paris: J. P. Migne, 1841).

64. "Grace is a glow of soul, a real quality, like beauty of body"; Thomas Aquinas, *Summa Theologica,* I ae. Q. 110, Art. 2; *Aquinas on Nature and Grace,* trans. A. M. Fairweather (Philadelphia: Westminster Press, 1954), 159.

65. For the role of bodies in the theory and practice of Christianity, see my *The Word Made Flesh: A History of Christian Thought* (Oxford: Blackwell, 2005).

PART ONE: The Religious Breast

The epigraph is from Caroline Walker Bynum, "The Female Body and Religious Practice in the Later Middle Ages," in *Fragments for a History of the Body,* ed. Michael Feher (New York: Zone Books, 1989), 2: 161, 164.

1. Stanley Meltzoff, *Botticelli, Signorelli, and Savonarola: Theologia poetica and Painting from Boccaccio to Poliziana* (Florence: L. S. Olschki, 1987), 294.

2. Giorgio Vasari, *Lives of Seventy of the Most Eminent Painters, Sculptors, and Architects,* ed E. W. Blashfield and A. A. Hopkins (London: George Bell and Sons, 1897), 2: 351–52.

3. Ruth Hubbard, "Constructing Sex Difference," *New Literary History* 19 (autumn 1987), 131.

4. Quoted in Pierluigi De Vecchi, "The Syntax of Form and Posture from the Ceiling to the *Last Judgment*." In *The Sistine Chapel: A Glorious Restoration,* ed. Pierluigi De Vecchi (London: Harry N. Abrams, 1994), 230.

CHAPTER 2: The Virgin's One Bare Breast

The epigraph is from Augustine, *De doctrina Christiana,* 1.2.2; *Saint Augustine: On Christian Doctrine,* trans. D. W. Robertson, Jr. (New York: Bobbs-Merrill, 1958). Deborah Haynes noticed that Augustine's definition of "sign" approximates Paul Tillich's definition of "symbol" (discussed in the preface of this book).

1. Victor Lasareff, "Studies in the Iconography of the Virgin," *Art Bulletin* 20, no. 1 (March 1938), 26–65. However, Millard Meiss suggests a Tuscan origin for paintings of the nursing Virgin, based on many examples painted by Simon Marmion, Lippo Memmi, Sandro Botticelli, Taddeo Gaddi, Andrea di Bartolo, and others; Millard Meiss, *Painting in Florence and Siena after the Black Death* (New York: Harper, 1964), 133ff.

2. William L. Langer, *An Encyclopedia of World History* (Boston: Houghton Mifflin, 1940), 454.

3. John Aberth, *From the Brink of the Apocalypse: Confronting Famine, War, Plague, and Death in the Later Middle Ages* (New York: Routledge, 2000), 154.

4. Robert S. Gottfried, *The Black Death: Natural and Human Disaster in Medieval Europe* (New York: Free Press, 1983), 15, 27.

5. Philip Ziegler, *The Black Death* (New York: Harper, 1969), 44. For an argument against a connection between hunger and disease, see Aberth, *Brink of the Apocalypse,* 16.

6. Quoted in Ferdinand Schevill, *History of Florence* (New York: Frederick Ungar, 1961), 237.

7. Aberth, *Brink of the Apocalypse,* 127–28.

8. Peter Lewis Allen, *The Wages of Sin: Sex and Disease, Past and Present* (Chicago: University of Chicago Press, 2000), 62.

9. The profound effects of plague on Western European societies and culture have been studied in detail. See Aberth, *Brink of the Apocalypse;* Allen, *Wages of Sin;* and George Huppert, *After the Black Death; A Social History of Early Modern Europe* (Bloomington: Indiana University, 1986).

10. Quoted in Aberth, *Brink of the Apocalypse,* 155–56.

11. Allen, *Wages of Sin,* 64.

12. Christopher F. Black, *Italian Confraternities in the Sixteenth Century* (New York: Cambridge University Press, 1989), 151–52.

13. Quoted in Aberth, *Brink of the Apocalypse,* 160–61.

14. Quoted in ibid., 154.

15. James Bruce Ross, "The Middle Class Child in Urban Italy, Fourteenth to Early Sixteenth Century," in *The History of Childhood,* ed. Lloyd de Mause (New York: Harper, 1974), 184.

16. Mary Martin McLaughlin, "Survivors and Surrogates: Children and Parents from the Ninth to the Thirteenth Centuries," in *History of Childhood,* 115.

17. Paolo da Certaldo, *Libro di buoni costumi,* quoted in Ross, "Middle Class Child," in *History of Childhood,* 187.

18. Quoted in Ross, "Middle Class Child," 186.

19. Iris Origo, "The Domestic Enemy: The Eastern Slaves in Tuscany in the Fourteenth and Fifteenth Centuries," *Speculum* 30, no. 3 (1955), 321ff. Wet-nursing practices are discussed further in chapter 4.

20. Tertullian, *De carne Christi,* 17; *The Ante-Nicene Fathers,* vol. 3, trans. D. Holmes (New York: Christian Literature Publishing Company, 1853).

21. From the Council of Ephesus comes the only generic use of "woman" of which I am aware in the history of Christianity. The all-male Council declared: "The blessed Virgin was woman as we are." *The Anathematisms of St. Cyril against Nestorius,* in *The Nicene and Post-Nicene Fathers,* 2nd ser., vol. 14: *The Seven Ecumenical Councils* (New York: Charles Scribner's Sons, 1900), 206.

22. Canon 1 of the Fourth Lateran Council (1215) states: "To carry out the mystery of unity we ourselves receive from him the body that he himself receives from us."

23. Translated in Hilda Graef, *Mary: A History of Doctrine and Devotion,* vol. 1 (New York: Sheed and Ward, 1963), 316–17.

24. Thomas Aquinas, *Summa Theologica,* 3a, q. 31, art. 4; *Summa Theologica,* trans. Fathers of the English Dominican Province, vol. 2 (New York: Benziger Brothers, 1948).

25. These and other parallel events in the lives of Christ and the Virgin appear in Giotto's 1304 paintings in the Scrovegni Chapel in Padua, Italy.

26. Aquinas, *Summa Theologica,* 3a, qs. 27–30.

27. Meiss, *Painting in Florence and Siena,* 132ff.

28. Michael Baxandall, *Painting and Experience in Fifteenth Century Italy* (New York: Oxford University Press, 1972), 72ff.

29. Leo Steinberg, *The Sexuality of Christ in Renaissance Painting and in Modern Oblivion* (New York: Pantheon, 1984), 91. Indisputably, the phenomenon Steinberg observed in Renaissance painting and preaching existed. It was not, however, as Steinberg writes, the first time that Christ's "full humanity" had been displayed: Christ's full humanity was demonstrated in his presentation by the Blessed Virgin Mary (from her flesh). The Christ Child's bare feet also signaled his human vulnerability.

30. Ibid., 90.

31. Bonaventure [pseudo], *Meditations on the Life of Christ: An Illustrated Manuscript of the Fourteenth Century,* ed. and trans. Isa Ragusa and Rosalie B. Green (Princeton: Princeton University Press, 1961), 55.

32. Jacobus de Voragine, *The Golden Legend,* trans. Granger Ryan and Helmut Ripperger (New York: Arno Press, 1969), 150.

33. Quoted in Caroline Walker Bynum, *Jesus as Mother: Studies in the Spirituality of the High Middle Ages* (Berkeley: University of California, 1982), 137, n. 90.

34. Ibid., 145.

35. Julian of Norwich, *Showings,* trans. Edmund Colledge, O.S.A. and James Walsh, S.J. (New York: Paulist Press, 1978), 297–99.

36. Heinrich Kramer and James Sprenger, *Malleus Maleficarum,* trans. Montague Summers (New York: Dover, 1971), 47.

37. Jane Gallop, *The Daughter's Seduction: Feminism and Psychoanalysis* (Ithaca, N.Y.: Cornell University Press, 1982), 35.

38. Meiss, *Painting in Florence and Siena,* 151–52.

39. Joan Kelly-Gadol, "The Social Relation of the Sexes: Methodological Implications of Women's History," in *Signs: A Journal of Women in Culture and Society* 1 (1976), 809–23. See also Martha C. Howell, *Women, Production, and Patriarchy in Late Medieval Cities* (Chicago: University of Chicago, 1986).

40. David Herlihy, "Life Expectancies for Women in Medieval Society," in *The Role of Women in the Middle Ages,* ed. Rosemary Thee Morewedge (Albany: State University of New York, 1975), 15.

41. Howell, *Women, Production, and Patriarchy,* 180.

42. Ibid., 32.

43. Ibid., 33.

44. Ibid., 176.

45. Ibid., 179.

46. Ibid., 177.

47. Ibid., 178.

48. Ibid., 181.

49. Giovanna Casagrande, "Confraternities and Lay Female Religiosity in Late Medieval and Renaissance Umbria," in *The Politics of Ritual Kinship: Confraternities and Social Order in Early Modern Italy,* ed. Nicholas Terpstra (Cambridge: Cambridge University Press, 2000), 51.

50. Howell, *Women, Production, and Patriarchy,* 119.

51. Michael Mitterauer and Reinhard Sieder, *The European Family: Patriarchy to Partnership from the Middle Ages to the Present* (Chicago: University of Chicago Press, 1982), 105.

52. Howell, *Women, Production, and Patriarchy,* 122.

53. Ibid., 122–23.

54. Mitterauer and Sieder, *European Family,* 104.

55. Howell, *Women, Production, and Patriarchy,* 116.

56. Ibid., 177.

57. Ibid., 175.

58. Nicholas Terpstra, Introduction, in Terpstra, *Politics of Ritual Kinship,* 3.

59. Richard Trexler, "Florentine Religious Experience: The Sacred Image," *Studies in the Renaissance* 19 (1972), 30–31.

60. Nicholas Terpstra, *Lay Confraternities and Civic Religion in Renaissance Bologna* (New York: Cambridge University Press, 1995), 171.

61. Black, *Italian Confraternities*, 21.

62. In the seventeenth century, however, due to an ever-increasing social and economic crisis, Bolognese confraternities defined the poor as nobles who had fallen into poverty; Black, *Italian Confraternities*, 149.

63. Terpstra, *Lay Confraternities*, 54.

64. Ibid., 84.

65. Ibid., 118.

66. Ibid., 119.

67. Casagrande, "Confraternities and Lay Female Religiosity," 66.

68. Black, *Italian Confraternities*, 103.

69. Terpstra, *Lay Confraternities*, 123.

70. Ariel Glucklich, *Sacred Pain: Hurting the Body for the Sake of the Soul* (New York: Oxford University Press, 2001). By contrast, modern people, some of whom still suffer unmanageable pain, "waste" that pain.

CHAPTER 3: Mary Magdalen's Penitent Breast

The epigraph is from Michael Baxandall, *Patterns of Intention* (New Haven: Yale University Press, 1985), 115.

1. Bonaventure [pseudo], *Meditations on the Life of Christ: An Illustrated Manuscript of the Fourteenth Century*, ed. and trans. Isa Ragusa and Rosalie B. Green (Princeton: Princeton University Press, 1961), 172.

2. *Meditations*, 343.

3. Quoted in Katherine Ludwig Jansen, "Mary Magdalena: Apostolorum Apostola," in *Women Preachers and Prophets through Two Millennia of Christianity*, ed. Beverly Mayne Kienzle and Pamela J. Walker (Berkeley: University of California Press, 1998), 60.

4. A fifth-century Palestinian monk, Zosimus, first circulated the legend of Mary of Egypt, and it was subsequently embellished in Jacobus de Voragine's *Golden Legend* (1255–66).

5. See my *Carnal Knowing: Female Nakedness and Religious Meaning in the Christian West* (Boston: Beacon, 1989), 66. The composite Mary Magdalen was not agreed upon by all medieval authors, and discussion of her identity continued throughout the Middle Ages; see Giles Constable, *Three Studies in Medieval Religious and Social Thought* (Cambridge: Cambridge University Press, 1995), 6–7. The Eastern Orthodox churches did not accept the conflation of several women found in the gospels into the composite figure of the Magdalen.

6. Richard Kieckhefer, *Unquiet Souls: Fourteenth-Century Saints and Their Religious Milieu* (Chicago: University of Chicago, 1984), 133.

7. Jonathan Sumption, *Pilgrimage: An Image of Medieval Religion* (London: Faber and Faber, 1975), 214.

8. The most comprehensive study to date on the cult of the Magdalen was done by Victor Saxer, *Le Culte de Marie Madeleine en Occident des origins à la fin du moyen age* (Paris: Librarie Clavreuill, 1959); Saxer documents the Magdalen's popularity by mapping the churches dedicated to her, liturgies composed in her honor, and pilgrimages and other cultic practices associated with her until Renaissance scholarship questioned and gradually dissolved the Magdalen's composite figure and the medieval Magdalen vanished. At present, a website is devoted to facts and theories about Mary Magdalen (www.Magdalene.org). See also Marjorie M. Malvern, *Venus in Sackcloth: The Magdalen's Origins and Metamorphoses* (Carbondale: Southern Illinois University Press, 1975).

9. Richard Rex, *The Theology of John Fisher* (Cambridge: Cambridge University Press, 1991), 65–77.

10. Miles, *Carnal Knowing*, 48–52; Dennis R. MacDonald, *There is No Male and Female: The Fate of a Dominical Saying in Paul and Gnosticism* (Philadelphia: Fortress Press, 1987), 98ff; J. Duncan Derrett, "Religious Hair," in *Studies in the New Testament: Glimpses of Legal and Social Presuppositions of the Authors* (Leiden: Brill, 1977), 171.

11. Francis Ames-Lewis, *The Intellectual Life of the Early Renaissance Artist* (New Haven: Yale University Press, 2000), 187.

12. Ibid., 273, 276.

13. Hans Belting, *Likeness and Presence: A History of the Image before the Era of Art*, trans. Edmund Jephcott (Chicago: University of Chicago Press, 1994), 390.

14. Ibid., 471.

15. Leon Battista Alberti, *On Painting*, ed. M. Kemp, trans. Cecil Grayson (London: Phaidon, 1991), 72.

16. "The Divine Machine: Artists and Academies," in Martin Kemp and Marina Wallace, *Spectacular Bodies: The Art and Science of the Human Body from Leonardo to Now*, exh. cat. (Berkeley: University of California Press, 2000), 69.

17. See, for example, Simon Schama, *Rembrandt's Eyes* (New York: Alfred A. Knopf, 1999).

18. Beverly Mayne Kienzle, "The Prostitute-Preacher: Patterns of Polemic against Medieval Waldensian Women Preachers," in Kienzle and Walker, *Women Preachers and Prophets*, 102.

19. Procopius, *Anecdota*, 17.5–6 and *Histories, Buildings*, 1.9.2; *Procopius*, vols. 6 and 7, trans. H. B. Dewing (Cambridge, Mass.: Harvard University Press, 1943–45).

20. Saxer, *Le Culte de Marie Madeleine*, 250.

21. Probably the first church leader to call Mary Magdalen "apostle to the apostles" was the third-century bishop Hippolytus.

22. *Meditations*, 362–63.

23. Quoted in Elizabeth Clark and Herbert Richardson, *Women and Religion* (New York: Harper and Row, 1977), 52.

24. Jansen, "Mary Magdalena," 57–58.

25. Kienzle, "Prostitute-Preacher," 102; Kienzle points out that "disparaging remarks against lay men preachers were prompted by their disobedience, while comments against women reflect what the polemicists believed to be their fundamental inferiority, unalterable sinfulness, and proclivity for seduction."

26. Jansen, "Mary Magdalena," 79.

27. Mary D. Garrard writes: "The English word 'maudlin,' meaning 'tearfully or weakly emotional,' is a corruption of the Magdalen's name"; *Artemisia Gentileschi around 1622: The Shaping and Reshaping of an Artistic Identity* (Berkeley: University of California Press, 2001), 47. See also James Elkins, *Pictures and Tears* (New York: Routledge, 2001).

28. *Meditations,* 309.

29. *The Book of Margery Kempe,* trans. W. Butler Bowdon (London: J. Cape, 1936), 57.

30. If alleged witches *did* cry, as they must have almost always done in response to their torture and execution, the *Malleus* explains that they must have used spit to wet their cheeks. Heinrich Kramer and James Sprenger, *Malleus Maleficarum,* trans. Montague Summers (New York: Dover, 1971), 227.

31. Fray Pedro Malón de Chaide, *Tratado de la conversión de la Magdalena* (1592), in *Biblioteca de autores españoles,* vol. II (Madrid: Rivadeneyra, 1856), 152; quoted in Susan Verdi Webster, *Art and Ritual in Golden-Age Spain* (Princeton: Princeton University Press, 1998), 364–65.

32. Augustine, *Confessions,* 4.5.10; trans. Rex Warner (New York: Mentor, 1963).

33. Quoted in Webster, *Art and Ritual,* 179.

34. *Book of Margery Kempe,* 5.

35. Quoted in William A. Christian, "Provoked Religious Weeping in Early Modern Spain," in *Religious Organization and Religious Experience,* ed. J. Davis (London: Academic Press, 1982), 97–111.

36. Constable, *Three Studies,* 116.

37. It may be difficult, however, to tell whether contemplation or repentance is indicated in paintings of the Magdalen. See Mary Garrard's description of Artemisia Gentileschi's appropriation, in *Mary Magdalen as Melancholy,* of an existing artistic convention by which the depiction of masculine melancholy indicated "artistic creativity" and inspired thought; "Gentileschi thus enlarged the identity of the feminine contemplative to include the idea of masculine melancholy"; *Artemisia Gentileschi around 1622,* 74.

38. At this writing, the painting is not available for reproduction. Its authenticity was announced only in 2005.

39. David Freedberg, *The Power of Images* (Chicago: University of Chicago, 1989), 352.

40. However, the kind of historical evidence that would enable a historian to specify the range of reactions within a society is seldom available.

41. Webster, *Art and Ritual,* 108.

42. Freedberg, *Power of Images,* 322.

43. *The Life of St. Teresa of Avila,* 29.17; trans. David Lewis (London: Burns and Oates, 1962), 226.

44. *The Magdalen in Ecstasy* is "the most frequently copied of any of [Caravaggio's] works"; *The Age of Caravaggio,* exh. cat. (New York: Metropolitan Museum of Art, 1985), 313. A black-and-white reproduction of Louis Finson's copy (which is in the collection of the Musée des Beaux-Arts, Marseilles) appears on page 315. Perhaps the painting's strong sexual overtones explain its popularity.

45. Augustine, *De doctrina Christiana,* 1.22; *Saint Augustine: On Christian Doctrine,* trans. D. W. Robertson, Jr. (New York: Bobbs-Merrill, 1958).

46. I discuss this tradition in my *The Word Made Flesh: A History of Christian Thought* (Oxford: Blackwell, 2005), passim.

47. Bonaventure, *The Mind's Road to God,* 1.15; trans. George Boas (New York: Bobbs-Merrill, 1953).

48. Ibid., 6.3 (my emphasis).

49. Emile Mâle, *L'Art religieux de la fin du XVIe siècle, du XVIIe siècle et du XVIIIe siècle: Étude sur l'iconographie après le Concile de Trente* (Paris: Librarie Armand Colin, 1972), 2 (my translation).

50. Ibid.

51. Ibid., 511.

52. Ibid., 69.

53. See, for example Mateo Cerezo the Younger's *Penitent Magdalen* (before 1666, Figure 18), in which the Magdalen's right breast is exposed as she gazes at the crucified Christ.

54. Mary Garrard has called attention to the strong and active hands in Artemisia Gentileschi's paintings of female figures. In *Penitent Magdalen,* the Magdalen's large, strong right hand indents her breast with its urgent pressure, while the awkward position of her left hand shows agitation; "Artemisia's Hand," in *Reclaiming Female Agency: Feminist Art History after Postmodernism,* ed. Norma Broude and Mary Garrard (Berkeley: University of California Press, 2005), 63–80.

55. Anne Hollander, *Seeing Through Clothes* (New York: Avon, 1975), 98.

56. Mary Garrard describes the Magdalen's breasts in Orazio Gentileschi's depiction as "inorganic" and "molded, with little anatomical articulation"; *Artemisia Gentileschi: The Image of the Female Hero in Italian Baroque Art* (Princeton: Princeton University Press, 1989), 200.

PART TWO: The Secular Breast

The epigraphs are from Michel Foucault, *The Foucault Reader,* ed. Paul Rabinow (New York: Pantheon, 1984), 187, and G. Ferrero, quoted in Jean Delumeau, *La Peur en Occident, 14e–18e siècles* (Paris: Fayard, 1978), 2 (my translation).

1. Delumeau, *La Peur,* 305f.

2. *The Enchiridion of Erasmus,* trans. Raymond Himelick (Bloomington: University of Indiana Press, 1963), 178.

3. Walter Stephens, *Demon Lovers: Witchcraft, Sex, and the Crisis of Belief* (Chicago: University of Chicago Press, 2002), 4.

4. Heinrich Kramer and James Sprenger, *Malleus Maleficarum*, 1.6; trans. Montague Summers (New York: Dover, 1971), 43.

5. *Enchiridion of Erasmus*, 179.

6. Slavoj Žižek, *The Sublime Object of Ideology* (London: Verso, 1989), 49.

7. William Bercher, *The Nobility of Women* (1559), ed. R. Warwick Bond (London: Chiswick Press, 1904), 28.

8. Susanne Reid, "Writing Motherhood in the Reign of Louis XIV," in *Women in Renaissance and Early Modern Europe,* ed. Christine Meek (Dublin: Four Courts Press, 2000), 176.

9. See my *Carnal Knowing: Female Nakedness and Religious Meaning in the Christian West* (Boston: Beacon, 1989), 141.

10. Kramer and Sprenger, *Malleus Maleficarum*, 47.

11. On the prevalence of depictions of musical instruments in paintings of brothel scenes, see Sacha Fegan, "Hidden Pleasures: The Representation of the Prostitute in Seventeenth-Century Dutch Painting," in Meek, *Women in Renaissance and Early Modern Europe,* 115–16. Fegan says that plucked instruments were "symbolically erotic," as symbols of female genitals.

12. Robert Darnton, *The Forbidden Best-Sellers of Pre-Revolutionary France* (New York: W. W. Norton, 1995), 237.

CHAPTER 4: The Anatomical Breast

The epigraph is from Augustine, *The City of God,* 22.24; trans. Henry Bettenson (New York: Penguin, 1972).

1. Philip Melancthon, *Commentarius de anima* (Wittenberg, 1540), 44v–45r; quoted in Martin Kemp and Marina Wallace, *Spectacular Bodies: The Art and Science of the Human Body from Leonardo to Now,* exh. cat. (Berkeley: University of California Press, 2000), 14.

2. Ibid., 68. For the "strong figurative associations" of the idea of "Woman" in the Renaissance, see Ian Maclean, *The Renaissance Notion of Woman: A Study in the Fortunes of Scholasticism and Medical Science in European Intellectual Life* (New York: Cambridge University Press, 1980), 7.

3. Nancy G. Siraisi, *Medieval and Early Renaissance Medicine: An Introduction to Knowledge and Practice* (Chicago: University of Chicago Press, 1990), 86.

4. Claude Thomasset, "The Nature of Woman," in *A History of Women in the West, vol. 2: Silences of the Middle Ages,* ed. Christiane Klapisch-Zuber, Georges Duby, and Michelle Perrot (Cambridge, Mass.: Harvard University Press, 1992), 45.

5. Barbara Duden, *The Woman beneath the Skin: A Doctor's Patients in Eighteenth-Century Germany* (Cambridge, Mass.: Harvard University Press, 1991), 133.

6. Gianna Pomata, *Contracting a Cure: Patients, Healers, and the Law in Early Modern Bologna* (Baltimore: Johns Hopkins University Press, 1998), 65.

7. Ibid., 135.

8. Incidentally, forceps deliveries also meant that medical practitioners did not need to coach labor patiently for long hours as midwives had done.

9. Pomata, *Contracting a Cure,* xvi.

10. Ibid., 37–38.

11. Ibid., 158.

12. Ibid., 165.

13. Ibid., 46.

14. Ibid., 97.

15. Ibid., xiv.

16. Ibid., 60. See also Siraisi, *Medieval and Early Renaissance Medicine,* 2, 120–23.

17. Siraisi, *Medieval and Early Renaissance Medicine,* 121.

18. Pomata, *Contracting a Cure,* 64.

19. Ibid., 142.

20. Mary Lindemann concludes that "most physicians and surgeons wanted to control midwives, not displace them"; *Medicine and Society in Early Modern Europe* (Cambridge: Cambridge University Press, 1999), 117.

21. Ibid., 61–62.

22. Siraisi, *Medieval and Early Renaissance Medicine,* 27.

23. Ibid.

24. Ibid., 221.

25. Rudolph Bell, *How to Do It: Guides to Good Living for Renaissance Italians* (Chicago: University of Chicago Press, 1999), 98.

26. Duden, *Woman beneath the Skin,* 84–85.

27. Ibid., 81–85.

28. Quoted in Bell, *How to Do It,* 14.

29. Quoted in ibid., 99.

30. Jean Donnison, *Midwives and Medical Men: A History of Inter-Professional Rivalries and Women's Rights* (New York, Schocken Books, 1977), 1–21.

31. Pomata, *Contracting a Cure,* 64.

32. Mary Povey, "Scenes of an Indelicate Character: The Medical Treatment of Victorian Women," in *The Making of the Modern Body: Sexuality and Society in the Nineteenth Century,* ed. Catherine Gallagher and Thomas Laqueur (Berkeley: University of California Press, 1987), 138.

33. Ibid.

34. Lindemann, *Medicine and Society,* 221.

35. Pomata, *Contracting a Cure,* 116.

36. Ibid., 227, n. 71.

37. Suzanne Reid, "Writing Motherhood in the Reign of Louis XIV," in *Women in Renaissance and Early Modern Europe,* ed. Christine Meek (Dublin: Four Courts Press, 2000), 176.

38. Ibid., 178.

39. Pomata, *Contracting a Cure,* 138.

40. Duden, *Woman beneath the Skin,* 129.

41. Augustine, *Enarratione in Psalmos,* 136.10 (my translation); *Sancti Aurelii Augustini: Opera Omnia,* 1st ser., vol. 37 (Paris: J. P. Migne, 1845).

42. Siraisi, *Medieval and Early Renaissance Medicine,* 25.

43. Lindemann, *Medicine and Society,* 209.

44. Ibid., 13.

45. Pomata, *Contracting a Cure,* 60.

46. Siraisi, *Medieval and Early Renaissance Medicine,* 118.

47. Roger French and Andrew Wear, Introduction, in *The Medical Revolution of the Seventeenth Century,* ed. Roger French and Andrew Wear (New York: Cambridge University Press, 1989), 4.

48. John Henry, "The Matter of Souls: Medical Theory and Theology in Seventeenth-Century England," in French and Wear, *Medical Revolution,* 112.

49. French and Wear, Introduction, in French and Wear, *Medical Revolution,* 3–4.

50. Francesca Medioli, "The Enforcement of *clausura* before and after the Council of Trent," in Meek, *Women in Renaissance and Early Modern Europe,* 143.

51. Quoted in ibid., 151.

52. Quoted in ibid., 143.

53. Ibid., 152. Michel Foucault claims, in *Discipline and Punish,* that "the cloister was so effective in enclosing communities of women that the idea was later borrowed and adapted by penologists as the inspiration for the development of prisons based on a cellular system"; quoted in Carol Baxter, "Notions of the Body among the Nuns of Port-Royal," in Meek, *Women in Renaissance and Early Modern Europe,* 161.

54. Quoted in Baxter, "Notions of the Body," 149. Because it was recognized that constraint was a major factor in women's religious vocations, the Council of Trent decreed that vocations must be freely chosen (Articles XXVII–XIX).

55. Ibid., 150.

56. Baxter, "Notions of the Body," 156.

57. George Huppert, *After the Black Death: A Social History of Early Modern Europe,* (Bloomington: Indiana University Press, 1986), 38.

58. Christiane Klapisch-Zuber, *Women, Family, and Ritual in Renaissance Italy,* trans. Lydia G. Cochrane (Chicago: University of Chicago Press, 1985), 141.

59. Leah L. Otis, *Prostitution in Medieval Society* (Chicago: University of Chicago Press, 1985), 110.

60. Huppert, *After the Black Death,* 37.

61. Alain Corbin, "Commercial Sexuality in Nineteenth-Century France: A System of Images and Regulations," in Gallagher and Laqueur, *Making of the Modern Body,* 211.

62. Otis, *Prostitution,* 108.

63. Huppert, *After the Black Death*, 6,

64. James S. Olson, *Bathsheba's Breast: Women, Cancer, and History* (New York: Oxford University Press, 2002), 240.

65. Lindemann, *Medicine and Society*, 222.

66. Thomasset, "Nature of Woman," 45.

67. Ibid., 47.

68. Thomas Laqueur, *Making Sex: Body and Gender from the Greeks to Freud* (Cambridge, Mass.: Harvard University Press), 63.

69. Thomasset, "Nature of Woman," 65.

70. Ibid., 62, 65.

71. Quoted in Londa Schiebinger, "Skeletons in the Closet: The First Illustrations of the Female Skeleton in Eighteenth-Century Anatomy," in Gallagher and Laqueur, *Making of the Modern Body*, 74.

72. Laqueur, *Making Sex*, viii.

73. Ibid., viii.

74. Barbara Duden, *Disembodying Women: Perspectives on Pregnancy and the Unborn*, (Cambridge, Mass.: Harvard University Press, 1993), 79–82.

75. Claudia Opitz, "Life in the Late Middle Ages," in Klapisch-Zuber, Duby, and Perrot, *History of Women in the West, vol. 2*, 290.

76. Opitz, "Life in the Later Middle Ages," 290.

77. Duden, *Disembodying Women*, 60: the sixteenth-century Carolina Criminal Law punished only the abortion of a "living child after it had been quickened"; "the concept of feticide was first introduced only in 1871 in the legislation of the new German Reich."

78. Thomasset, "Nature of Woman," 51.

79. Silvana Vecchio, "The Good Wife," in Klapisch-Zuber, Duby, and Perrot *History of Women in the West, vol. 2*, 114–15.

80. Jacques Dalarun, "The Clerical Gaze," in *History of Women in the West, vol. 2*, 48.

81. Laqueur, *Making Sex*, 57–58.

82. Jacques Gélis, "The Child: From Anonymity to Individuality," in *A History of Private Life*, ed. Roger Chartier (Cambridge, Mass.: Harvard University Press, 1989), 318.

83. Quoted in Laqueur, *Making Sex*, 104.

84. Klapisch-Zuber, *Women, Family, and Ritual*, 161. See also Charles T. Wood, "The Doctor's Dilemma: Sin, Salvation, and the Menstrual Cycle in Medieval Thought," *Speculum* 56 (October 1981), 710–27.

85. Klapisch-Zuber, *Women, Family, and Ritual*, 162. See also Bell, *How to Do It*, 124–45.

86. Klapisch-Zuber, *Women, Family, and Ritual*, 143. We must consider the possibility that the importance of the father may have been emphasized not only to determine the father's authority, but also to call fathers to familial responsibility.

87. Ibid., 142.

88. Quoted in ibid., 140.

89. Ibid., 154.

90. Ibid., 146.

91. Gélis, "The Child," 320.

92. Reid, "Writing Motherhood," 173.

93. Ibid., 178.

94. Schiebinger, "Skeletons in the Closet," 49.

95. *The Notebooks of Leonardo da Vinci,* ed. Pamela Taylor (New York: New American Library, 1960), 110.

96. Kemp and Wallace, *Spectacular Bodies,* 23.

97. Elizabeth L. Eisenstein, *The Printing Press as an Agent of Change: Communications and Cultural Transformation in Early-Modern Europe* (New York: Cambridge University Press, 1980), 573.

98. Ibid., 574.

99. Laqueur, *Making Sex,* 4.

100. Ibid., 35.

101. Londa Schiebinger, "Skeletons in the Closet," 42.

102. Laqueur, *Making Sex,* 74: "In the frontispieces of fourteen anatomy books published between 1493 and 1658, the body being dissected is male in nine cases, female in four, and indeterminate in one."

103. Kemp and Wallace, *Spectacular Bodies,* 22. See also Schiebinger, "Skeletons in the Closet," 49.

104. Roy Porter, "The Early Royal Society and the Spread of Medical Knowledge," in French and Wear, *Medical Revolution,* 277.

105. Olson, *Bathsheba's Breast,* 1.

106. Ibid., 24.

107. Ibid., 18.

108. Ibid., 19.

109. Ibid., 25.

110. Ariel Glucklich, *Sacred Pain: Hurting the Body for the Sake of the Soul* (New York: Oxford University Press, 2001).

111. Olson, *Bathsheba's Breast,* 22.

112. Ibid., 240.

CHAPTER 5: The Pornographic Breast

The epigraph is from Hugh of Fouilloy, quoted in Umberto Eco, *History of Beauty* (New York: Rizzoli, 2002), 154.

1. Walter Stephens, *Demon Lovers: Witchcraft, Sex, and the Crisis of Belief* (Chicago: University of Chicago Press, 2002), 4–5.

2. Nachman Ben-Yehuda, "The European Witch Craze of the 14th to 17th Centuries: A Sociologist's Perspective," *American Journal of Sociology* 86 (July 1980), 11.

3. *The New Cambridge Modern History,* ed. G. R. Elton (Cambridge: Cambridge University Press, 1962), 2:360.

4. Ibid., 363.

5. Ibid.

6. Elizabeth L. Eisenstein, *The Printing Press as an Agent of Change: Communications and Cultural Transformation in Early-Modern Europe* (New York: Cambridge University Press, 1980), 570–71.

7. Ibid., 242.

8. Ibid., 348.

9. Elton, *New Cambridge History,* 365.

10. Steven Ozment, *Protestants: The Birth of a Revolution* (New York: Doubleday, 1992), 46.

11. Ibid., 47–48.

12. Ibid., 63.

13. Quoted in Carlo Ginzburg, *The Cheese and the Worms: The Cosmos of a Sixteenth-Century Miller,* trans. John and Anne Tedeschi (New York: Penguin, 1982), 6.

14. Eisenstein, *Printing Press,* 439.

15. Heinrich Kramer and James Sprenger, *Malleus Maleficarum,* trans. Montague Summers (New York: Dover, 1971), 47.

16. Eisenstein, *Printing Press,* 437.

17. Kramer and Sprenger, *Malleus Maleficarum,* 44.

18. Robin Briggs, *Witches and Neighbors: The Social and Cultural Context of European Witchcraft* (New York: Penguin, 1998), 260–61.

19. Steven Katz, *The Holocaust in Historical Context,* vol. 1 (New York: Oxford University Press, 1994), 433.

20. Briggs, *Witches and Neighbors,* 264–65, 270, 273.

21. Jenny Gibbons, "Recent Developments in the Study of the Great European Witch Hunt," *PanGaia* 21 (Autumn 1999), 24–34.

22. Kramer and Sprenger, *Malleus Maleficarum,* 140.

23. Freidrich Spee, "The Methods of the Witch-Persecutions," www.sacred-texts.com/pag/twp/twp10.htm (accessed June 22, 2006).

24. Briggs, *Witches and Neighbors,* 260–61.

25. Ben-Yehuda, "European Witch Craze," 15.

26. Elliot Rose, *A Razor for a Goat: Problems in the History of Witchcraft and Diabolism* (Toronto: University of Toronto Press, 1989), 30–31.

27. Jeffrey Burton Russell, *Witchcraft in the Middle Ages* (Ithaca, N.Y.: Cornell University Press, 1972), 231.

28. Stephens, *Demon Lovers,* 11.

29. Ibid., 138.

30. Ibid., 183.

31. Ibid., 184.

32. Quoted in Christopher Elwood, *The Body Broken: The Calvinist Doctrine of the Eucharist and the Symbolization of Power in Sixteenth-Century France* (New York: Oxford University Press, 1999), 16.

33. Robert Darnton, *The Forbidden Best-Sellers of Pre-Revolutionary France* (New York: W. W. Norton, 1995), 87.

34. Lynn Hunt, Introduction, in *The Invention of Pornography: Obscenity and the Origins of Modernity, 1500–1800,* ed. Lynn Hunt (Cambridge, Mass.: Zone Books, 1993), 10–12.

35. Paula Findlen, "Humanism, Politics, and Pornography in Renaissance Italy," in Hunt, *Invention of Pornography,* 60.

36. Elton, *New Cambridge History,* 376.

37. Rome's demise as the cultural center of Western Europe was caused partly by Charles V's 1527 conquest of Rome and the wholesale destruction of much of its art and architecture.

38. Findlen, "Humanism, Politics, and Pornography," 51.

39. Jacob Burckhardt, *The Civilization of the Renaissance in Italy,* ed. B. Nelson and C. Trinkhaus, trans. S.G.C. Middlemore (New York: Mentor, 1958), 170–71.

40. Ludwig Goldscheider, *Michelangelo: Paintings, Sculptures, Architecture* (London: Phaidon, 1953), 20.

41. See chapter 1, note 31 for information on the overpainting of Michelangelo's *Last Judgment.*

42. Findlen, "Humanism, Politics, and Pornography," 51.

43. Ibid., 52.

44. Darnton, *Forbidden Best-Sellers,* 86.

45. Linda Williams, *Hard Core: Pleasure, Power, and the Frenzy of the Visible* (Berkeley: University of California, 1989), 267.

46. Ibid., 270–71: "Pornography has ridden roughshod over the sexuality and sexual subjectivity of women."

47. The first illustrator of Aretino's *Sixteen Positions* was Giulio Romano (1492–1546). Marcantonio Raimondi produced sixteen copper engravings based on Romano's paintings and languished in prison for a year after their publication in 1524, until Aretino and others pled for his release. In 1527, Aretino published the book of sonnets he wrote to accompany the "lustful figures" and sent copies to patrons. Findlen, "Humanism, Politics, and Pornography," 95–96.

48. Darnton, "Sex for Thought," in *Sexualities in History,* ed. Kim M. Phillips and Barry Reay (New York: Routledge, 2002), 206.

49. The works of both Luther and Erasmus were placed on the Index.

50. Findlen, "Humanism, Politics, and Pornography," 57.

51. Darnton, "Sex for Thought," 116.

52. Ibid., 215.

53. A friend whose wife lost fifty pounds remarked to me: "I guess she *looks* better now, but she *felt* better [to him] when she weighed more." Renaissance men seem to have enjoyed *seeing* what they enjoyed *feeling.*

54. Quoted in Ioan P. Couliano, *Eros and Magic in the Renaissance,* trans. Margaret Cook (Chicago: University of Chicago Press, 1987), 213 (my emphasis). Couliano mentions that Giambattista della Porta, in his *Magiae Naturalis* (1664), offered prescriptions to shrink the size of breasts.

55. David Freedberg, *The Power of Images* (Chicago: University of Chicago Press, 1989), 351–52.

56. Darnton, *Forbidden Best-Sellers,* 89–90.

57. Joan Dejean, "The Politics of Pornography: L'école des Filles," in Hunt, *Invention of Pornography,* 110.

58. Eisenstein, *Printing Press,* 147.

59. Darnton, "Sex for Thought," 205.

60. Quoted in Darnton, *Forbidden Best-Sellers,* 96–97.

61. Ibid., 97.

62. Darnton, "Sex for Thought," 207.

63. Ibid., 212.

64. Darnton, *Forbidden Best-Sellers,* 93.

65. Significantly, the contents of the Roman sewer were called "*mixtura.*"

66. *The Enchiridion of Erasmus,* trans. Raymond Himelick (Bloomington; University of Indiana Press, 1963), 80.

67. Margaret C. Jacob, "The Materialist World of Pornography," in Hunt, *Invention of Pornography,* 157.

AFTERWORD: A Complex Delight

The epigraphs are from Donna Haraway, "The Persistence of Vision," in *Writing on the Body: Female Embodiment and Feminist Theory,* ed. Katie Conboy, Nadia Medina, and Sarah Stanbury (New York: Columbia University Press, 1997), 285, and R. G. Collingwood, *The Idea of History* (Oxford: Oxford University Press, 1956), 215.

1. The neo-baroque Romantic painter Eugène Delacroix's *Liberty Leading the People* (1830) contains the best-known Marianne. In 1999, after the supermodel Laetitia Casta, a Victoria's Secret and Guess? model, was named by 36,000 French mayors as the country's "Marianne for the twenty-first century"—the living embodiment of liberty, equality, and fraternity—journalist Deborah Ollivier commented: "It is undoubtedly Marianne's breasts—flush, freewheeling, insolently raised in protest or subdued in a state of heraldic order, that have the most symbolic weight." Writer and historian Maurice Agulhon wrote: "The Republic prefers a more opulent, maternal breast, with its promise of generosity and abundance." A pair of identically sized breasts, he added, "are an additional symbol of the egalitarian spirit." Both quoted in "Model Maria Laetitia Casta Voted France's National Symbol," *Brunswickian* 133, no. 20 (1999); http://www.unb.ca/bruns /9900/issue20/nuts/france/html (accessed June 26, 2006).

2. *The General Crisis of the Seventeenth* Century, ed. Geoffrey Parker and Lesley M. Smith (New York: Routledge, 1978), 121.

3. S. Brent Plate, *Walter Benjamin, Religion, and Aesthetics: Rethinking Religion Through the Arts* (New York: Routledge, 2005), 47.

4. Margaret R. Miles, "Vision: The Eye of the Body and the Eye of the Mind in St. Augustine's *De trinitate* and the *Confessions*," *Journal of Religion* 63, no. 2 (April 1983) 125–42.

5. Mitchell B. Merback, *The Thief, the Cross, and the Wheel: Pain and the Spectacle of Punishment in Medieval and Renaissance Europe* (Chicago: University of Chicago, 1998), 298.

6. See David Chidester, *Word and Light: Seeing, Hearing, and Religious Discourse* (Urbana: University of Illinois Press, 1992), 3.

7. Merback, *Thief, Cross, and Wheel,* 279.

8. Margaret R. Miles, *The Word Made Flesh: A History of Christian Thought* (Oxford: Blackwell, 2005), 390–91.

9. Margaret R. Miles, *Carnal Knowing: Female Nakedness and Religious Meaning in the Christian West* (Boston: Beacon, 1989), passim. For a study of "the consequences of erecting a breast-centered culture within a patriarchal order," see Simon Richter, *Missing the Breast: Gender, Fantasy, and the Body in the German Enlightenment* (Seattle: University of Washington Press, 2006), 17.

10. Jessica Benjamin, *The Bonds of Love: Psychoanalysis, Feminism, and the Problem of Domination* (New York: Pantheon, 1988), 45.

11. Benjamin, *Bonds of Love,* 45–46. Philosopher Emmanuel Levinas similarly describes the face-to-face encounter as the "primordial production of being. . . . [The face is] the way in which the other presents himself, exceeding *the idea of the other in me*, . . . an encounter of unique beings that represents both separation and proximity"; *Totality and Infinity,* trans. Alphonso Lingis (The Hague: Nijhoff, 1961), 305, 40.

12. Mary Garrard, *Artemisia Gentileschi: The Image of the Female Hero in Italian Baroque Art* (Princeton: Princeton University Press, 1989), 25. Garrard argues for attributing to Artemisia the *Madonna and Child* of 1608–9 that previously had been attributed to her father, Orazio Gentileschi. She argues that the "emotional intimacy" of the painting (in which the infant gazes at his mother's face), the Madonna's dimpled knuckles (never found in Orazio's paintings), and the work's "earthy physicality" all suggest an attribution to Artemisia.

13. Leo Steinberg, *The Sexuality of Christ in Renaissance Painting and in Modern Oblivion* (New York: Pantheon, 1984), 2–3.

14. Jessica Benjamin, *The Shadow of the Other: Intersubjectivity and Gender in Psychoanalysis* (New York: Routledge, 1998), 42.

15. Benjamin, *Bonds of Love,* 84.

16. Ibid., 186.

17. Maxine Sheets-Johnstone writes: "By absenting ourselves as bodies we erase ourselves as subjects"; Sheets-Johnstone, *The Roots of Power: Animate Form and Gendered Bodies* (Chicago: Open Court, 1994), 11.

18. Ibid., 394.

19. Ibid., 32.

20. Benjamin, *Bonds of Love,* 103. Benjamin writes: "Early experiences of mutual recognition already prefigure the dynamics of erotic life."

21. Historical images of caring men are rare, but the fourteenth-century *Meditations on the Life of Christ* contains a drawing showing Christ rising at night to tenderly cover the disciples as they sleep.

22. Plato, *Republic,* 6.488a; *Plato: Collected Dialogues,* ed. Edith Hamilton and Huntington Cairns (Princeton: Princeton University Press, 1961).

23. Augustine, *Confessions,* 9.2; trans. Rex Warner (New York: Mentor, 1963).

24. Augustine, *The City of God,* 22.17; trans. Henry Bettenson (New York: Penguin, 1972). Augustine himself found that he could achieve this only in nonsexual relationships and so renounced sexual relationships, though he did not urge others to do the same.

25. Ibid.

26. René Girard, *I See Satan Fall Like Lightning,* trans. James G. Williams (Maryknoll, N.Y.: Orbis, 1999), 10.

27. Benjamin, *Bonds of Love,* 55–61. For Augustine on the gendering of power relationships, see *City of God,* 19.13–15.

28. Augustine, *De trinitate,* 14.19.25 (my translation); *Sancti Aurelii Augustini: Opera Omnia* (Paris: J. P. Migne, 1841).

29. Frigga Haug et al., *Female Sexualization: A Collective Work of Memory,* trans. Erica Carter (London: Verso, 1987), 39.

SELECT BIBLIOGRAPHY

Aberth, John. *From the Brink of the Apocalypse: Confronting Famine, War, Plague, and Death in the Later Middle Ages.* New York: Routledge, 2000.

Allen, Peter Lewis. *The Wages of Sin: Sex and Disease, Past and Present.* Chicago: University of Chicago, 2000.

Anderson, Bonnie S., and Judith P. Zinsser. *A History of Their Own.* 2 vols. New York: Harper and Row, 1988.

Banker, James R. *Death in the Community: Memorialization and Confraternities in an Italian Commune in the Late Middle Ages.* Athens: University of Georgia Press, 1988.

Baxandall, Michael. *Painting and Experience in Fifteenth Century Italy.* New York: Oxford University Press, 1972.

————. *Patterns of Intention: On the Historical Explanation of Pictures.* New Haven: Yale University Press, 1985.

Bell, Rudolph M. *How to Do It: Guides to Good Living for Renaissance Italians.* Chicago: University of Chicago Press, 1999.

Belting, Hans. *Likeness and Presence: A History of the Image before the Era of Art.* Trans. Edmund Jephcott. Chicago: University of Chicago Press, 1994.

Benjamin, Jessica. *The Bonds of Love: Psychoanalysis, Feminism, and the Problem of Domination.* New York: Pantheon, 1988.

————. *Like Subjects, Love Objects.* New Haven: Yale University Press, 1995.

————. *The Shadow of the Other: Intersubjectivity and Gender in Psychoanalysis.* New York: Routledge, 1998.

Ben-Yehuda, Nachman, "The European Witch Craze of the Fourteenth to Seventeenth Centuries: A Sociologist's Perspective," *American Journal of Sociology* 86, no. 1 (July 1980), 15–23.

Berliner, Rudolf, "The Freedom of Medieval Art," *Gazette des Beaux-Arts,* ser. 6, vol. 28 (1953), 263–88.

Black, Christopher F. *Italian Confraternities in the Sixteenth Century.* Cambridge: Cambridge University Press, 1989.

Bonaventure [pseudo]. *Meditations on the Life of Christ: An Illustrated Manuscript of the Fourteenth Century.* Ed. and trans. Isa Ragusa and Rosalie B. Green. Princeton: Princeton University Press, 1961.

Bradburne, James M., ed. *Blood: Art, Power, Politics, and Pathology.* New York: Prestel, 2004.

Briggs, Robin. *Witches and Neighbors: The Social and Cultural Context of European Witchcraft.* New York: Penguin, 1998.

Broude, Norma, and Mary Garrard, eds. *Reclaiming Female Agency: Feminist Art History after Postmodernism.* Berkeley: University of California Press, 2005.

Bynum, Caroline Walker. *Jesus as Mother: Studies in the Spirituality of the High Middle Ages.* Berkeley: University of California Press, 1982.

———. *Holy Feast and Holy Fast: The Religious Significance of Food to Medieval Women.* Berkeley: University of California Press, 1987.

The Canons and Decrees of the Council of Trent. Trans. H. J. Schroeder, O.P. Rockford, Ill.: Tan Books and Publishers, 1978.

Chadwick, Whitney. *Women, Art, and Society.* London: Thames and Hudson, 1990.

Chartier, Roger, ed. *A History of Private Life.* Cambridge, Mass.: Harvard University Press, 1989.

Chastel, André. *The Sack of Rome, 1527.* Trans. Beth Archer. Princeton: Princeton University, 1983.

Couliano, Ioan P. *Eros and Magic in the Renaissance.* Trans. Margaret Cook. Chicago: University of Chicago Press, 1987.

Darnton, Robert. *The Forbidden Best-Sellers of Pre-Revolutionary France.* New York: W. W. Norton, 1995.

———. "Sex for Thought." In Kim M. Phillips and Barry Reay, eds. *Sexualities in History.* New York: Routledge, 2002.

Delumeau, Jean. *La Peur en Occident, 14e–18e siècles.* Paris: Fayard, 1978.

Dillenberger, John. *Images and Relics: Theological Perceptions and Visual Images in Sixteenth-Century Europe.* New York: Oxford University Press, 1999.

Duden, Barbara. *The Woman beneath the Skin: A Doctor's Patients in Eighteenth-Century Germany.* Cambridge, Mass.: Harvard University Press, 1991.

———. *Disembodying Women: Perspectives on Pregnancy and the Unborn.* Cambridge, Mass.: Harvard University Press, 1993.

Eco, Umberto, ed. *History of Beauty.* New York: Rizzoli, 2002.

Eisenstein, Elizabeth L. *The Printing Press as an Agent of Change: Communications and Cultural Transformation in Early-Modern Europe.* New York: Cambridge University Press, 1980.

Elton, G. R., ed. *The New Cambridge Modern History.* Vol. 2. Cambridge: Cambridge University Press, 1962.

Elwood, Christopher. *The Body Broken: The Calvinist Doctrine of the Eucharist and the Symbolization of Power in Sixteenth-Century France.* New York: Oxford University Press, 1999.

The Enchiridion of Erasmus. Trans. Raymond Himelick. Bloomington: University of Indiana Press, 1963.

Fissell, Mary. "Gender and Generation: Representing Reproduction in Early Modern Europe." In Kim M. Phillips and Barry Reay, eds. *Sexualities in History.* New York: Routledge, 2002.

Freedberg, David. *The Power of Images.* Chicago: University of Chicago Press, 1989.

Freedberg, S. J. *Circa 1600: A Revolution of Style in Italian Painting.* Cambridge, Mass.: Harvard University Press, 1983.

French, Roger, and Andrew Wear, eds. *The Medical Revolution of the Seventeenth Century.* New York: Cambridge University Press, 1989.

Gallagher, Catherine, and Thomas Laqueur, eds. *The Making of the Modern Body: Sexuality and Society in the Nineteenth Century.* Berkeley: University of California Press, 1987.

Garrard, Mary D. *Artemisia Gentileschi: The Image of the Female Hero in Italian Baroque Art.* Princeton: Princeton University Press, 1989.

Gibbons, Jenny, "Recent Developments in the Study of the Great European Witch Hunt," *PanGaia* 21 (Autumn 1999), 24–34.

Ginzburg, Carlo. *The Cheese and the Worms: The Cosmos of a Sixteenth-Century Miller.* Trans. John and Anne Tedeschi. New York: Penguin, 1982.

———. *Ecstasies: Deciphering the Witches' Sabbath.* New York: Penguin, 1991.

Glucklich, Ariel. *Sacred Pain: Hurting the Body for the Sake of the Soul.* New York: Oxford University Press, 2001.

Gottfried, Robert S. *The Black Death: Natural and Human Disaster in Medieval Europe.* New York: Free Press, 1983.

Gregory, Brad. *Salvation at Stake: Martyrdom in Early Modern Europe.* Cambridge, Mass.: Harvard University Press, 1999.

Haskins, Susan. *Mary Magdalen: Myth and Metaphor.* New York: Harcourt, Brace, 1993.

Hearon, Holly. *The Mary Magdalen Tradition: Witness and Counter-Witness in Early Christian Communities.* Collegeville, Minn.: Liturgical Press, 2004.

Herlihy, David. *Medieval Households.* Cambridge, Mass.: Harvard University Press, 1985.

Hollander, Anne. *Seeing Through Clothes.* New York: Avon, 1975.

Howell, Martha C. *Women, Production, and Patriarchy in Late Medieval Cities.* Chicago: University of Chicago, 1986.

Hunt, Lynn, ed. *The Invention of Pornography: Obscenity and the Origins of Modernity, 1500–1800.* Cambridge, Mass.: Zone Books, 1993.

Huppert, George. *After the Black Death: A Social History of Early Modern Europe.* Bloomington: Indiana University Press, 1986.

Jansen, Katherine Ludwig. *The Making of the Magdalen: Preaching and Popular Devotion in the Later Middle Ages.* Princeton: Princeton University Press, 2000.

Katz, Steven. *The Holocaust in Historical Context.* Vol. 1. New York: Oxford University Press, 1994.

Kelly, Joan. "Did Women Have a Renaissance?" In *Women, History, and Theory: The Essays of Joan Kelly.* Chicago: University of Chicago Press, 1984.

Kelly, Veronica, and Dorothea E. von Müncke, eds. *Body and Text in the Eighteenth Century.* Stanford: Stanford University Press, 1994.

Kemp, Martin, and Marina Wallace. *Spectacular Bodies: The Art and Science of the Human Body from Leonardo to Now.* Exh. cat. Berkeley: University of California Press, 2000.

Kieckhefer, Richard. *Unquiet Souls: Fourteenth-Century Saints and Their Religious Milieu.* Chicago: University of Chicago Press, 1984.

Kienzle, Beverly Mayne, and Pamela J. Walker, eds. *Women Preachers and Prophets through Two Millennia of Christianity.* Berkeley: University of California Press, 1998.

Klapisch-Zuber, Christiane. *Women, Family, and Ritual in Renaissance Italy.* Trans. Lydia G. Cochrane. Chicago: University of Chicago Press, 1985.

———, Georges Duby, and Michelle Perrot, eds. *A History of Women in the West,* vol. 2: *Silences of the Middle Ages.* Cambridge, Mass.: Harvard University Press, 1992.

Klein, Melanie. "A Study of Envy and Gratitude." In *The Selected Melanie Klein.* Ed. Juliette Mitchell. New York: Free Press, 1987.

Kramer, Heinrich, and James Sprenger. *Malleus Maleficarum.* Trans. Montague Summers. New York: Dover, 1971.

Langer, William L. *An Encyclopedia of World History.* Boston: Houghton Mifflin, 1940.

Laqueur, Thomas. *Making Sex: Body and Gender from the Greeks to Freud.* Cambridge, Mass.: Harvard University Press, 1990,

Levack, Brian P. *The Witch-Hunt in Early Modern Europe.* Boston: Addison-Wesley, 1987.

Lindemann, Mary. *Medicine and Society in Early Modern Europe.* Cambridge: Cambridge University Press, 1999.

Maclean, Ian. *The Renaissance Notion of Woman: A Study in the Fortunes of Scholasticism and Medical Science in European Intellectual Life.* New York: Cambridge University Press, 1980.

Mâle, Émile. *L'Art religieux de la fin du XVIe siècle, du XVIIe siècle et du XVIIIe siècle: Étude sur l'iconographie après le Concile de Trente.* Paris: Librairie Armand Colin, 1972.

Malvern, Marjorie M. *Venus in Sackcloth: The Magdalen's Origins and Metamorphoses.* Carbondale: Southern Illinois University, 1975.

Mancinelli, Fabrizio, et al. "The Last Judgment: Notes on Its Conservation History, Technique, and Restoration." In Pierluigi De Vecchi, ed. *The Sistine Chapel: A Glorious Restoration.* New York: Harry N. Abrams, 1994.

Martin, John Rupert. *Baroque.* New York: Harper and Row, 1977.

Meek, Christine, ed. *Women in Renaissance and Early Modern Europe.* Dublin: Four Courts Press, 2000.

Meiss, Millard. *Painting in Florence and Siena after the Black Death*. New York: Harper, 1964.

Merback, Mitchell B. *The Thief, the Cross, and the Wheel: Pain and the Spectacle of Punishment in Medieval and Renaissance Europe*. Chicago: University of Chicago Press, 1998.

Miles, Margaret R. *Image as Insight: Visual Understanding in Western Christianity and Secular Culture*. Boston: Beacon, 1985.

————. *Carnal Knowing: Female Nakedness and Religious Meaning in the West*. Boston: Beacon, 1989.

————. *Desire and Delight: A New Reading of Augustine's* Confessions. New York: Crossroad, 1992.

Mitterauer, Michael, and Reinhard Sieder. *The European Family: Patriarchy to Partnership from the Middle Ages to the Present*. Chicago: University of Chicago Press, 1982.

Munck, Thomas. *The Enlightenment: A Comparative Social History, 1721–1794*. London: Arnold, 2000.

Olson, James S. *Bathsheba's Breast: Women, Cancer, and History*. New York: Oxford University Press, 2002.

Otis, Leah. *Prostitution in Medieval Society*. Chicago: University of Chicago Press, 1985.

Ozment, Steven. *Protestants: The Birth of a Revolution*. New York: Doubleday, 1992.

Parker, Geoffrey, and Lesley M. Smith, eds. *The General Crisis of the Seventeenth Century*. New York: Routledge, 1978.

Perniola, Mario. "Between Clothing and Nudity." In Michel Feher, ed. *Fragments for a History of the Body, Part 2*. New York: Zone Books, 1989.

Perry, R. "Colonizing the Breast: Sexuality and Maternity in Eighteenth-Century England," *Journal of the History of Sexuality* 2 (1991), 204–34.

Phillips, Kim, and Barry Reay, eds. *Sexualities in History*. New York: Routledge, 2002.

Pomata, Gianna. *Contracting a Cure: Patients, Healers, and the Law in Early Modern Bologna*. Baltimore: Johns Hopkins University Press, 1998.

Purkiss, Diane. *The Witch in History: Early Modern and Twentieth-Century Representations*. New York: Routledge, 1996.

Richter, Simon. *Missing the Breast: Gender, Fantasy, and the Body in the German Enlightenment*. Seattle: University of Washington Press, 2006.

Rose, Elliot. *A Razor for a Goat: Problems in the History of Witchcraft and Diabolism*. Toronto: University of Toronto Press, 1989.

Russell, Jeffrey Burton. *Witchcraft in the Middle Ages*. Ithaca, N.Y.: Cornell University Press, 1972.

Saxer, Victor. *La Culte de Marie Madeleine en Occident des origines à la fin du moyen age*. Paris: Librairie Clavreuill, 1959.

Schama, Simon. *Rembrandt's Eyes*. New York: Alfred A. Knopf, 1999.

Siraisi, Nancy G. *Medieval and Early Renaissance Medicine: An Introduction to Knowledge and Practice*. Chicago: University of Chicago Press, 1990.

Steinberg, Leo. *The Sexuality of Christ in Renaissance Painting and in Modern Oblivion*. New York: Pantheon, 1984.

Stephens, Walter. *Demon Lovers: Witchcraft, Sex, and the Crisis of Belief*. Chicago: University of Chicago Press, 2002.

Suleiman, Susan. *The Female Body in Western Culture: Contemporary Perspectives*. Cambridge, Mass.: Harvard University Press, 1985.

Sumption, Jonathan. *Pilgrimage: An Image of Medieval Religion*. London: Faber and Faber, 1975.

Terpstra, Nicholas. *Lay Confraternities and Civic Religion in Renaissance Bologna*. New York: Cambridge University Press, 1995.

———, ed. *The Politics of Ritual Kinship*. New York: Cambridge University Press, 2000.

Verdon, Timothy, and John Henderson. *Christianity and the Renaissance: Image and Religious Imagination in the Quattrocento*. Syracuse: Syracuse University Press, 1990.

Watt, Tessa. *Cheap Print and Popular Piety, 1550–1640*. Cambridge: Cambridge University Press, 1991.

Watts, Sheldon. *Epidemics and History: Disease, Power, and Imperialism*. New Haven: Yale University Press, 1997.

Webster, Susan Verdi. *Art and Ritual in Golden Age Spain: Sevillian Confraternities and the Sculpture of Holy Week*. Princeton: Princeton University Press, 1998.

Williams, Linda. *Hard Core: Power, Pleasure, and the Frenzy of the Visible*. Berkeley: University of California Press, 1989.

Wood, Charles T. "The Doctor's Dilemma: Sin, Salvation, and the Menstrual Cycle in Medieval Thought," *Speculum* 56 (1981), 710–27.

Yalom, Marilyn. *A History of the Breast*. New York: Alfred A. Knopf, 1997.

ILLUSTRATIONS

INDEX

Numbers in italics refer to illustrations.

Text:	11/14 Adobe Garamond
Display:	Adobe Garamond and Perpetua
Compositor:	International Typesetting and Composition
Printer and binder:	Thomson-Shore, Inc.